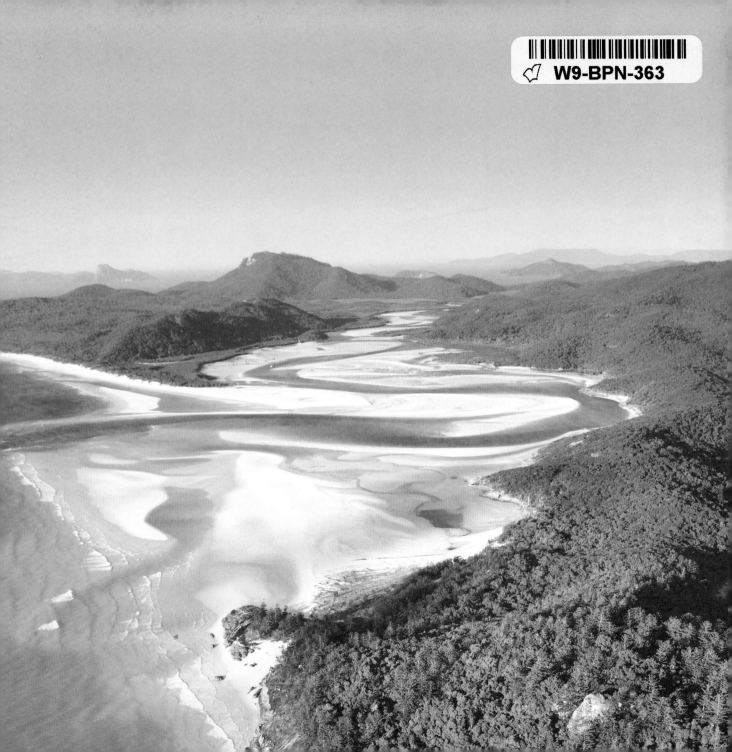

Australia

Contents

South Australia 150

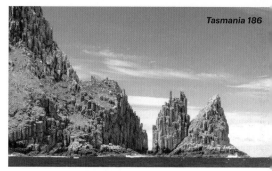

Tasmania 186

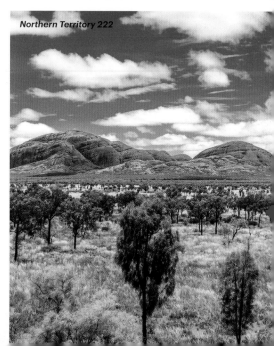

Northern Territory 222

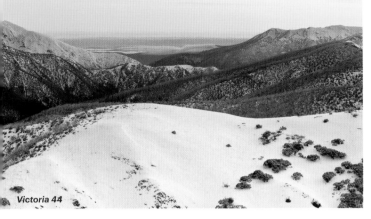

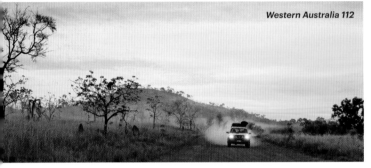

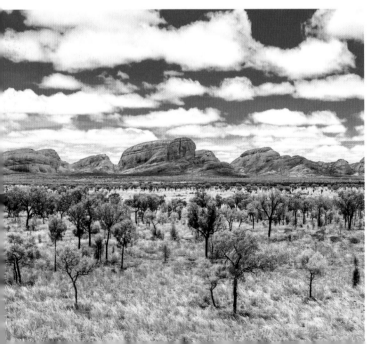

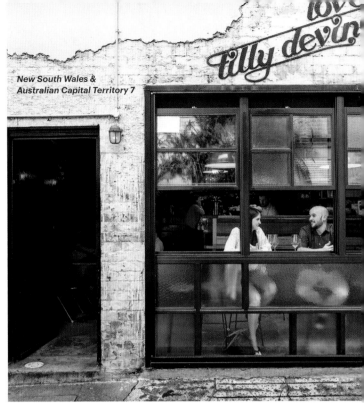

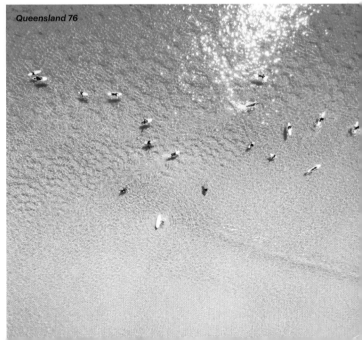

Australia

Such is Australia's scale that it can be snowing at one end of the country while daytime temperatures may be tropical at the other. In the hours that it takes to fly across its 8.6m sq km area (or the four days if you take the Ghan train from Adelaide to Darwin), you'll pass over vast deserts, forests, mountains, gorges and lakes. It is, after all, a continent.

Forty five million years ago, Australia split from the ancient supercontinent of Gondwana and remnants of that land's fauna and flora evolved into the unique Australian species that you see today – quokkas in Western Australia, quolls in Tasmania. Tracts of forest that date back to the era of the dinosaur survive in several locations.

But, as art critic Robert Hughes wrote in *The Fatal Shore*, his seminal account of Australia's founding, 'Australia is not, to me, a picturesque little country full of cute marsupials at the end of the world.' Its land may be old – and the earliest humans arrived 50,000 years ago – but Australia's modern cities are some of the youngest and most creative on the planet, some fewer than 200 years old.

This book of photography depicts the most beautiful aspects of Australia's natural world and its most extraordinary scenes. We'll travel from the warm waves of the Queensland coast, ushering surfers to shore, to the red deserts of its centre, where the land is so inhospitable that settlements are subterranean. We'll also visit Australia's thriving, cosmopolitan cities, experience rural life, and climb its highest mountains, trees and a very famous bridge.

We've organised the book by state and territory: the personality of each shines through the images, from raw and rugged Tasmania to the rocky, alien landscapes of the Northern Territory. We hope that this pictorial journey through Australia inspires you to take many trips of your own around this remarkable country.

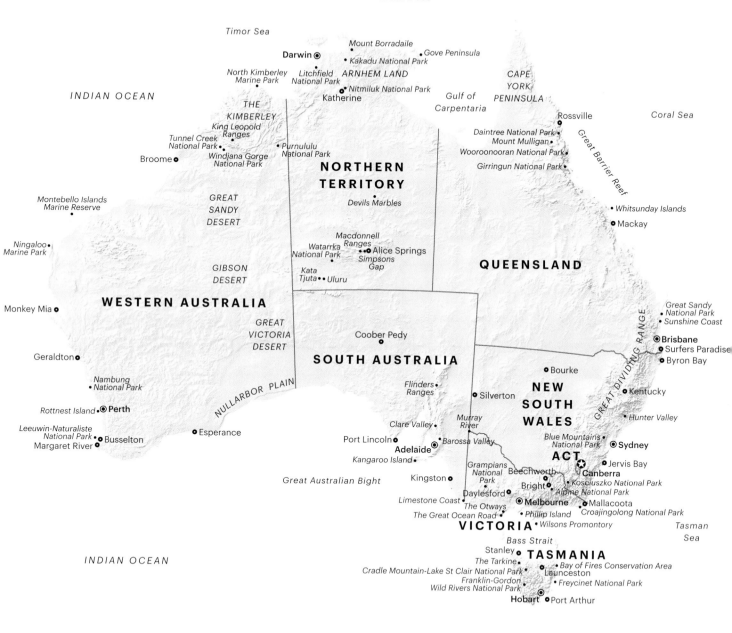

Arafura Sea

Timor Sea

Mount Borradaile
Gove Peninsula
Darwin ◉
Kakadu National Park
North Kimberley Litchfield ARNHEM LAND
Marine Park National Park
INDIAN OCEAN Nitmiluk National Park CAPE
THE Katherine Gulf of YORK
KIMBERLEY Carpentaria PENINSULA Coral Sea
Rossville
King Leopold
Ranges Daintree National Park
Tunnel Creek Mount Mulligan
National Park Purnululu Wooroonooran National Park
Broome ◉ Windjana Gorge National Park Girringun National Park
National Park

NORTHERN Whitsunday Islands
Montebello Islands GREAT TERRITORY Mackay
Marine Reserve SANDY Devils Marbles
DESERT
Ningaloo Macdonnell
Marine Park GIBSON Ranges QUEENSLAND
Watarrka Alice Springs
DESERT National Park Simpsons
Gap
WESTERN AUSTRALIA Kata
Tjuta Uluru Great Sandy
National Park
Monkey Mia GREAT Sunshine Coast
VICTORIA Coober Pedy ◉ Brisbane
DESERT Surfers Paradise
Geraldton SOUTH AUSTRALIA Byron Bay
Bourke
Nambung NULLARBOR PLAIN NEW Kentucky
National Park Flinders SOUTH
Ranges Silverton WALES Hunter Valley
Rottnest Island ◉ Perth Clare Valley Murray Blue Mountains
Leeuwin-Naturaliste River National Park ◉ Sydney
National Park Esperance Port Lincoln Barossa Valley ACT
Busselton Adelaide Jervis Bay
Margaret River Kangaroo Island Grampians Beechworth Canberra
Great Australian Bight National Bright Kosciuszko National Park
Kingston Park Alpine National Park
Daylesford Mallacoota
Limestone Coast The Otways Melbourne Croajingolong National Park
The Great Ocean Road Phillip Island Tasman
VICTORIA Wilsons Promontory Sea
Bass Strait
INDIAN OCEAN Stanley TASMANIA
The Tarkine Bay of Fires Conservation Area
Cradle Mountain-Lake St Clair National Park Launceston
Franklin-Gordon Freycinet National Park
Wild Rivers National Park
Hobart ◉ Port Arthur

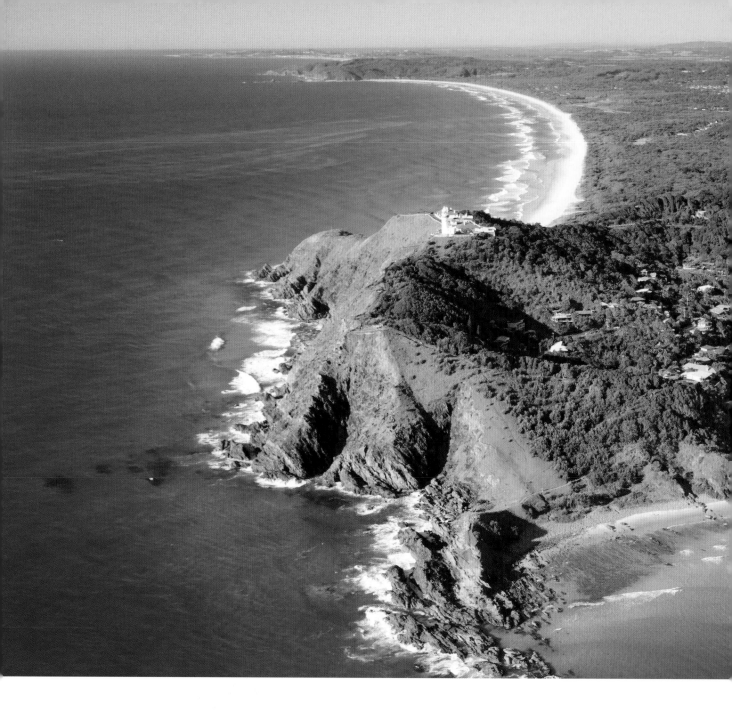

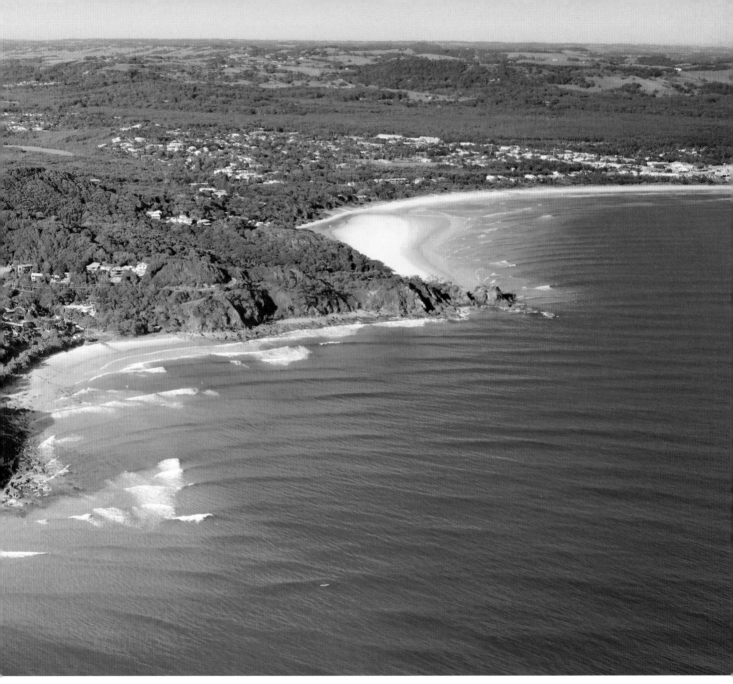

New South Wales › Byron Bay, bohemian town

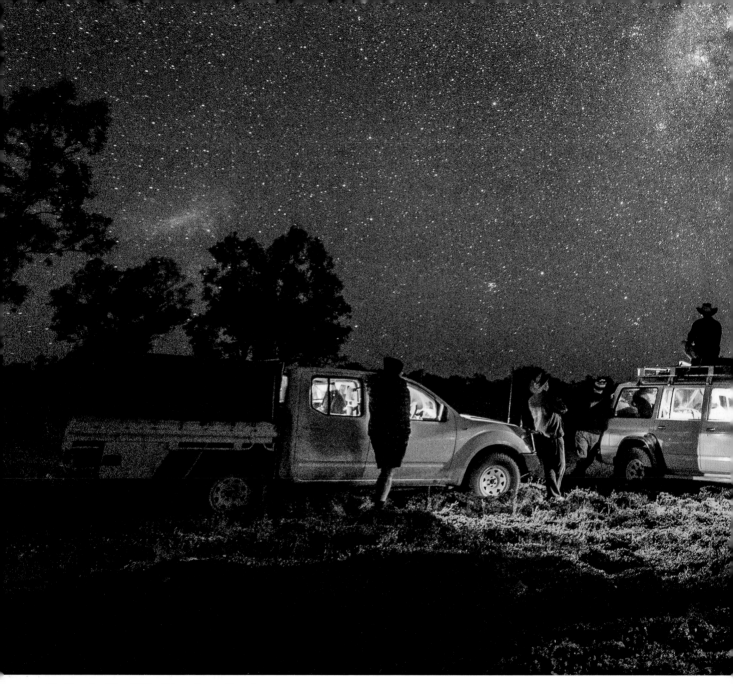

Outback › The Milky Way above Bourke

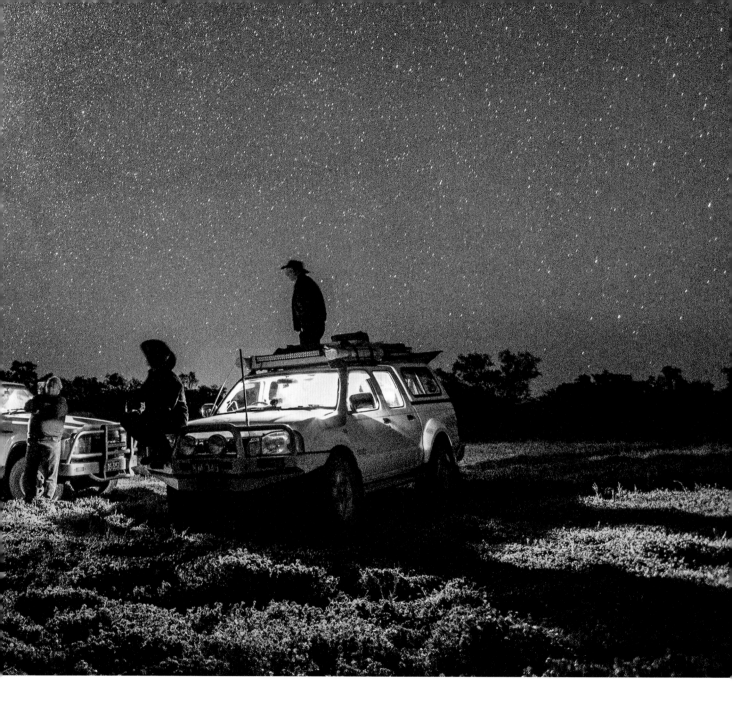

New South Wales & Australian Capital Territory

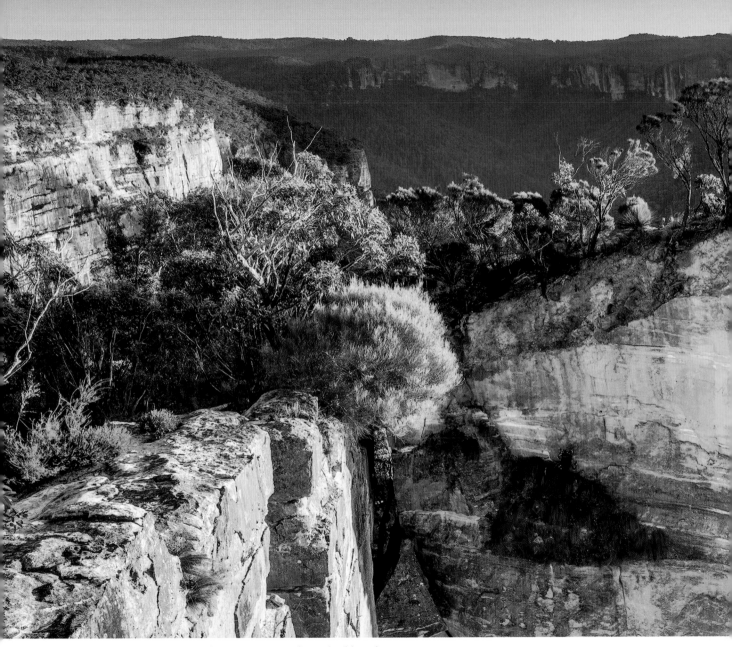

Blue Mountains National Park › Hanging Rock at Blackheath

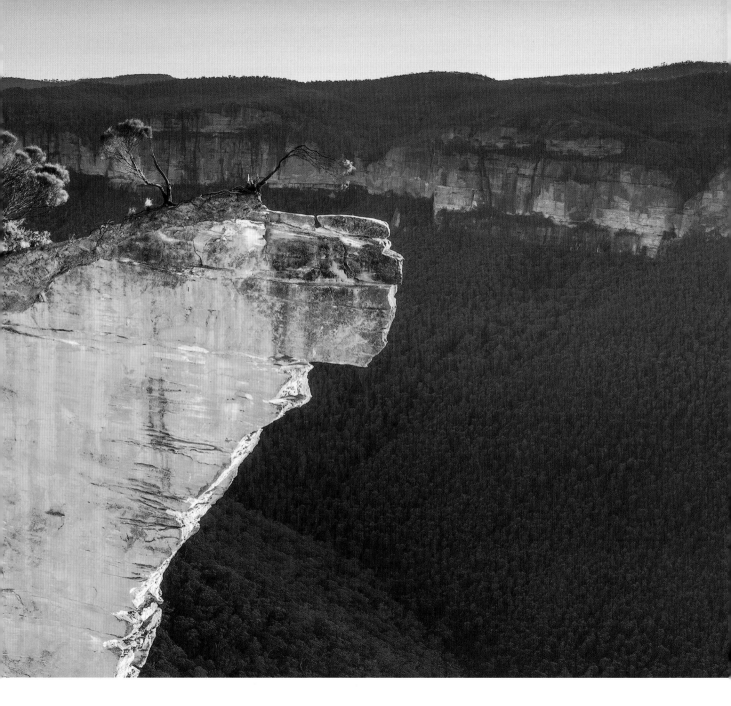

New South Wales & Australian Capital Territory

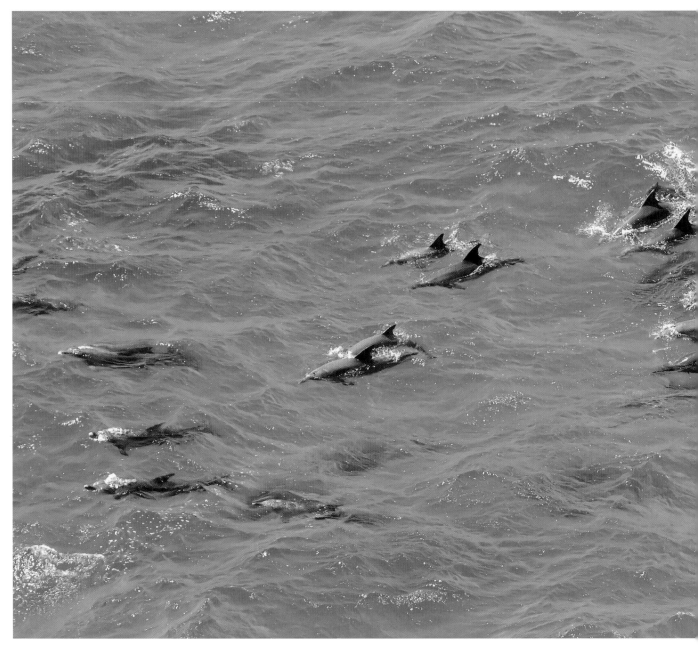

Byron Bay › Dolphins at Cape Byron

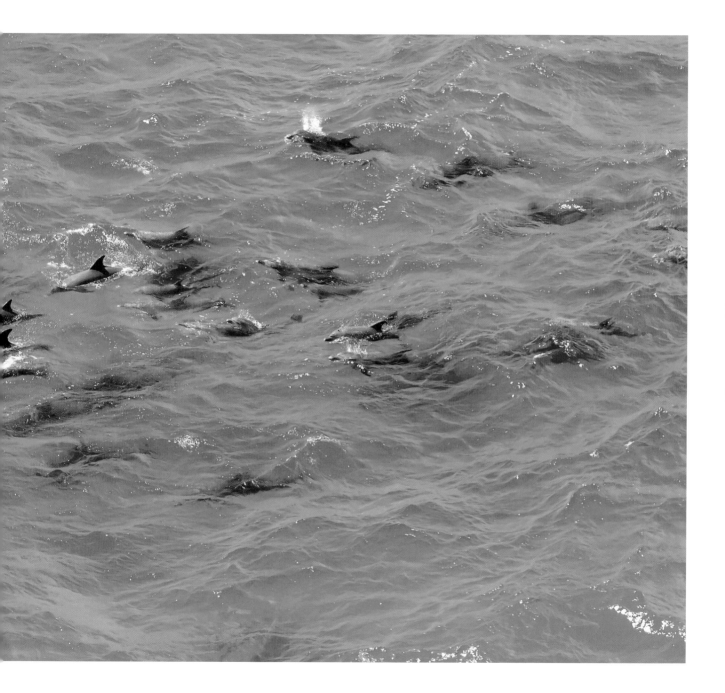

New South Wales & Australian Capital Territory

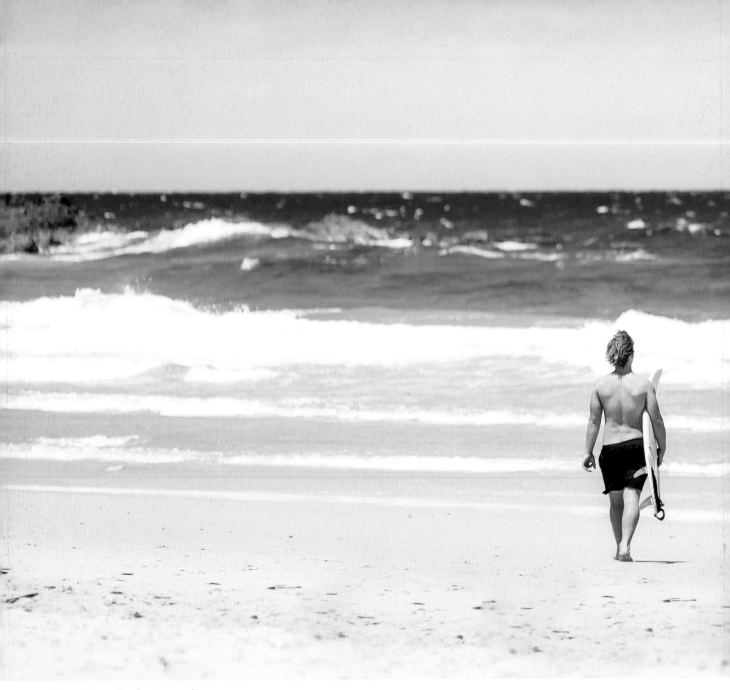

Byron Bay › Surfers' paradise

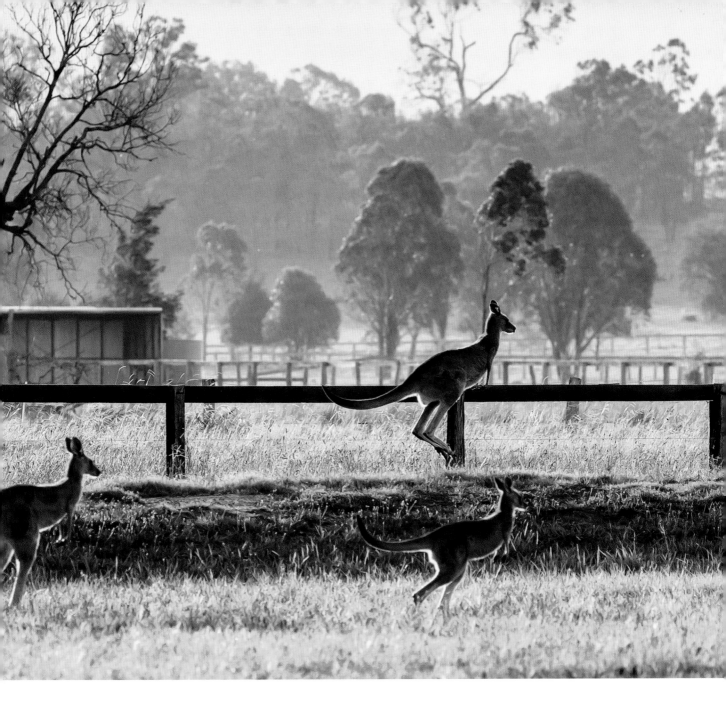

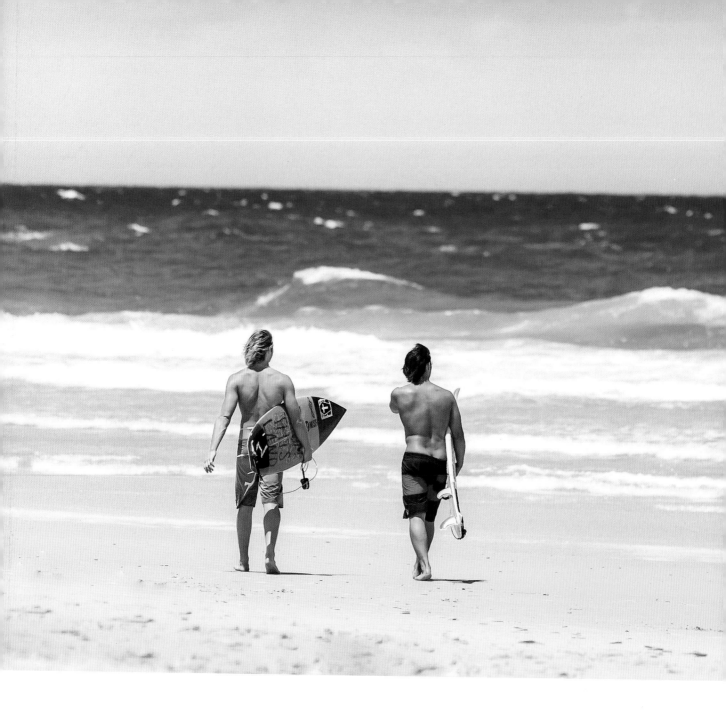

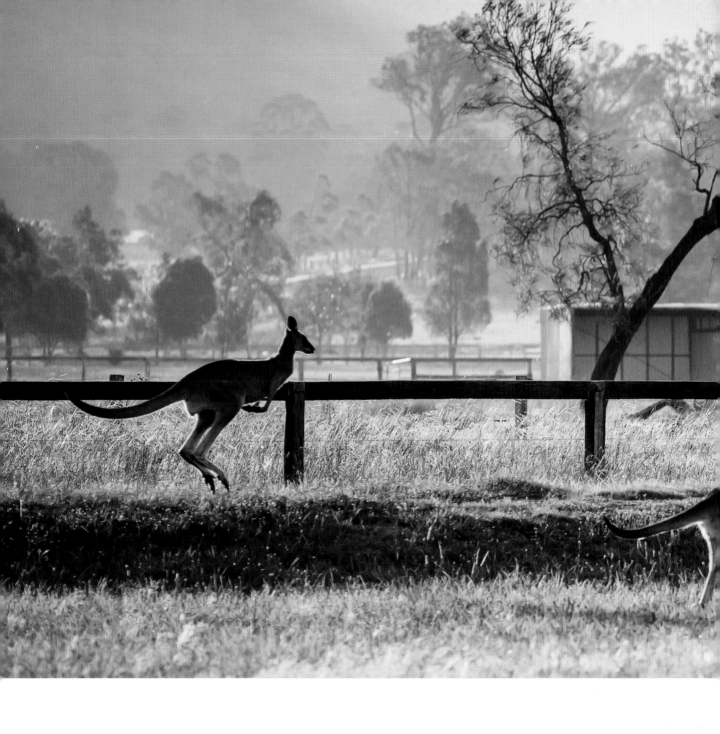

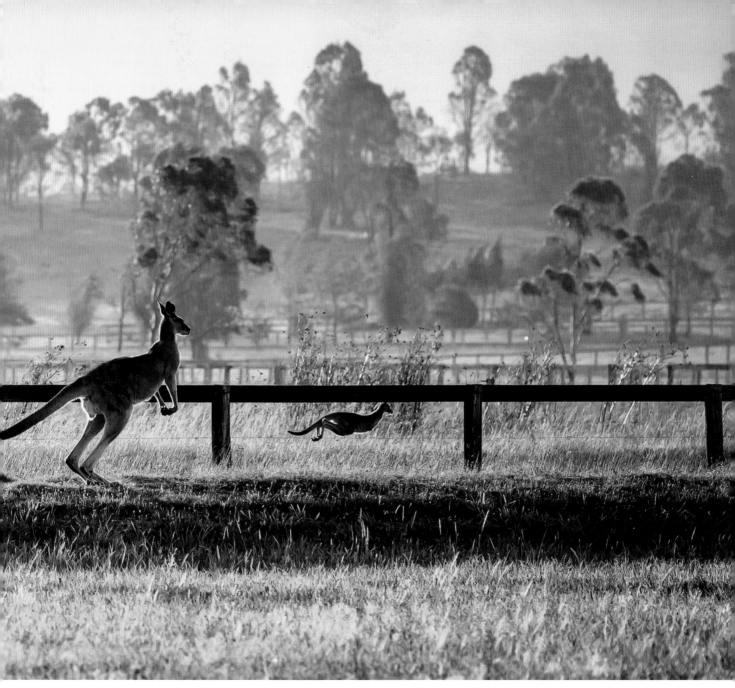

Hunter Valley › Food and vines

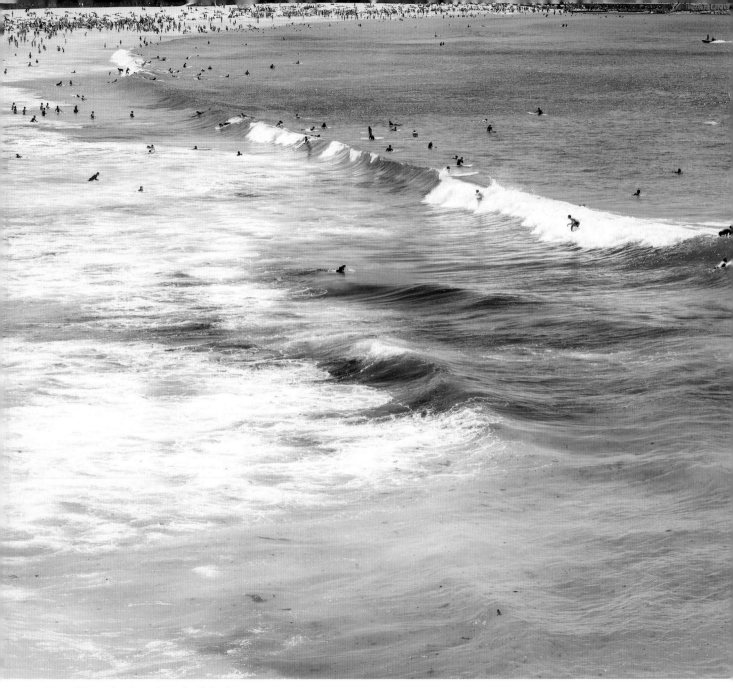

Bondi Beach › Star beach of Sydney

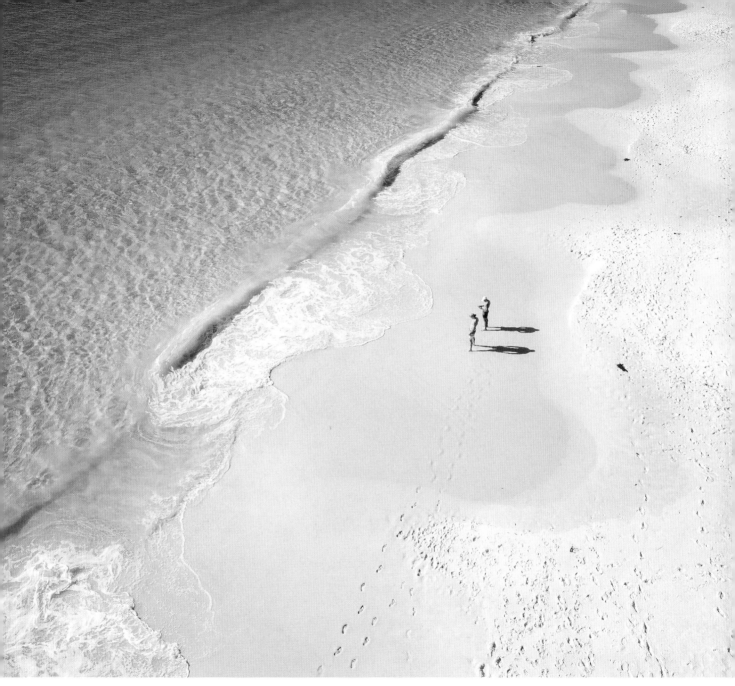

Jervis Bay › Hyams Beach

New South Wales & Australian Capital Territory

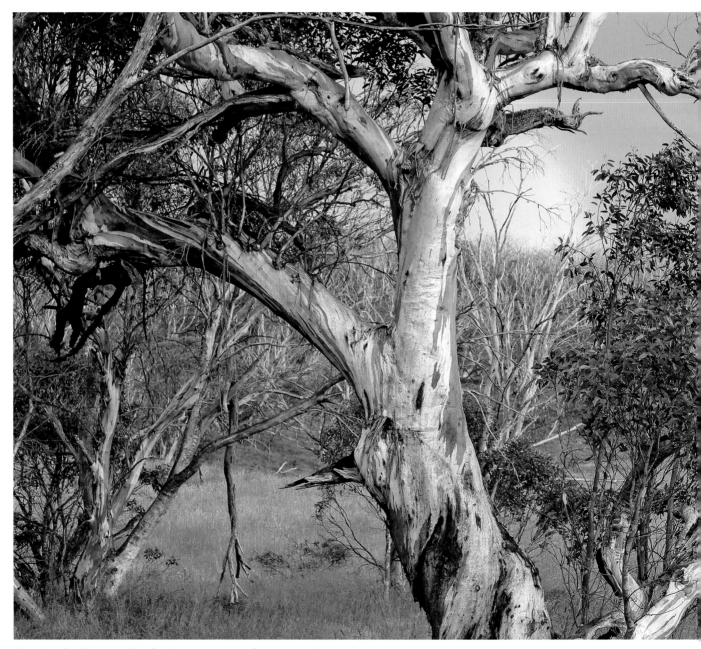

Kosciuszko National Park › Snow gums in the Snowy Mountains

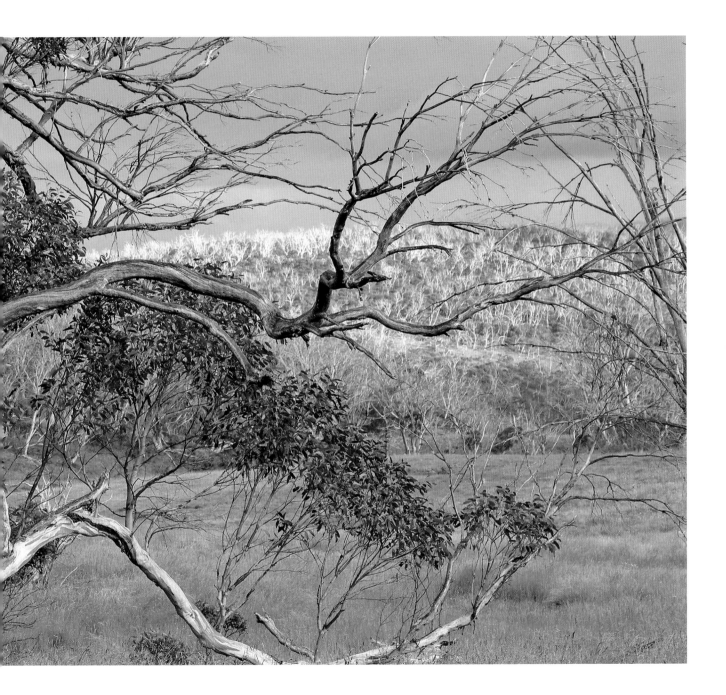

New South Wales & Australian Capital Territory

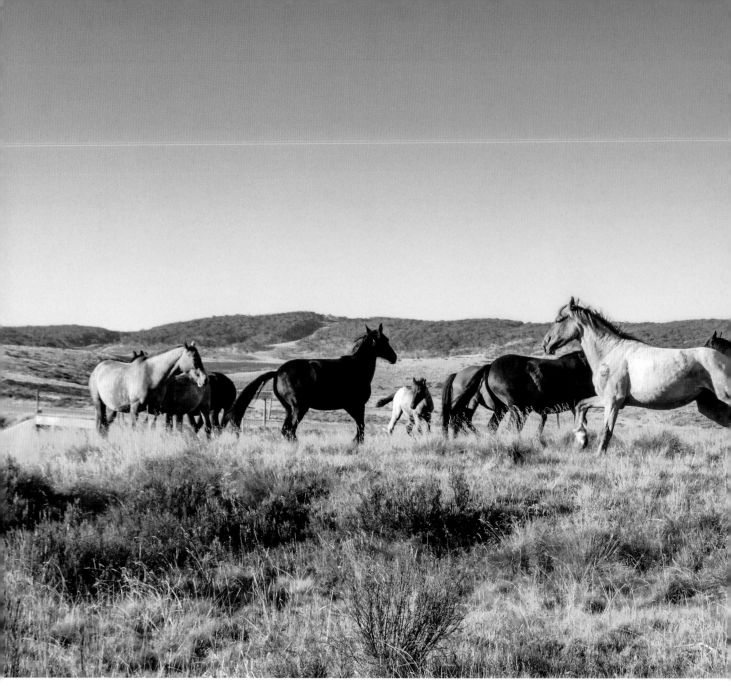

Snowy Mountains › Wild brumbies

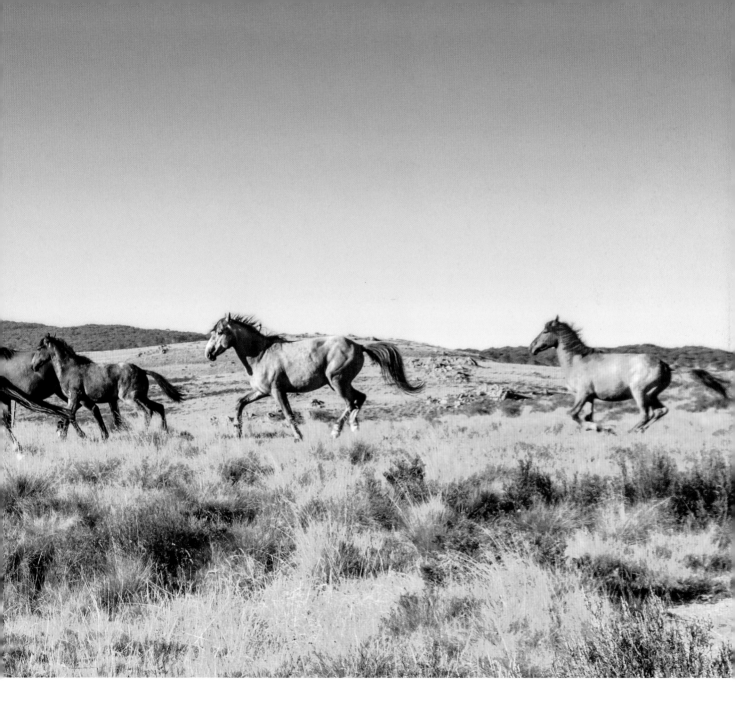

New South Wales & Australian Capital Territory

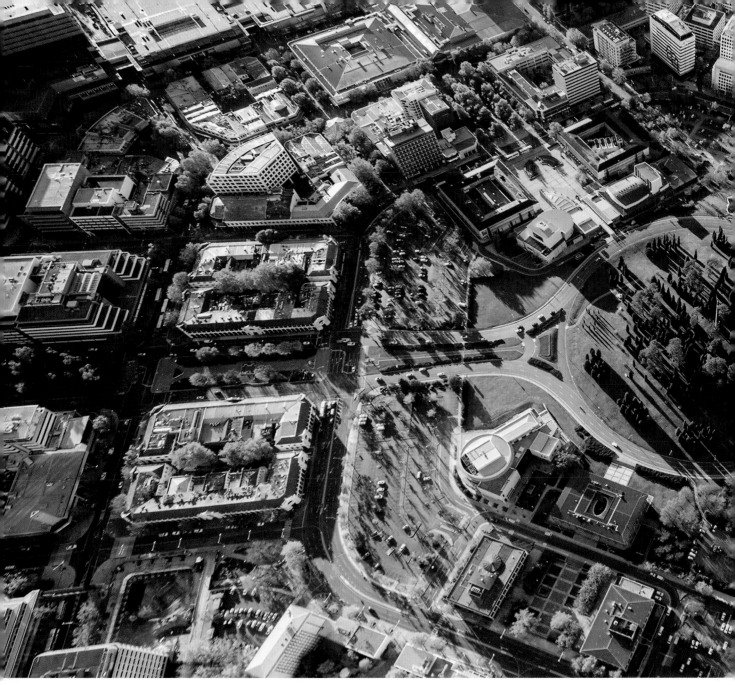

Canberra › City Hill in the capital

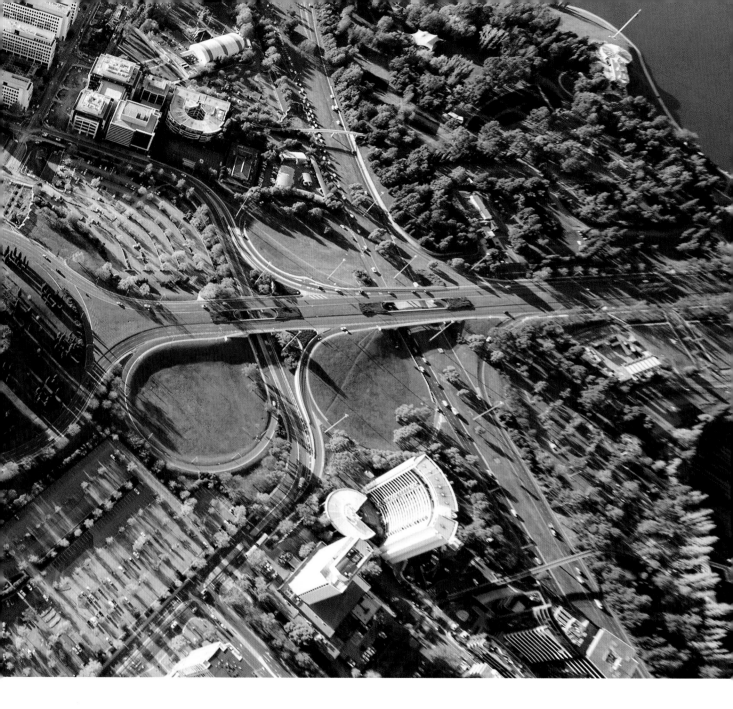

New South Wales & Australian Capital Territory

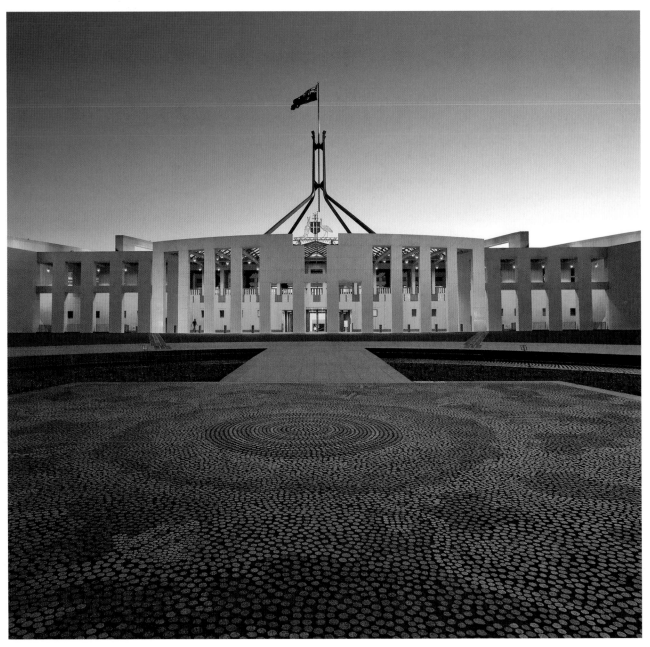

Canberra › Parliament House

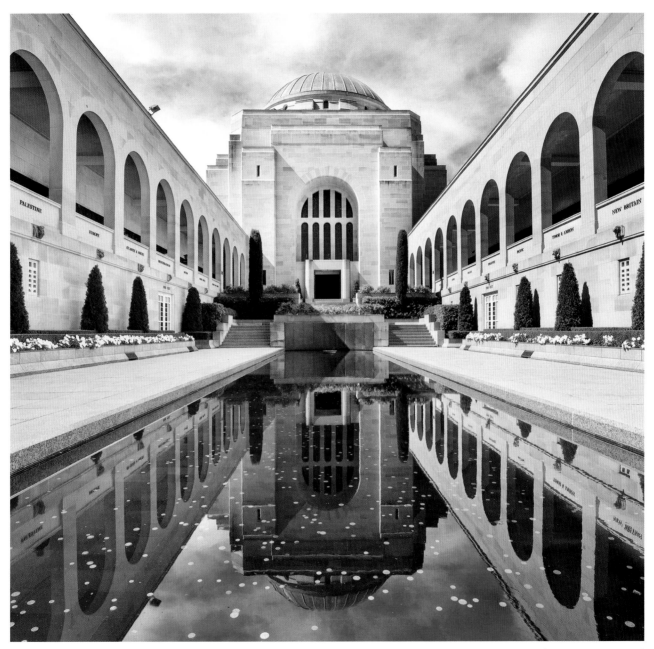

Canberra › The Australian War Memorial

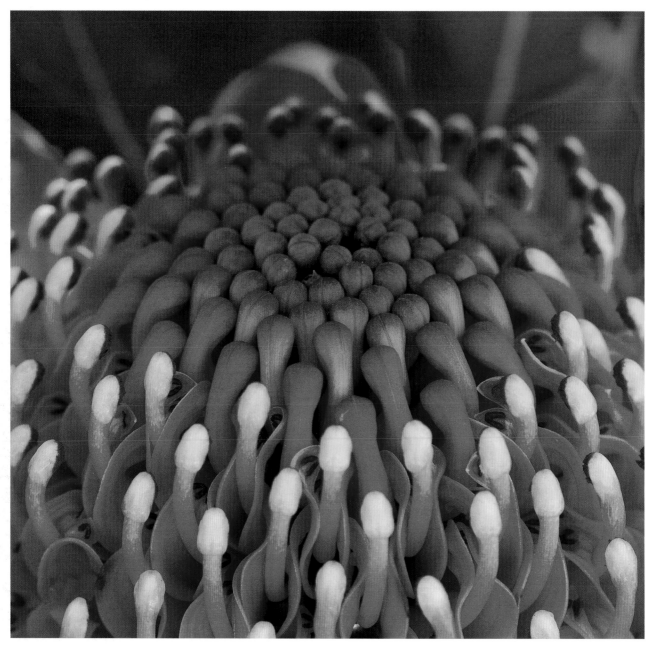

New South Wales › The waratah, state emblem

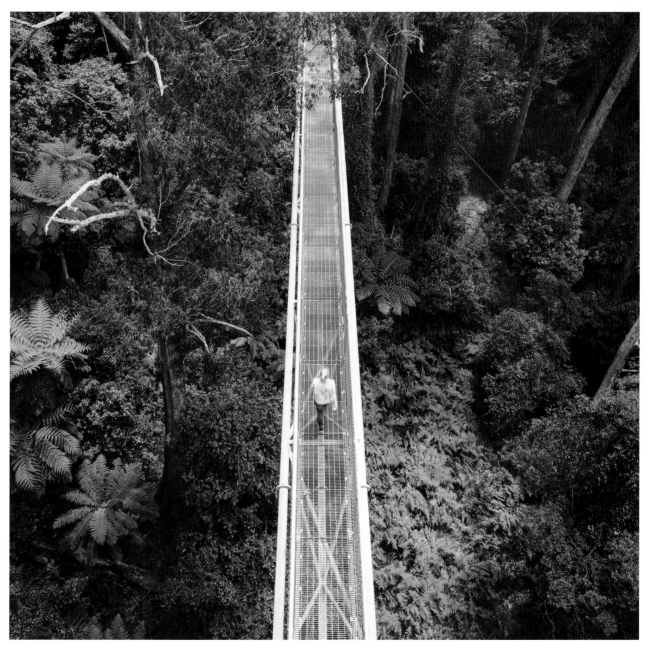

South coast › Illawarra Fly Treetop Walk

New South Wales & Australian Capital Territory

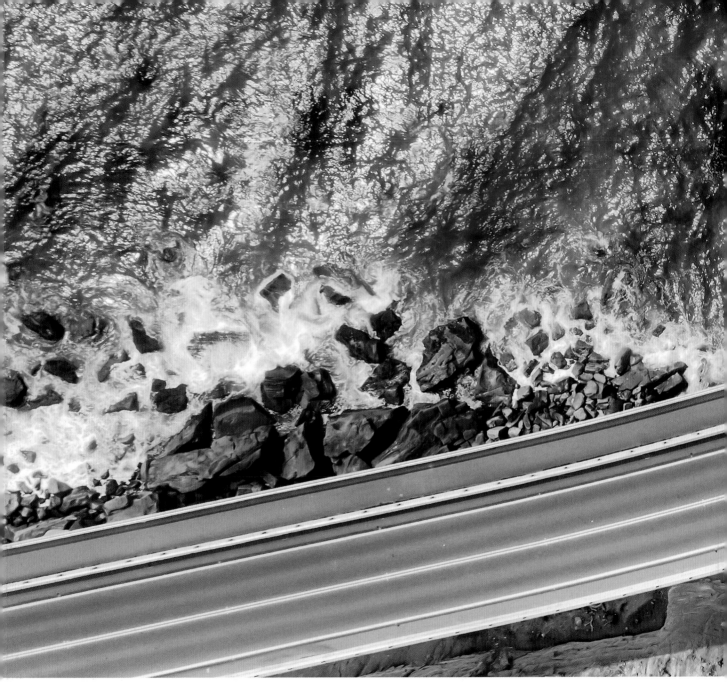

South coast › The Grand Pacific Drive

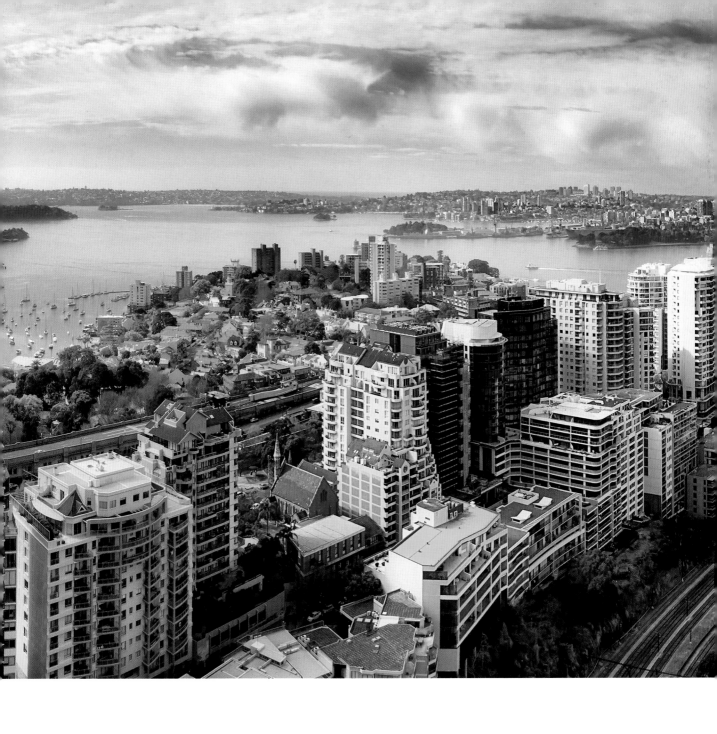

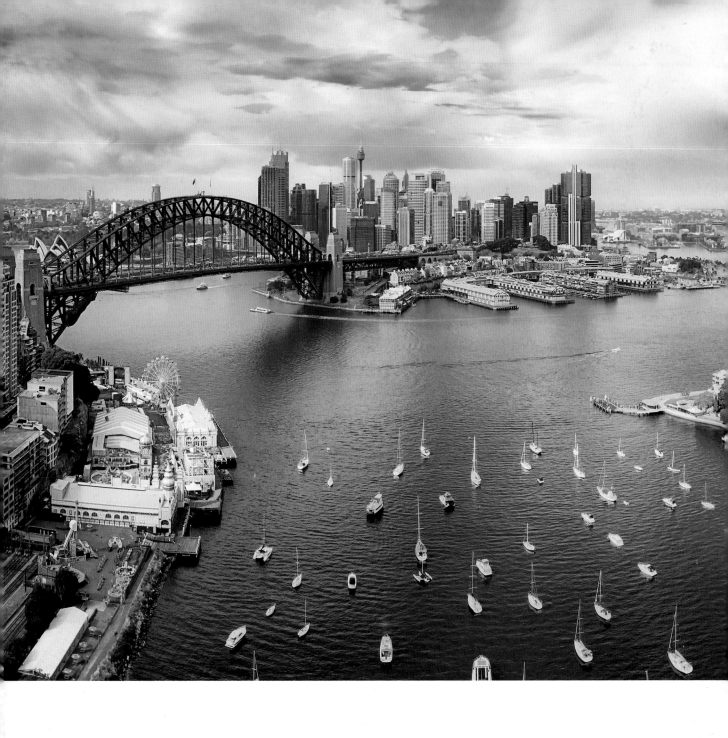

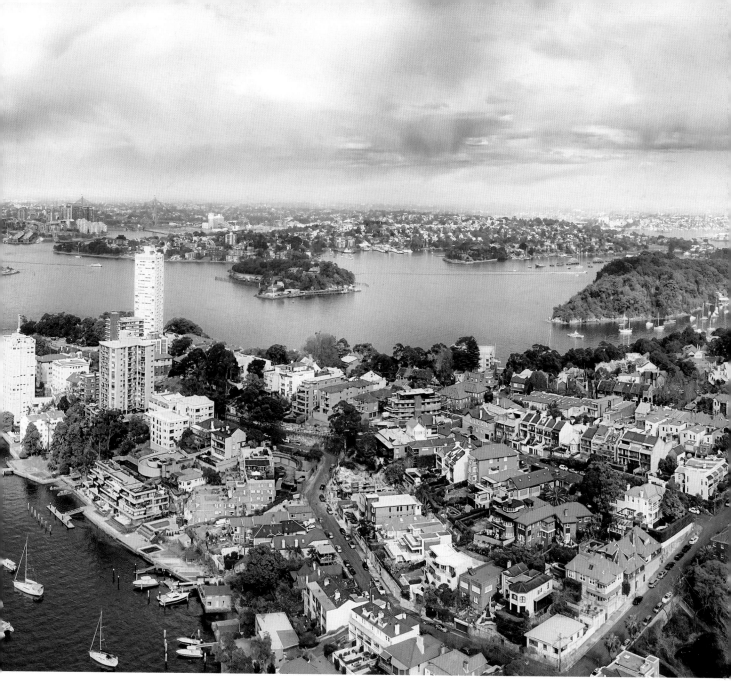

Sydney › The city harbour

New South Wales & Australian Capital Territory

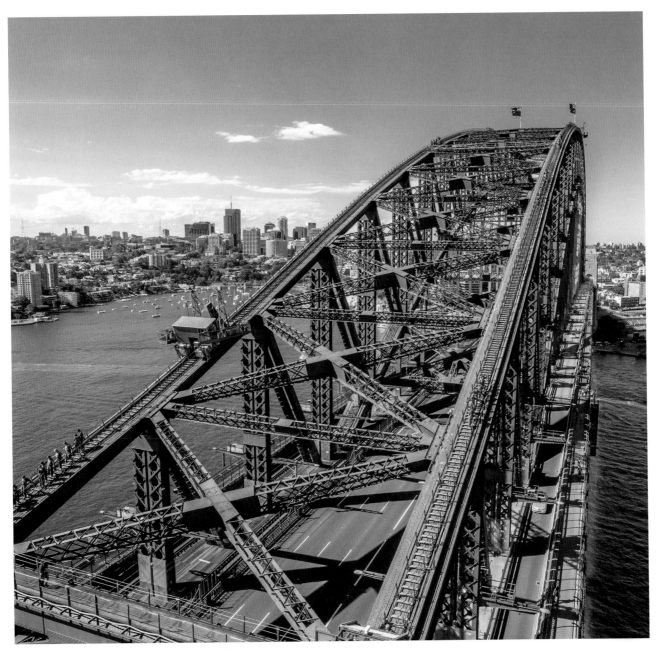

Sydney › Sydney Harbour Bridge

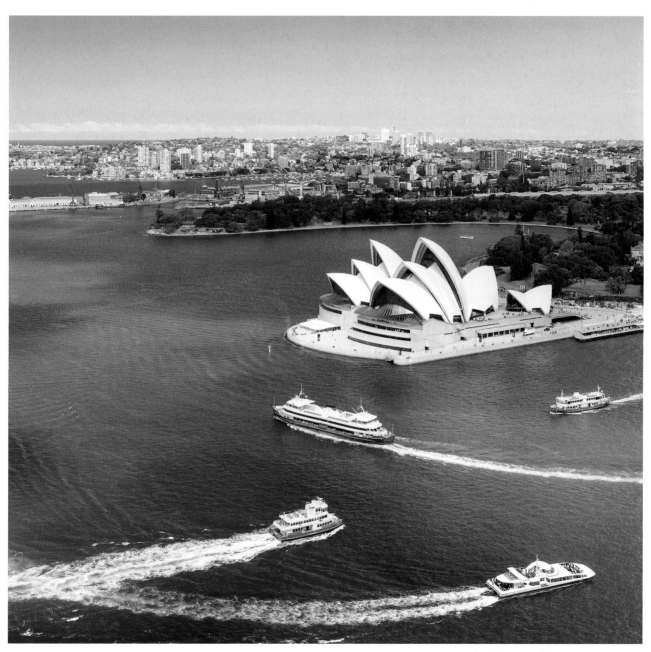

Sydney › Sydney Opera House

New South Wales & Australian Capital Territory

Sydney › Bondi Icebergs seawater pool

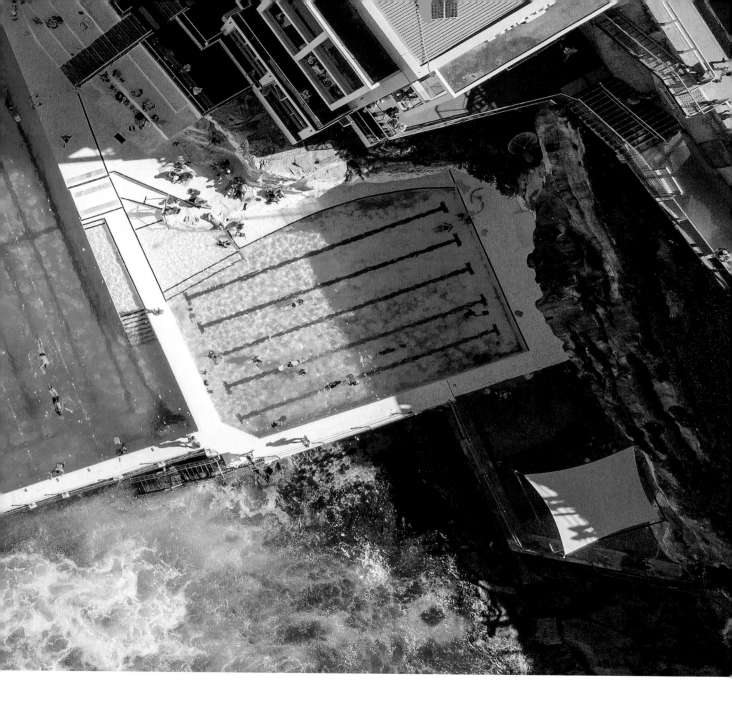

New South Wales & Australian Capital Territory

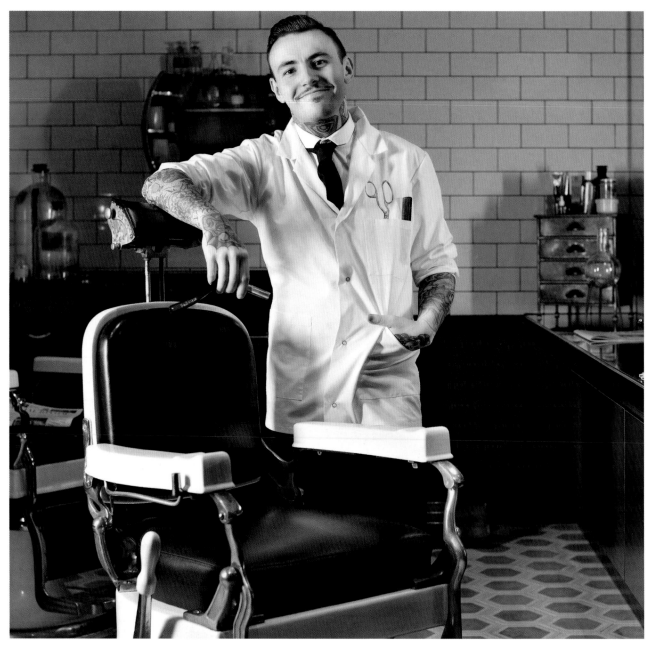

Sydney › Hipster hang-outs

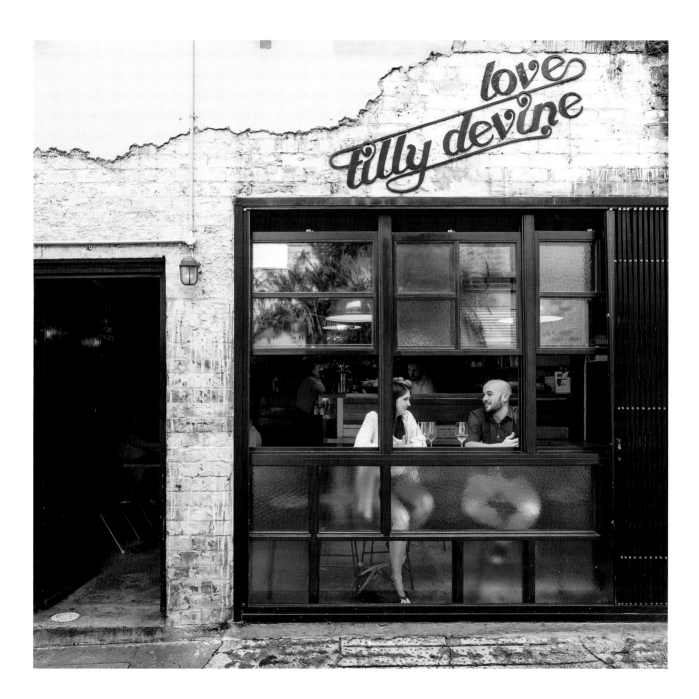

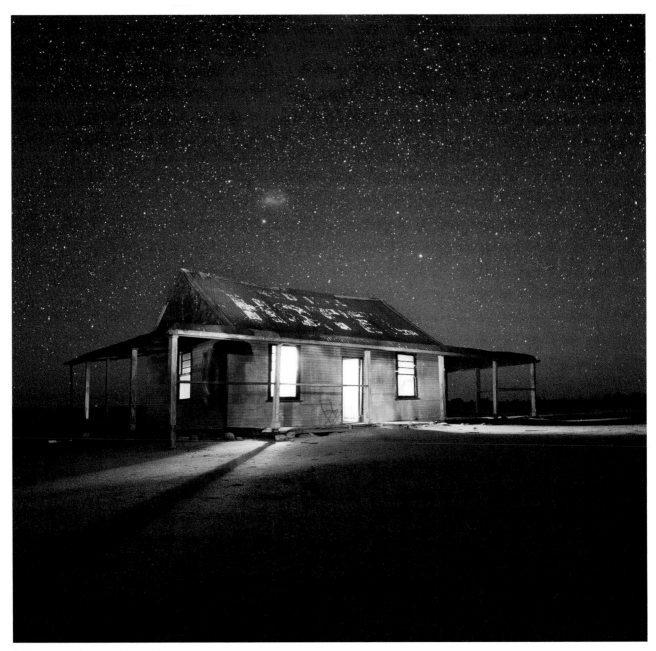

Silverton › Outback hotel

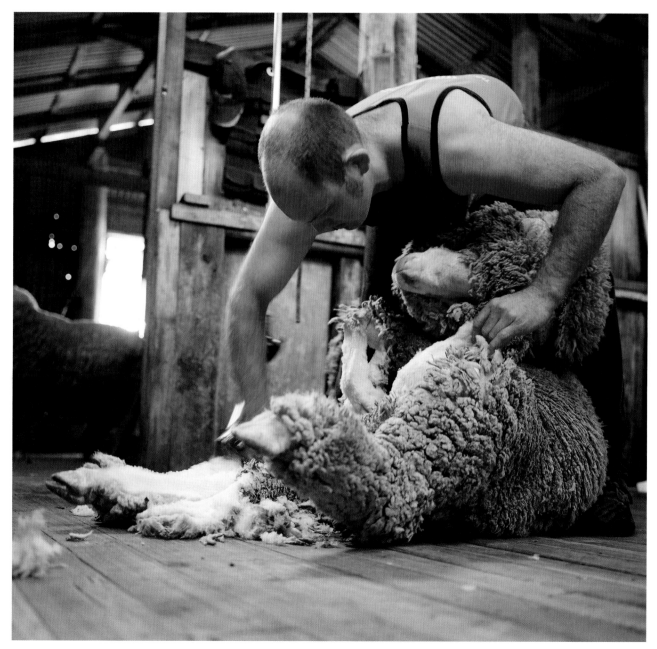

Kentucky › Rural life in New England

New South Wales & Australian Capital Territory

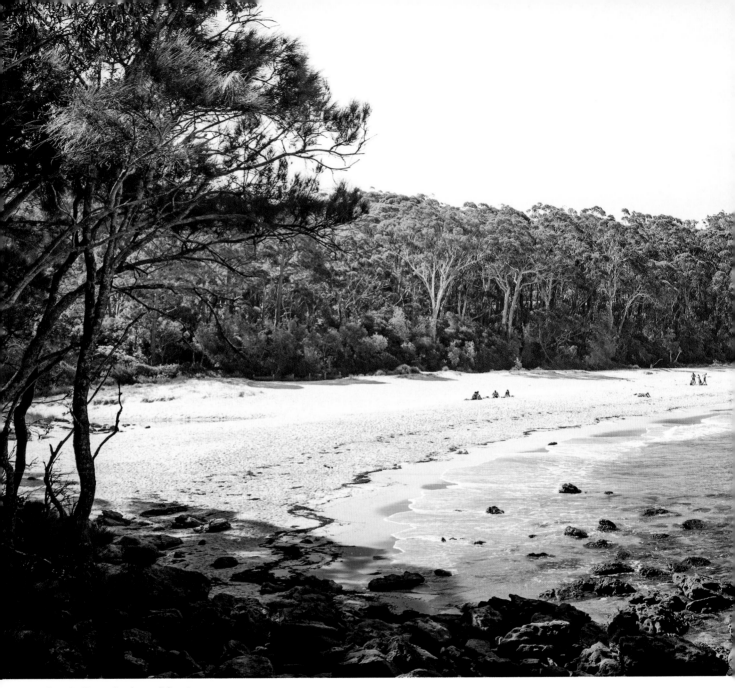

Jervis Bay › Sydneysiders' escape

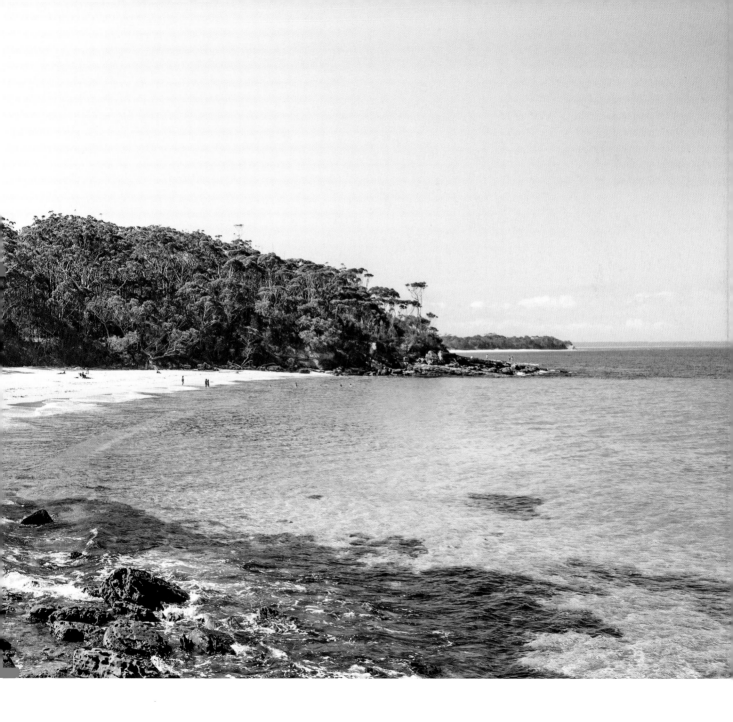

New South Wales & Australian Capital Territory

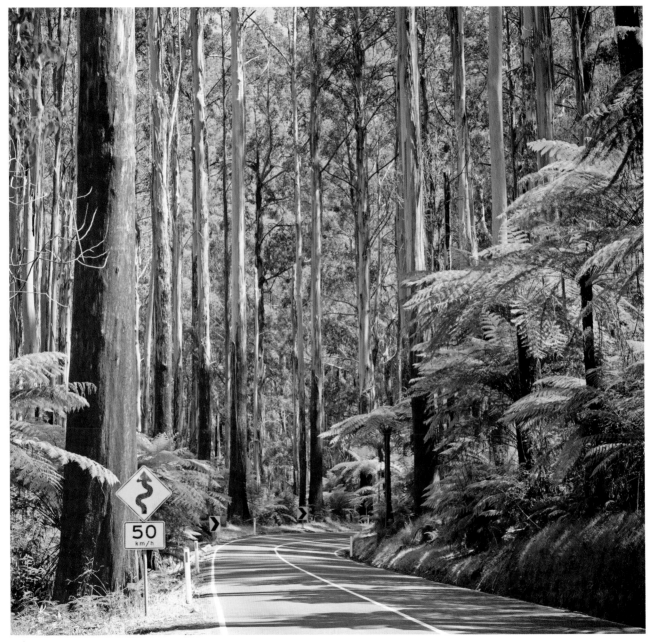

Yarra Ranges National Park › The Black Spur drive

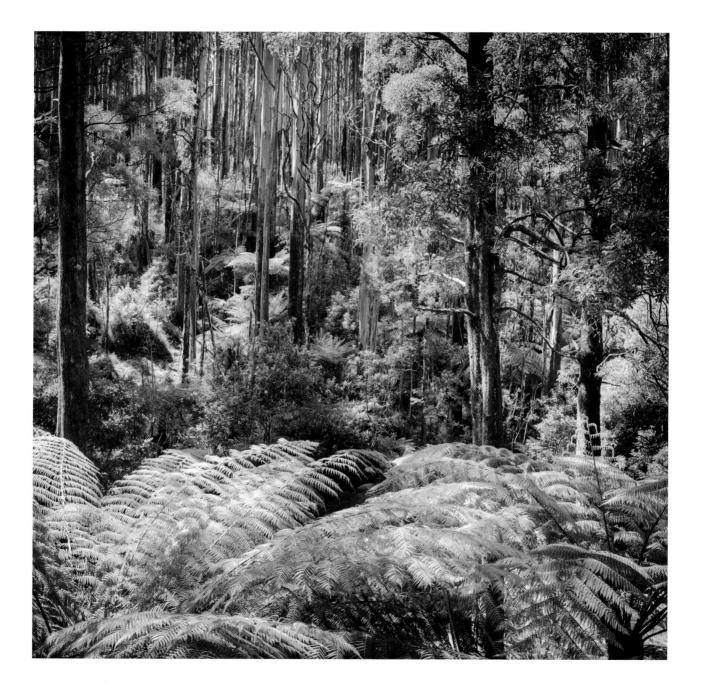

Victoria

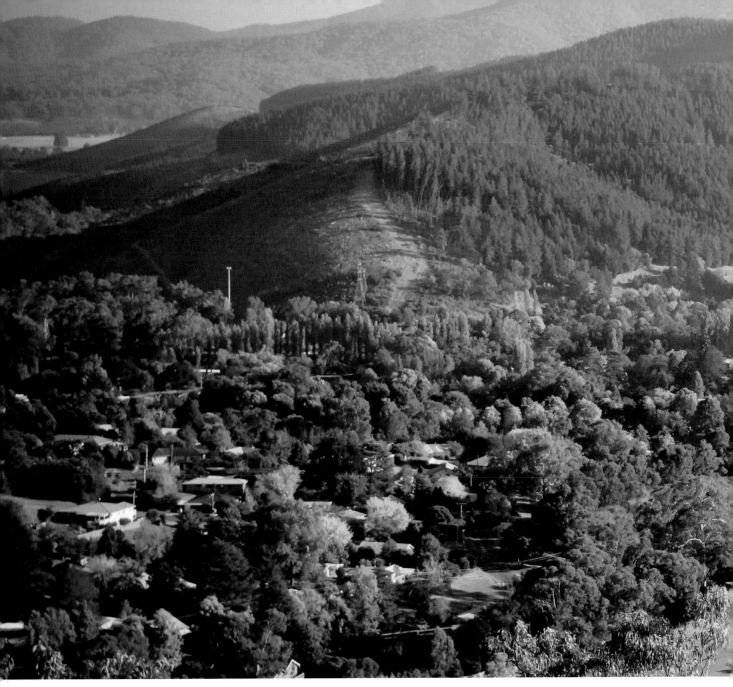

Bright › Gateway to the Victorian Alps

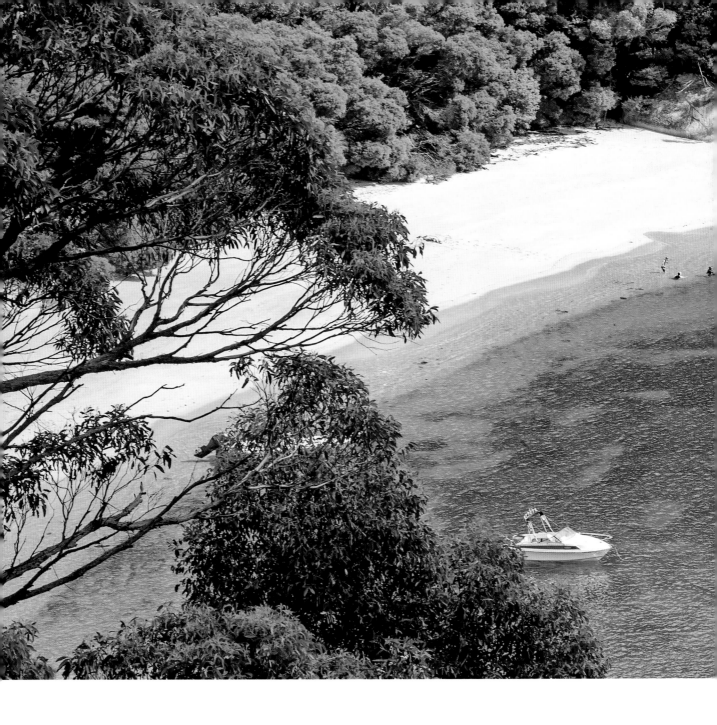

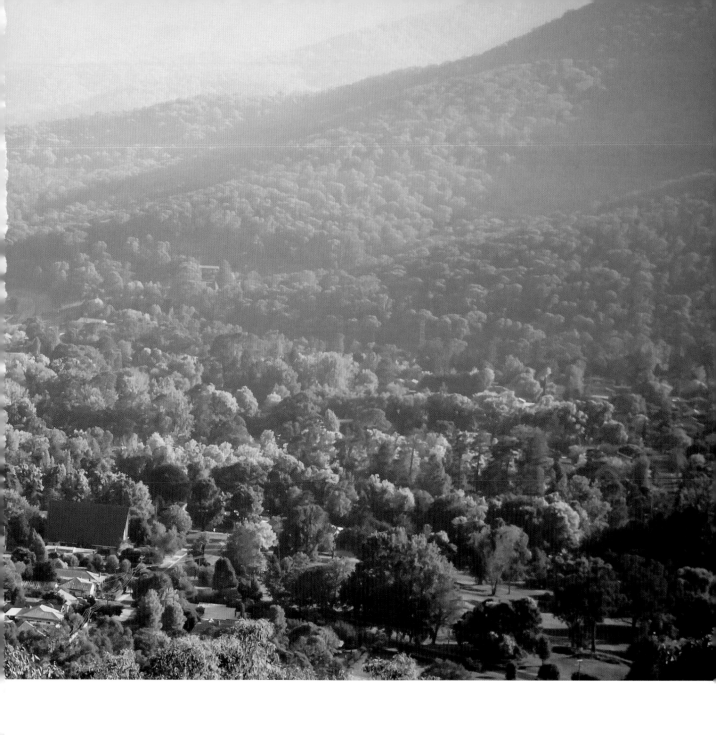

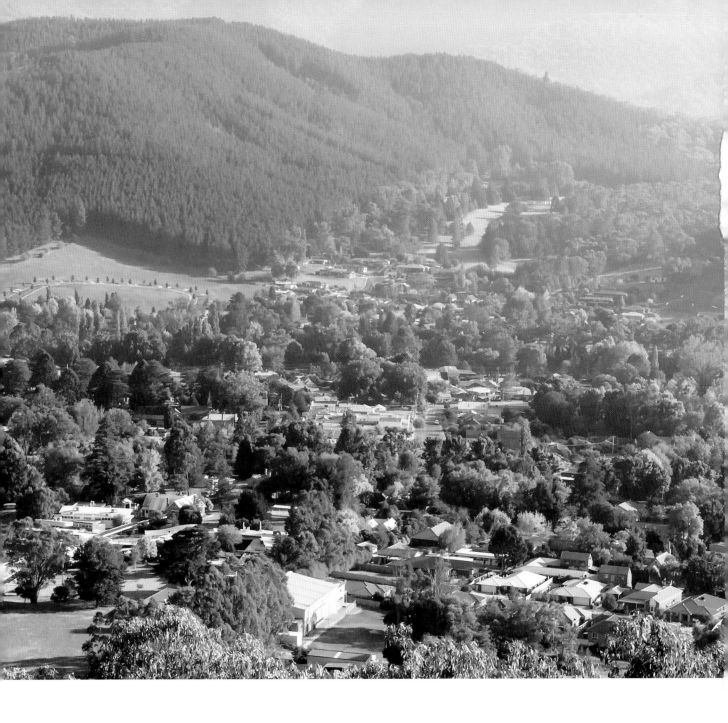

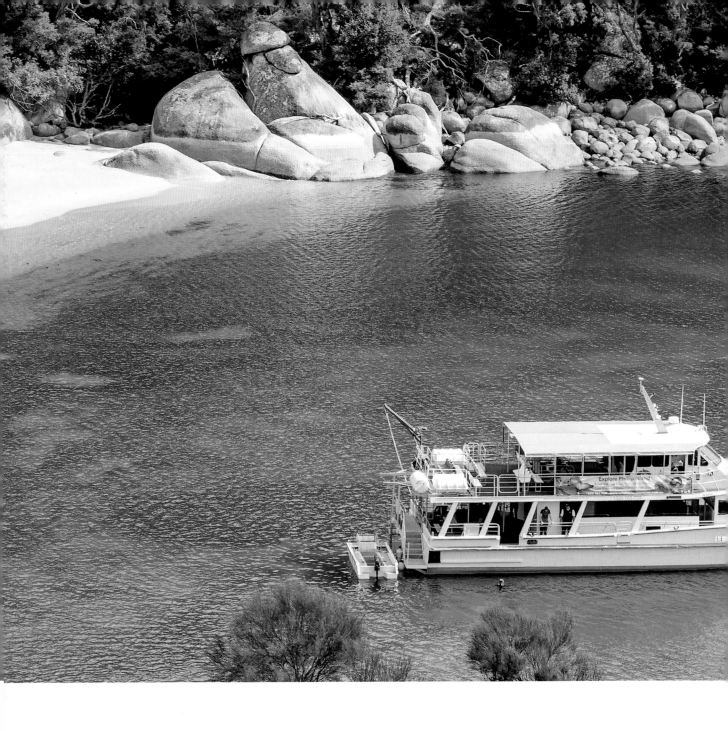

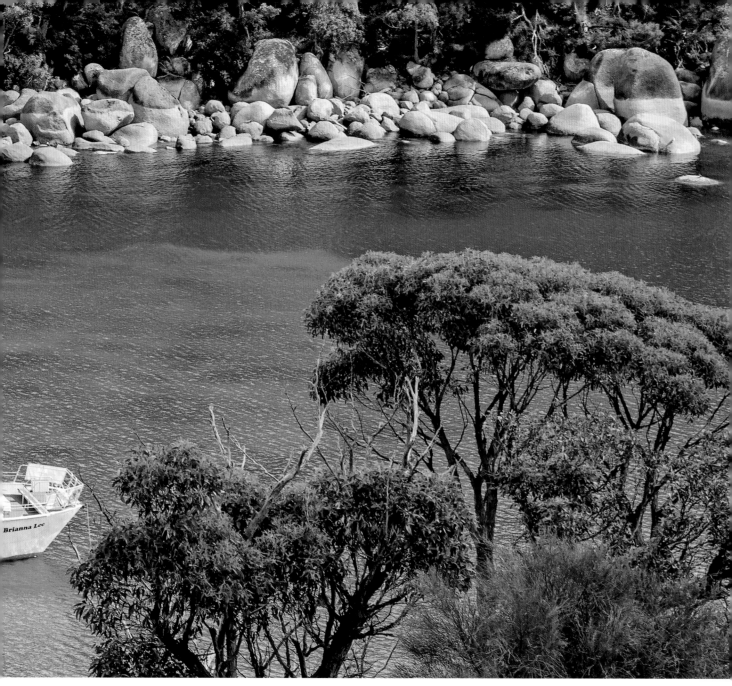

Wilsons Promontory National Park › Refuge Cove

Victoria

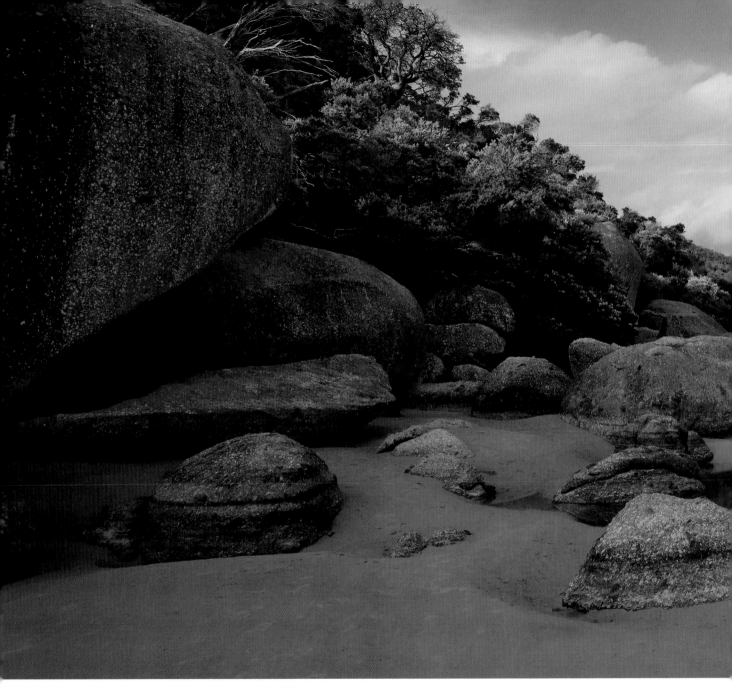

Wilsons Promontory National Park › Tidal River

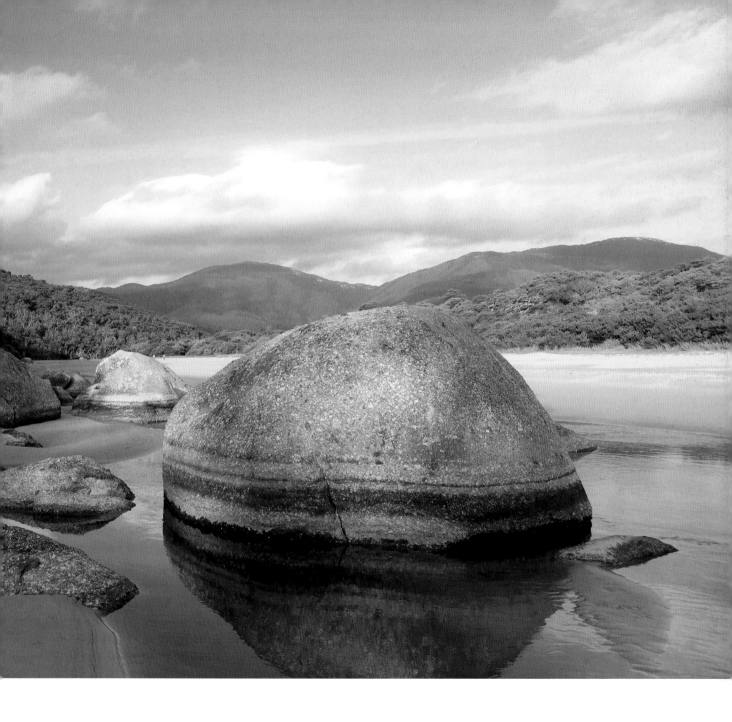

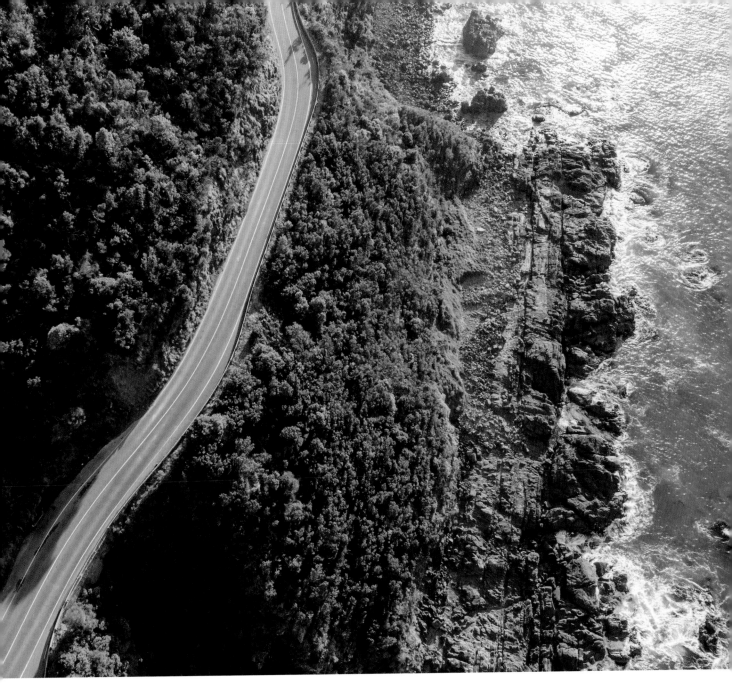

Great Ocean Road › From Torquay to Allansford

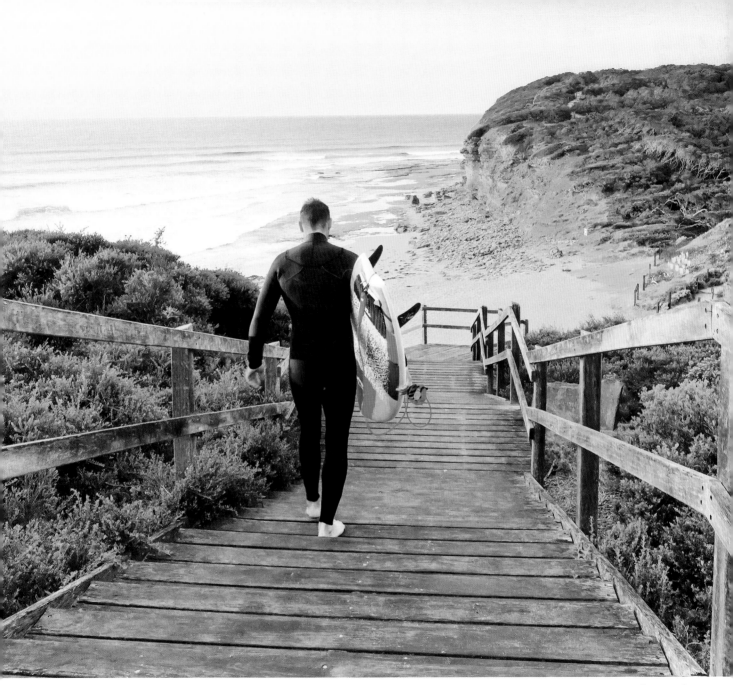

Torquay › Bells Beach

Victoria

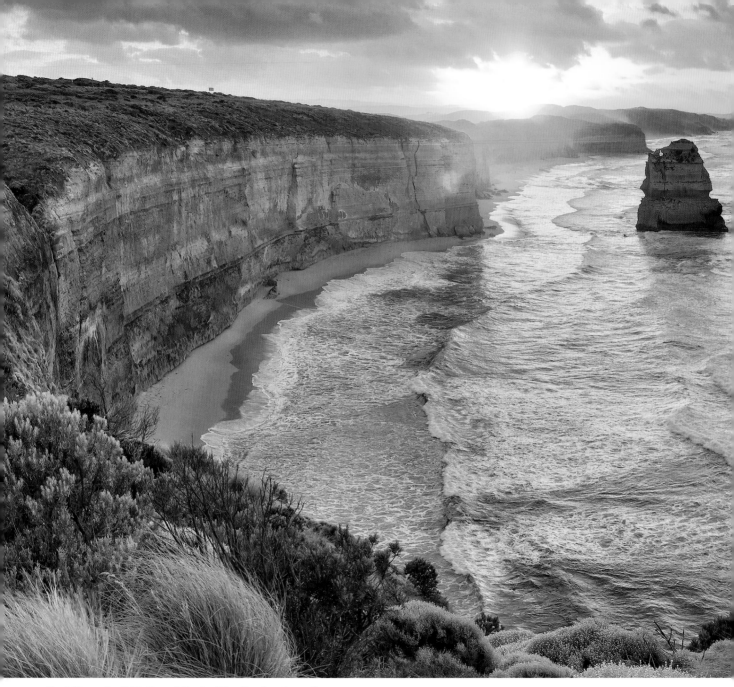

Port Campbell National Park › The Twelve Apostles

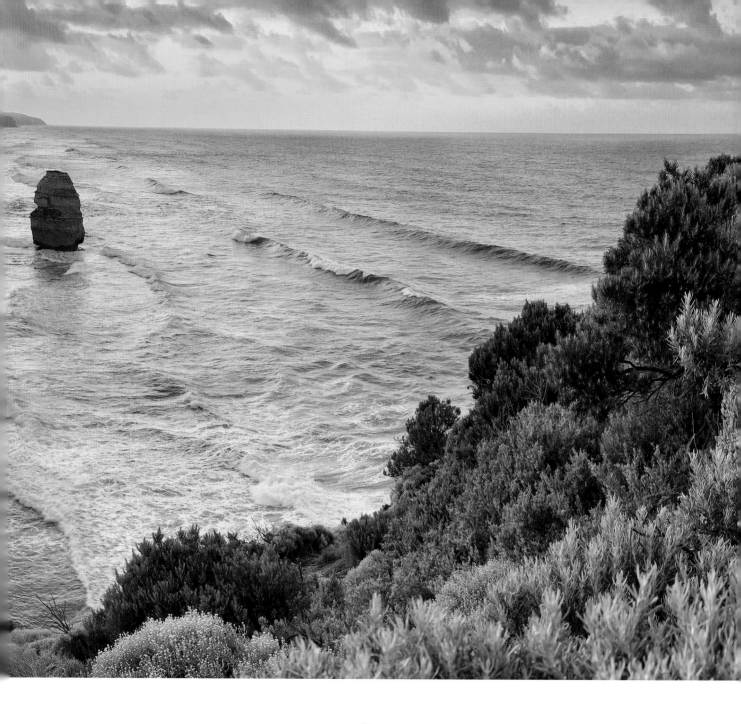

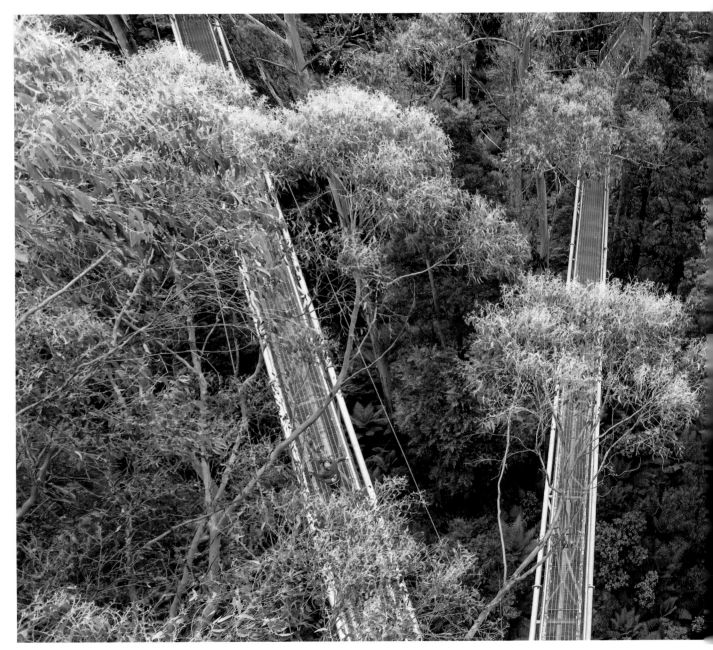

The Otways › Otway Fly Treetop Adventures

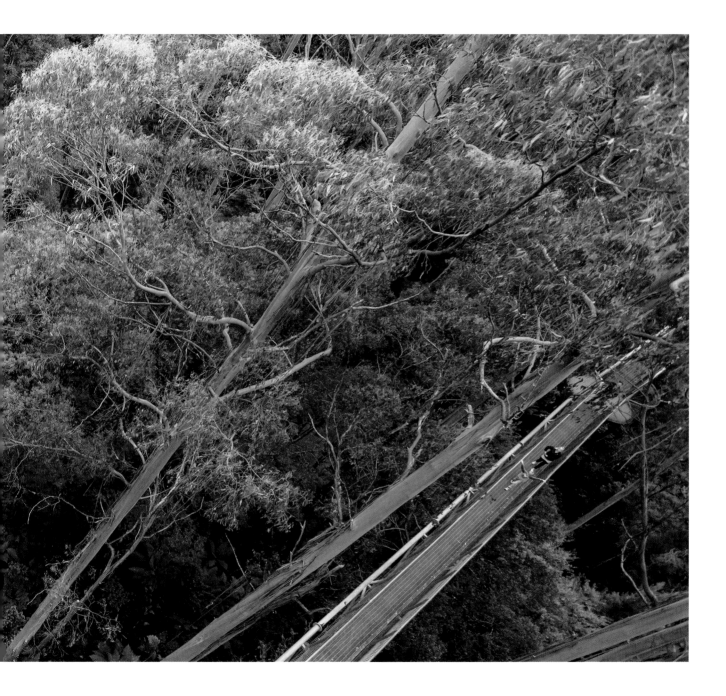

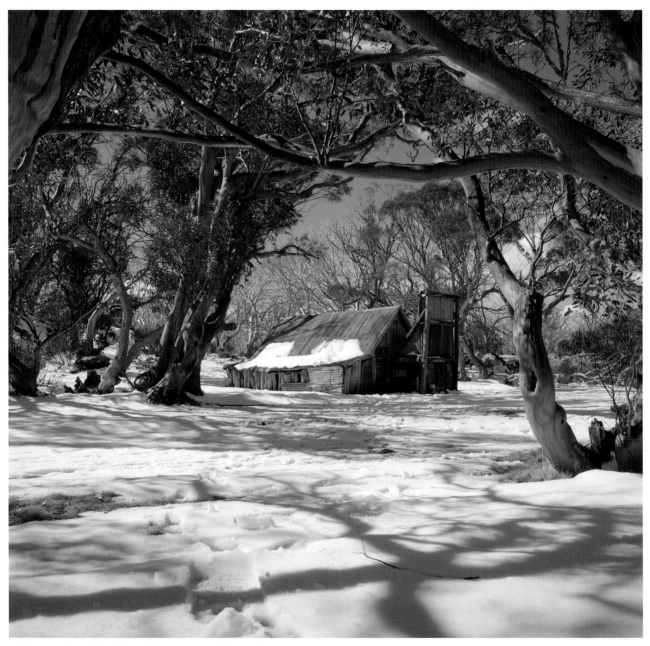

Alpine National Park › Wallace Hut in the High Country

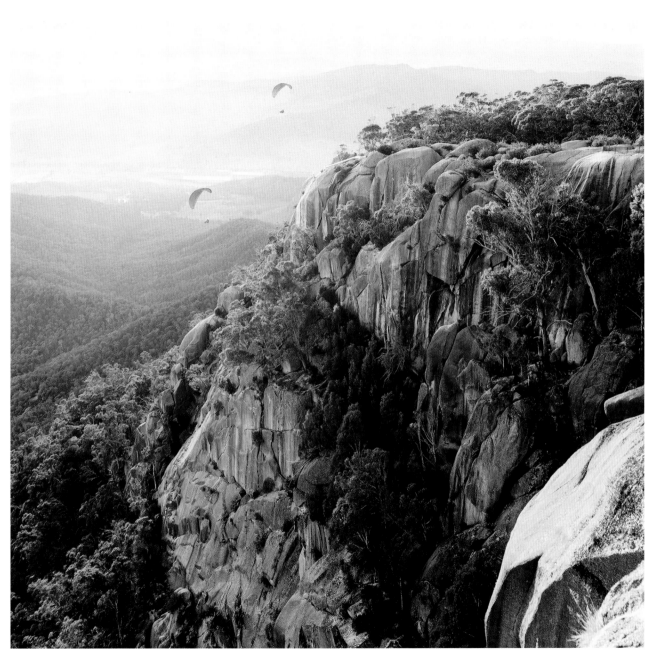

Mt Buffalo National Park › Adventure playground

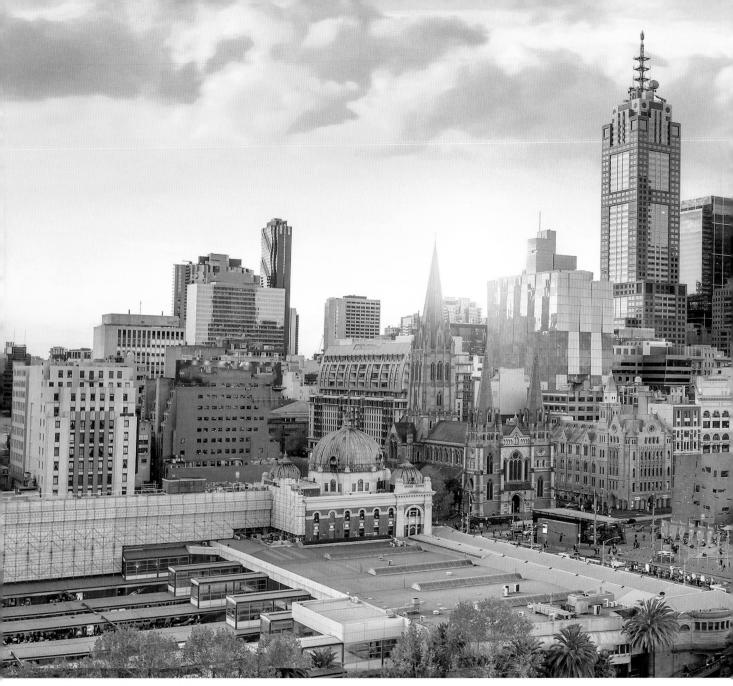

Melbourne › The central business district

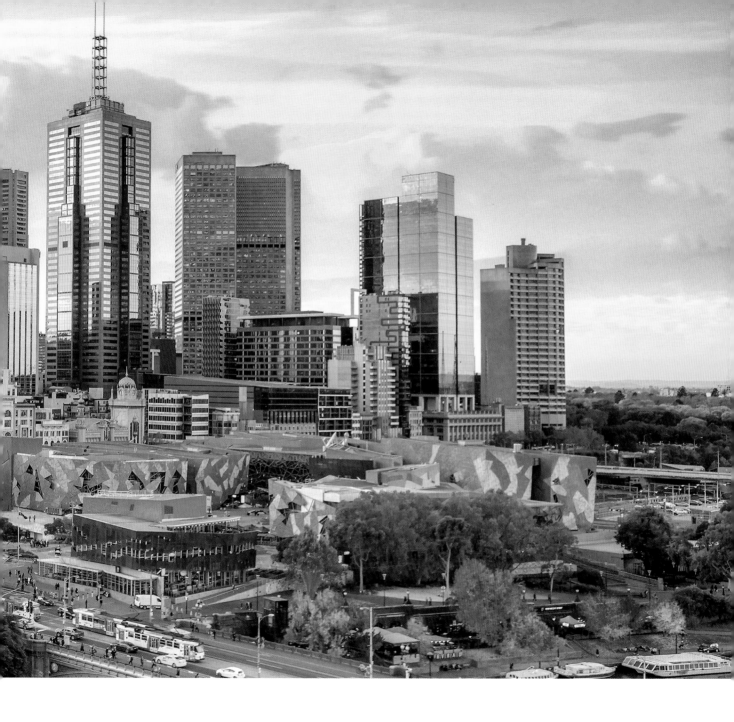

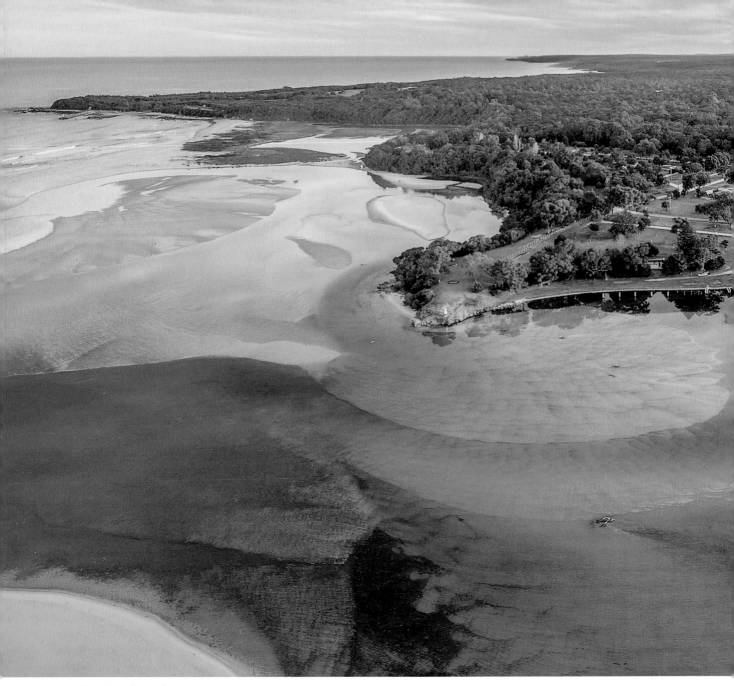

East Gippsland › Mallacoota

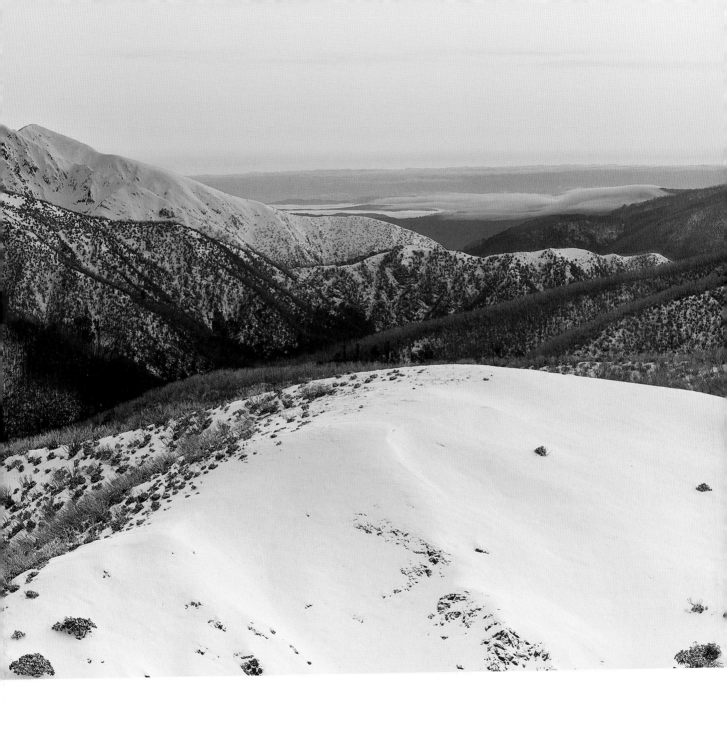

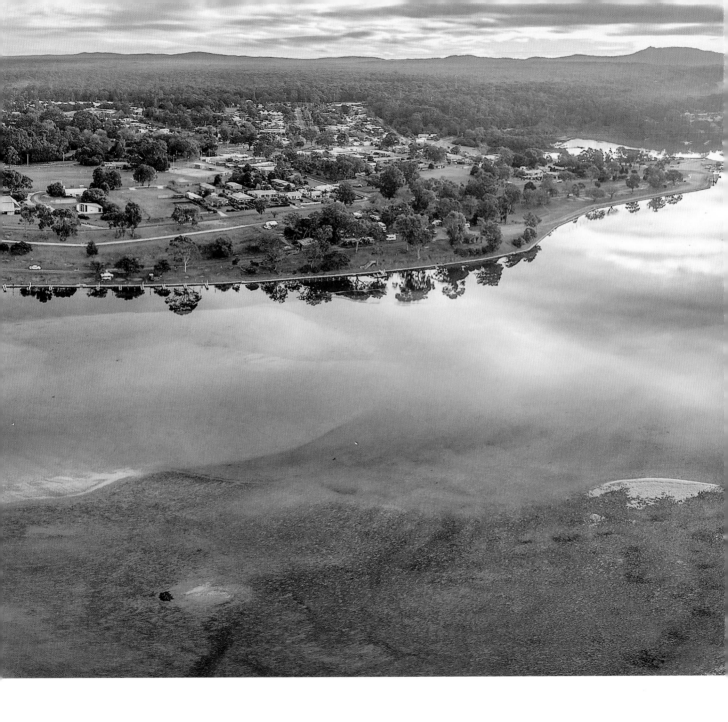

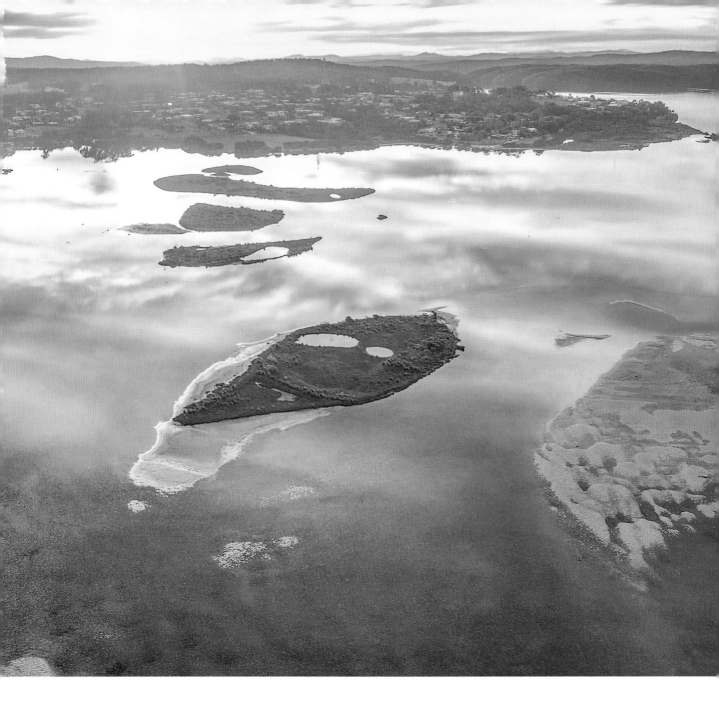

Alpine National Park › Razorback Ridge

Victoria

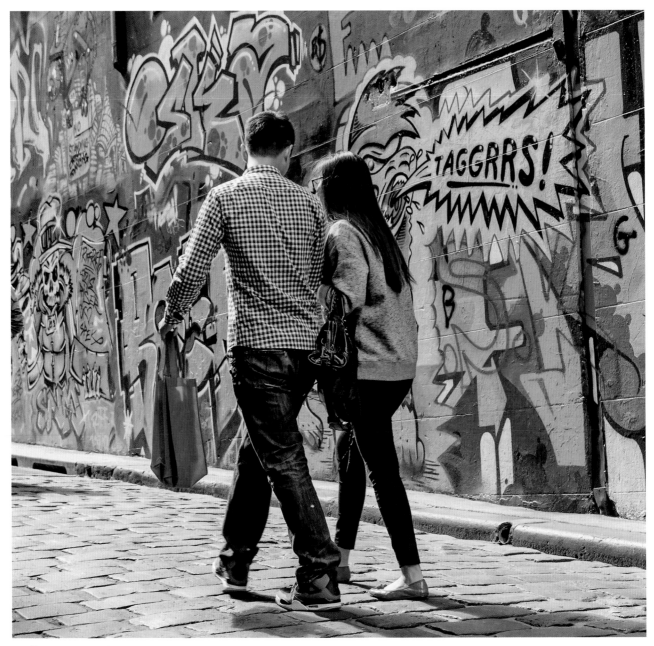

Melbourne › Hosier Lane

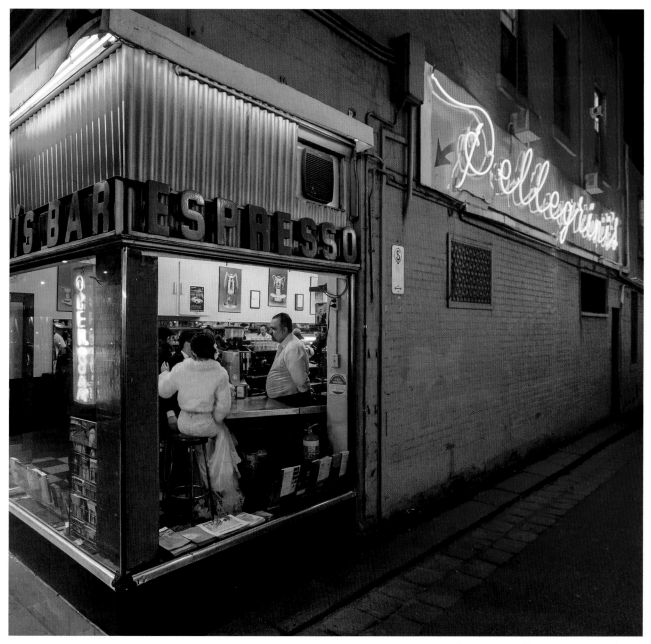

Melbourne › Pellegrini's on Bourke St

Victoria

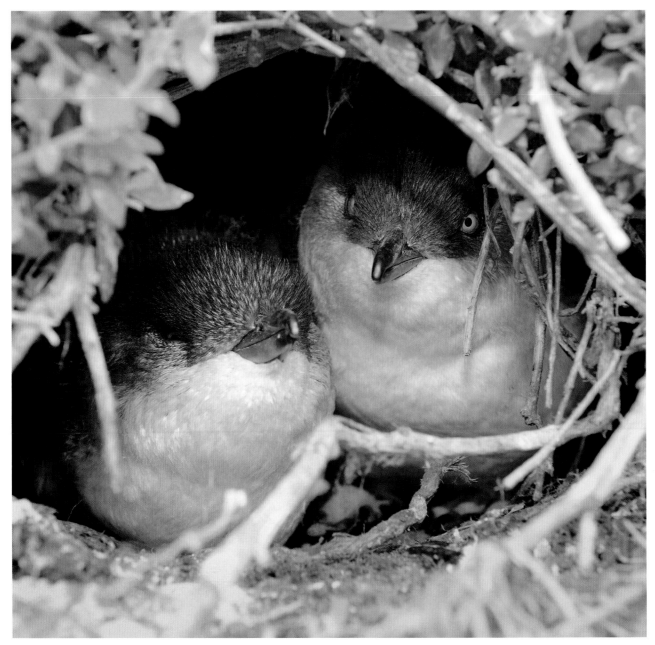

Phillip Island › Little penguins parade

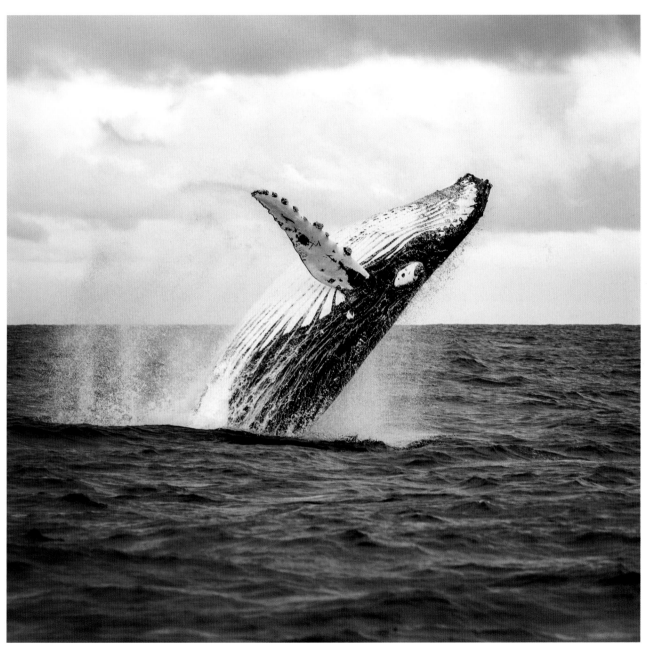

Phillip Island › Humpback whales migrate

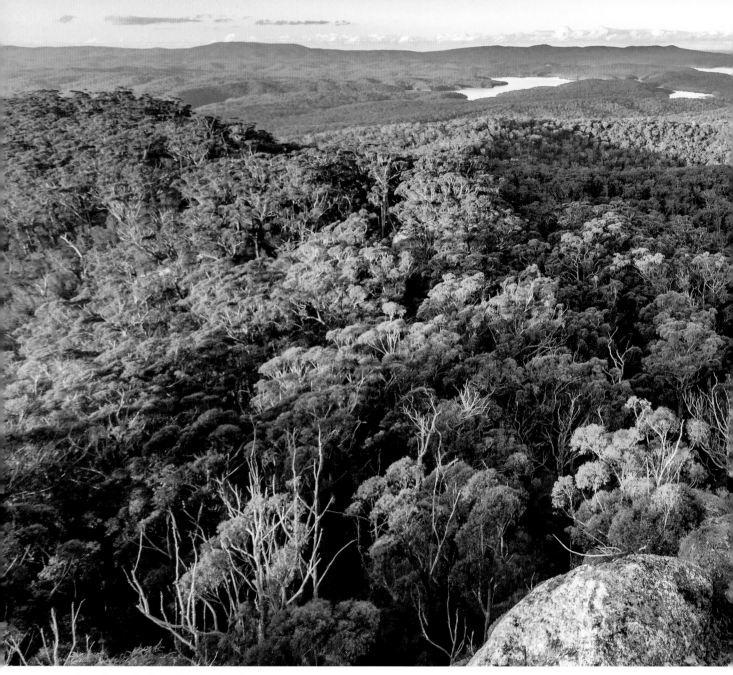

Croajingolong National Park › A wilderness to the east

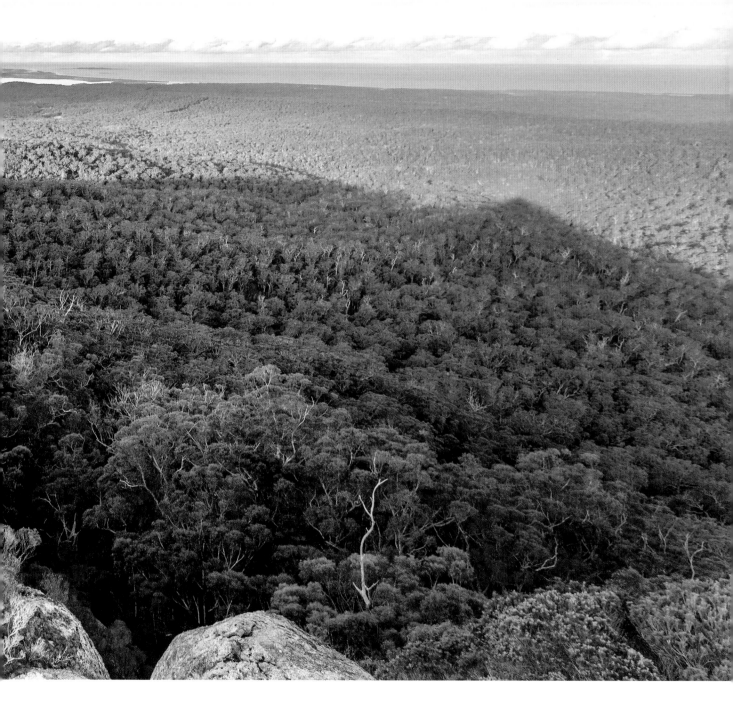

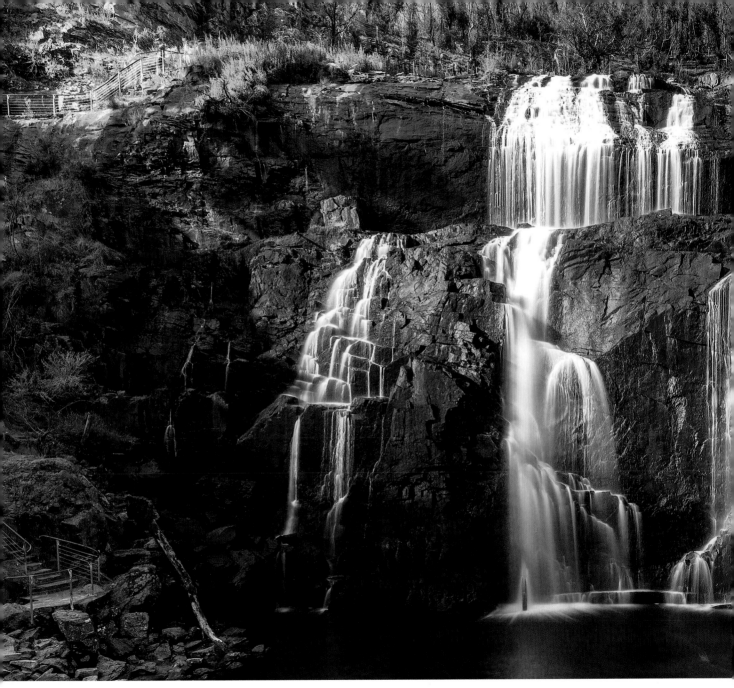

Grampians National Park › MacKenzie Falls

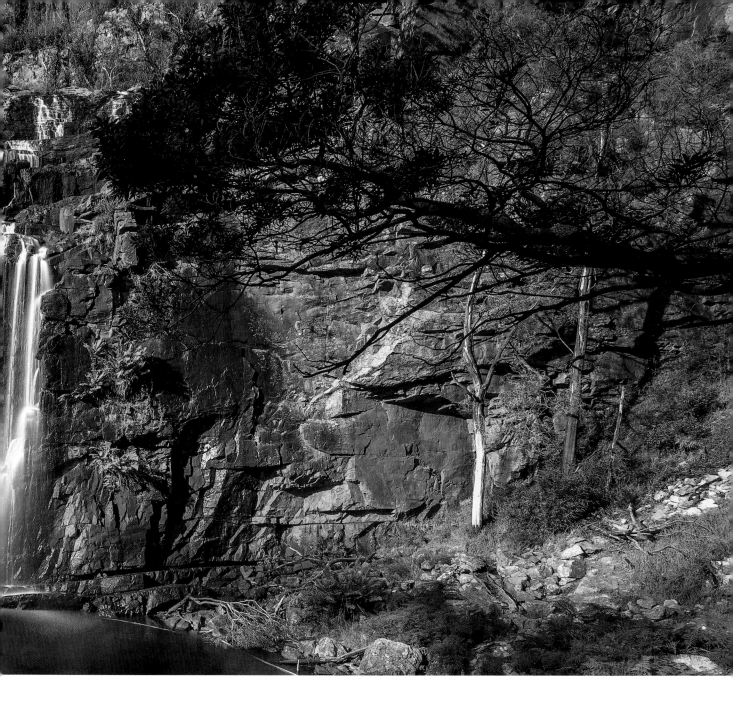

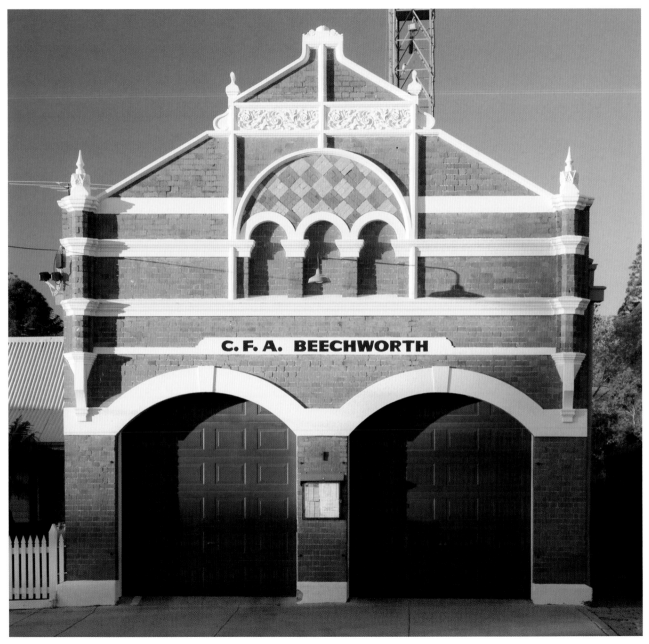

Beechworth › Gold Rush heritage

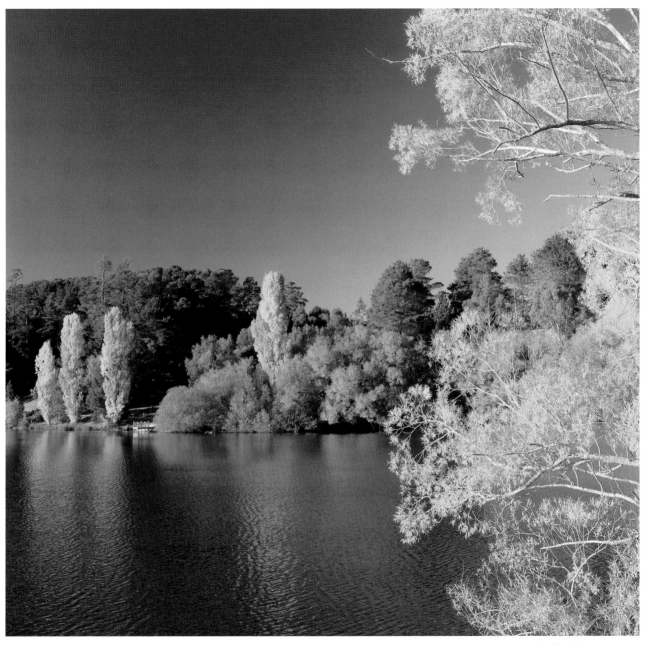

Daylesford › Spa town

Victoria

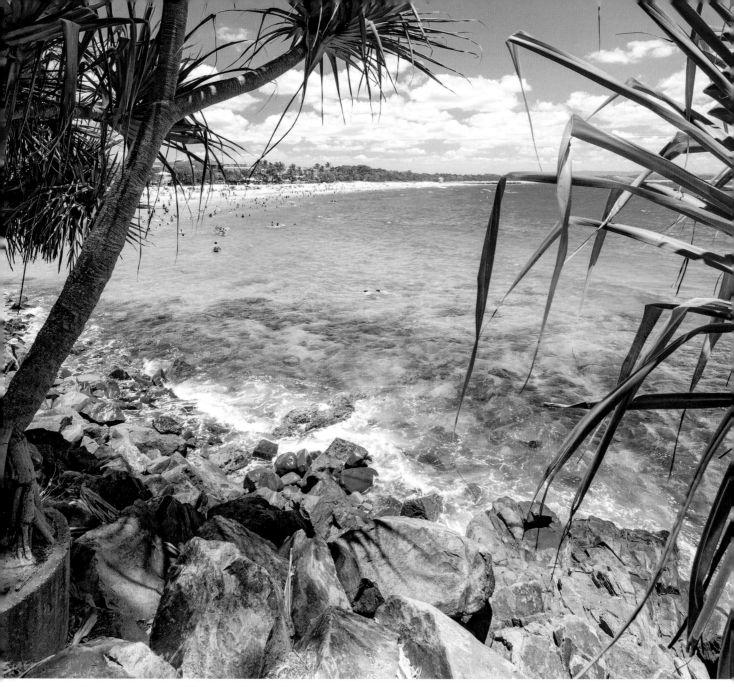

Sunshine Coast › Beach life in the Noosa Biosphere Reserve

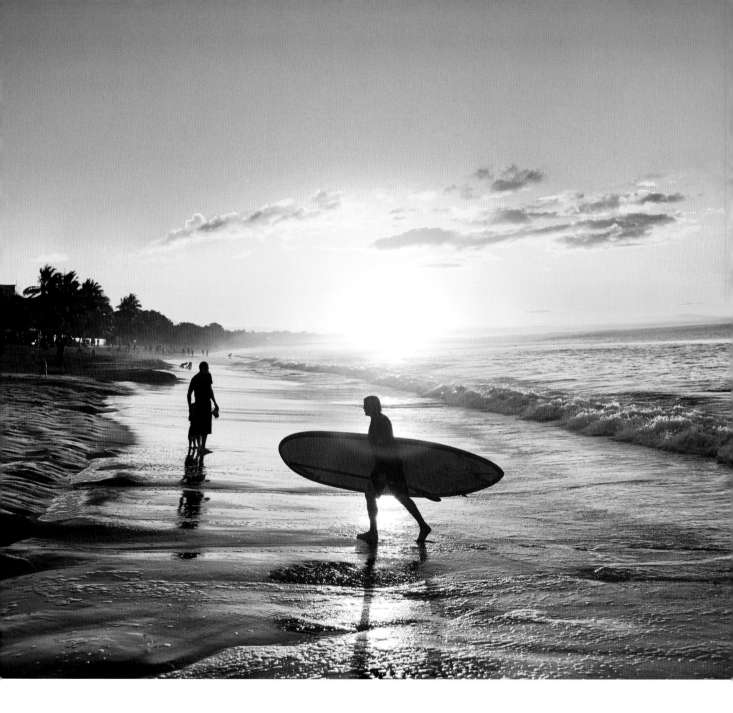

Queensland

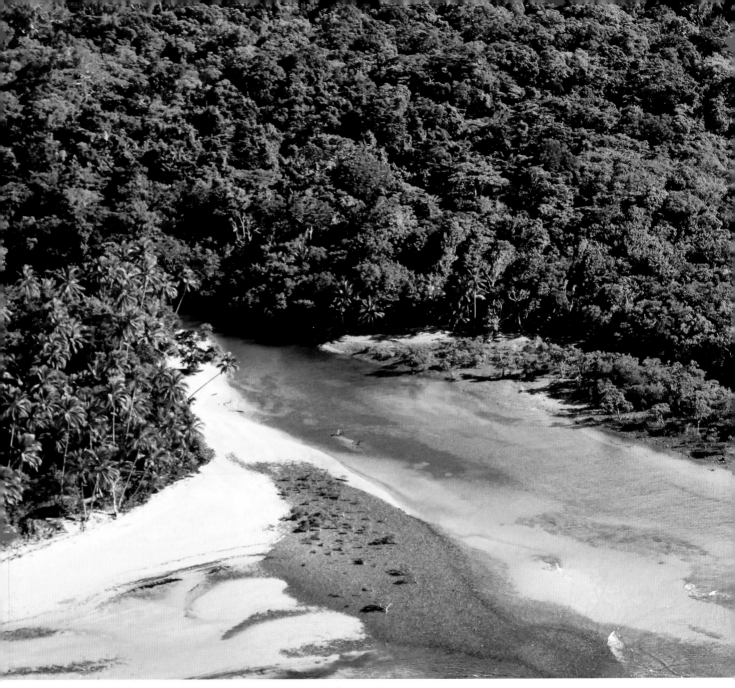

Cape Tribulation › Watch for crocs in Queensland's far north

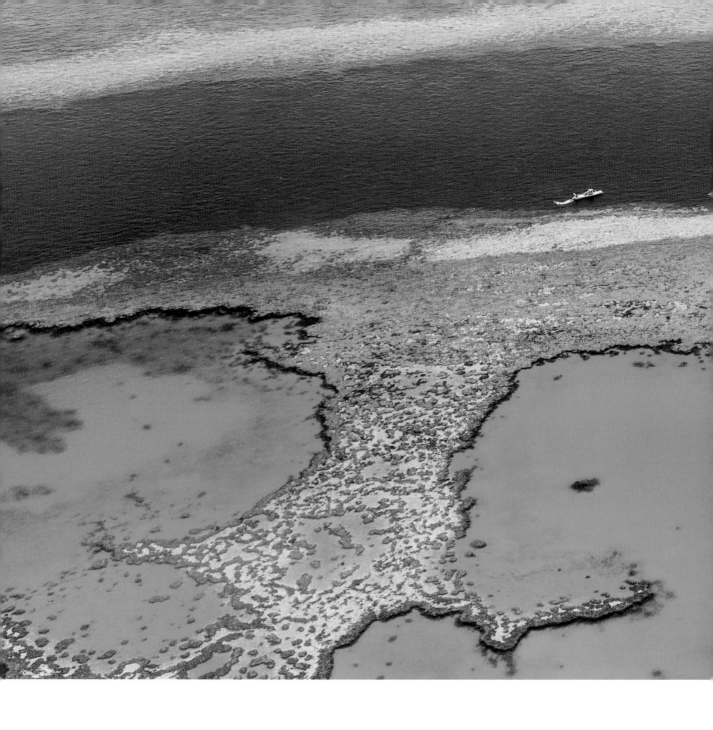

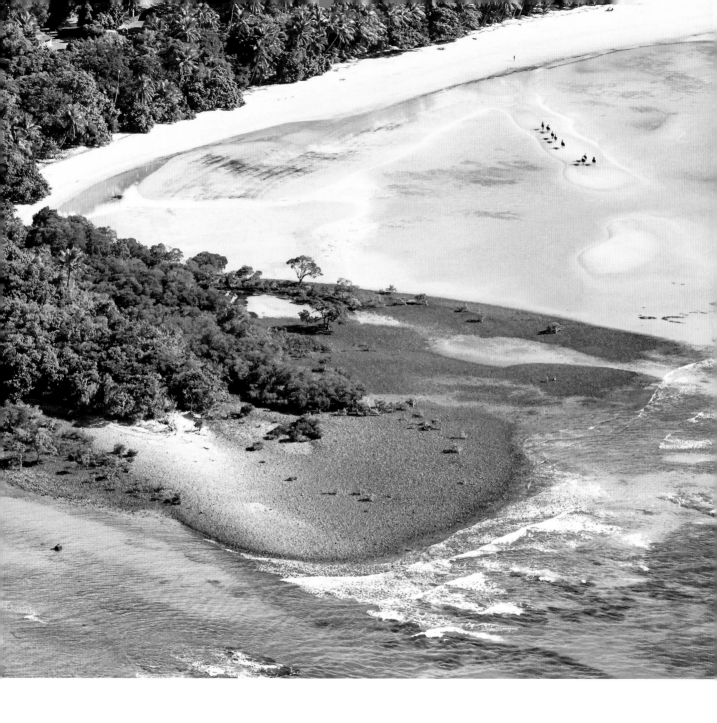

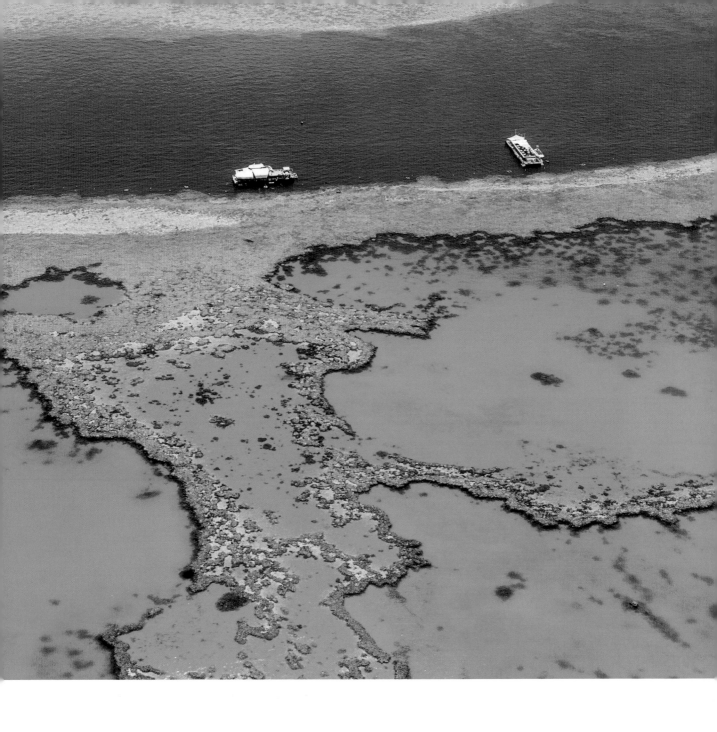

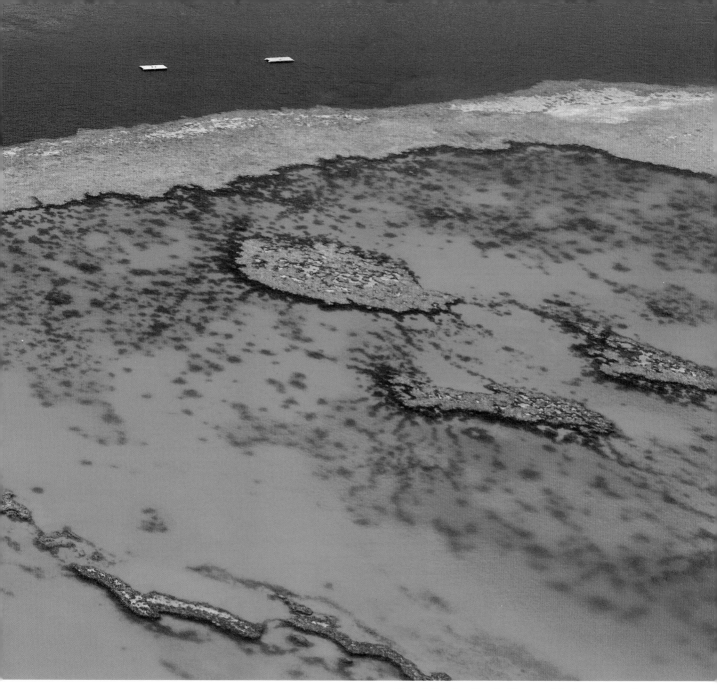

Great Barrier Reef › The world's largest reef system

Queensland

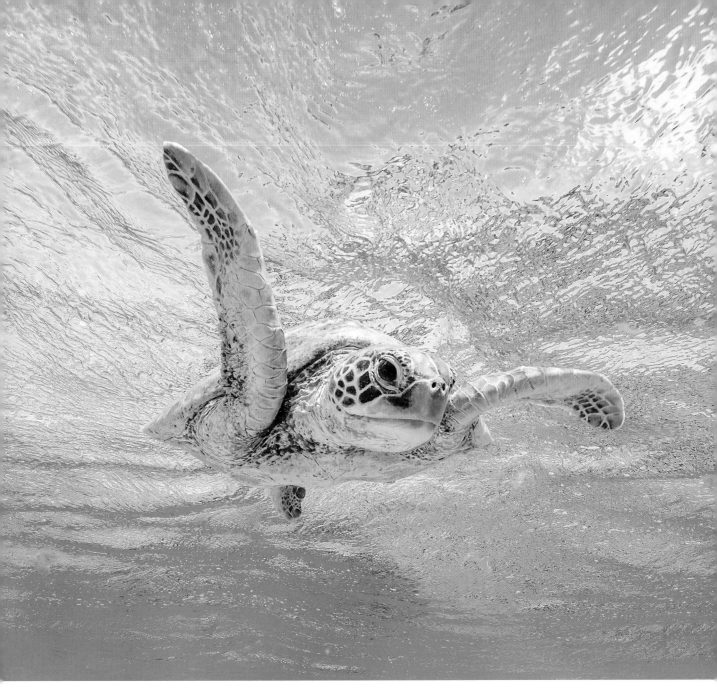

Great Barrier Reef › Nine hundred coral-fringed islands, thousands of species

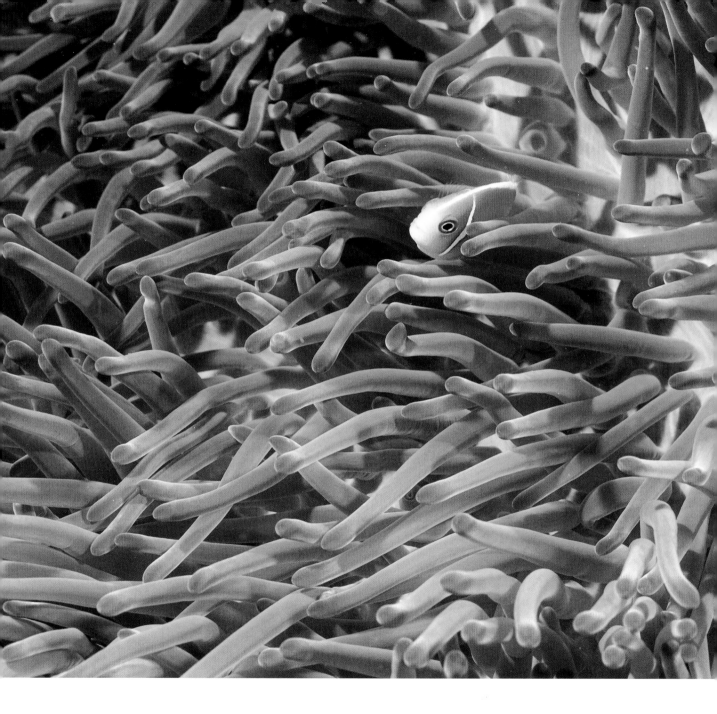

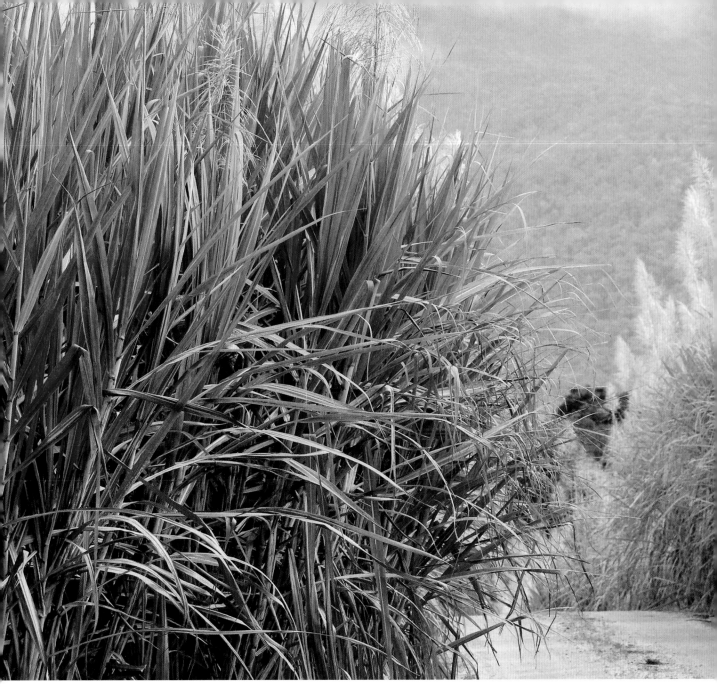

Queensland › Mackay is the Sugar Capital of Australia

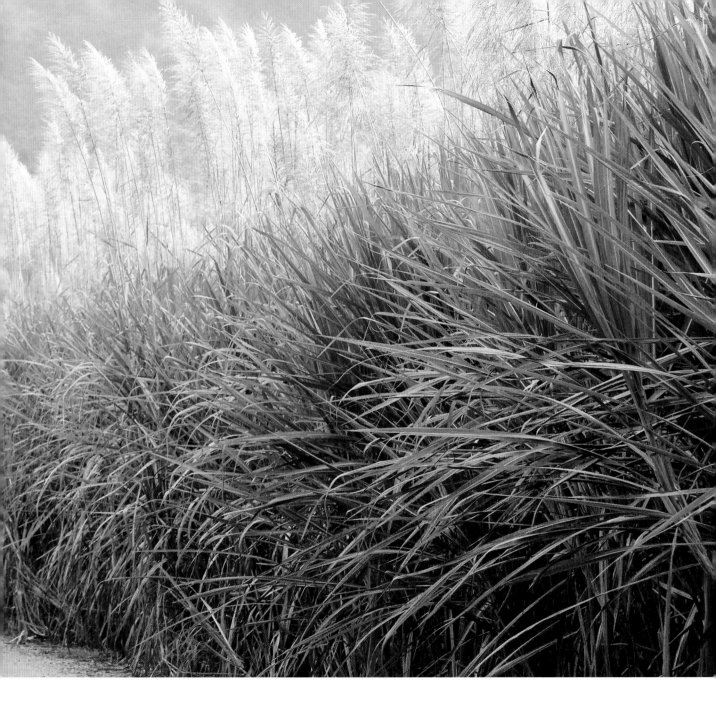

Queensland

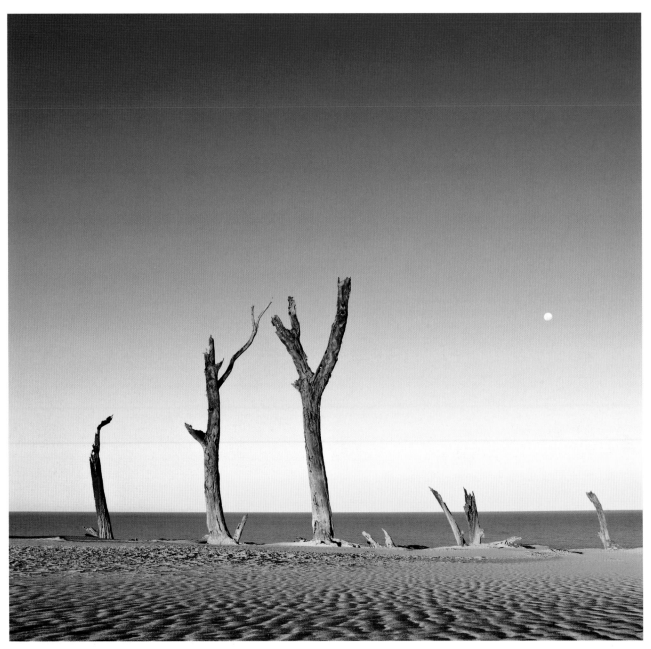

Great Sandy National Park › Dingoes inhabit Fraser Island

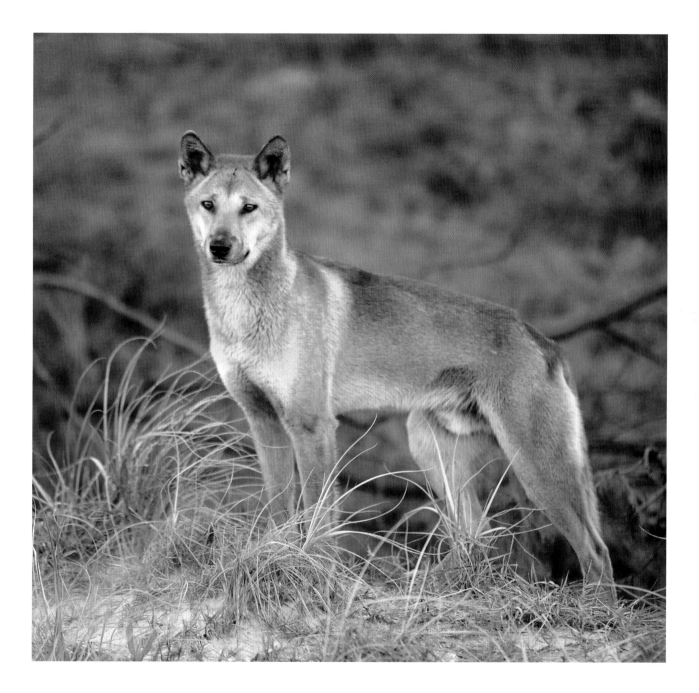

Queensland

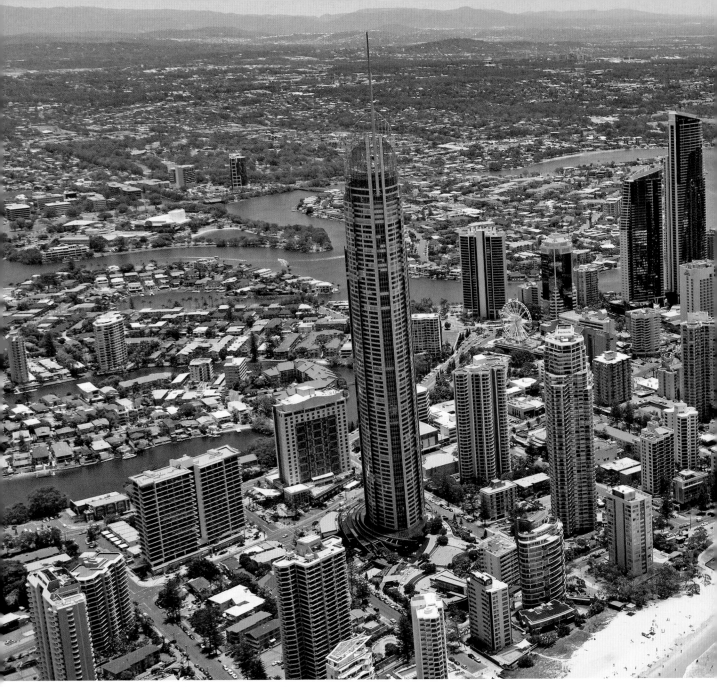

Gold Coast › Surfer's Paradise is party central

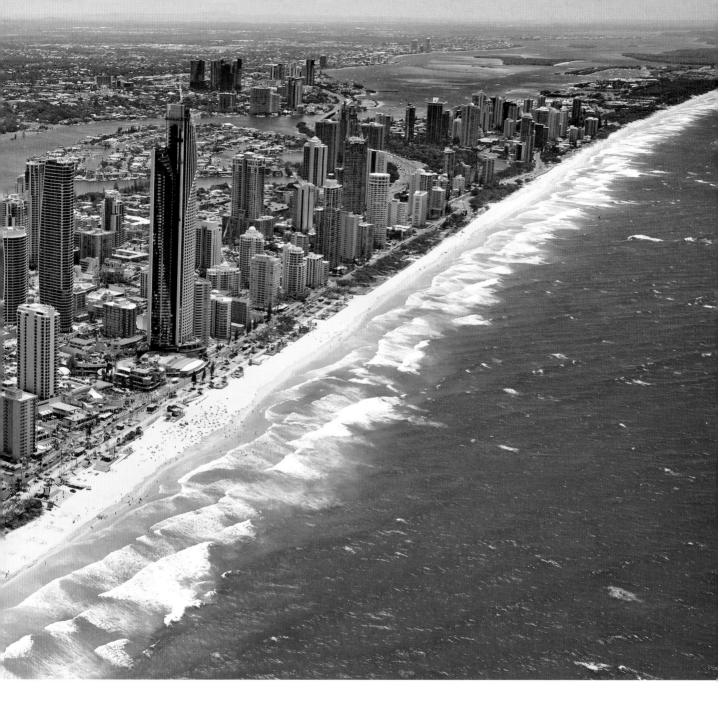

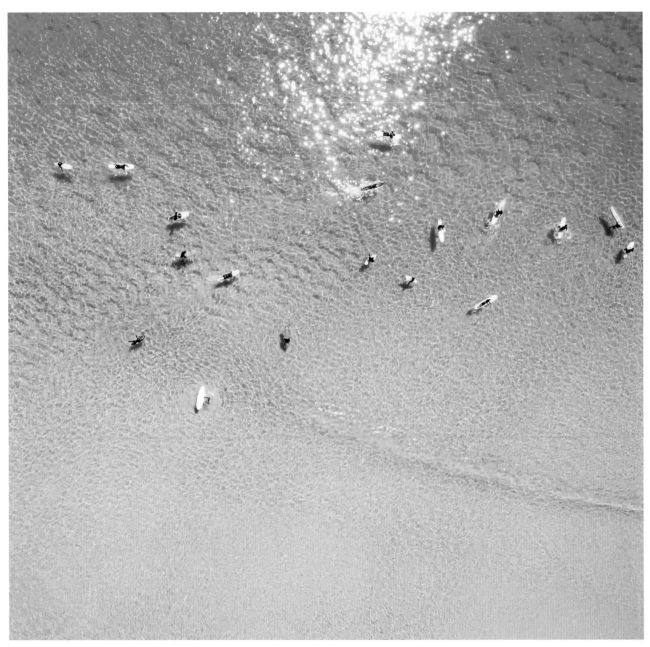

Queensland › Surfers wait for the perfect wave

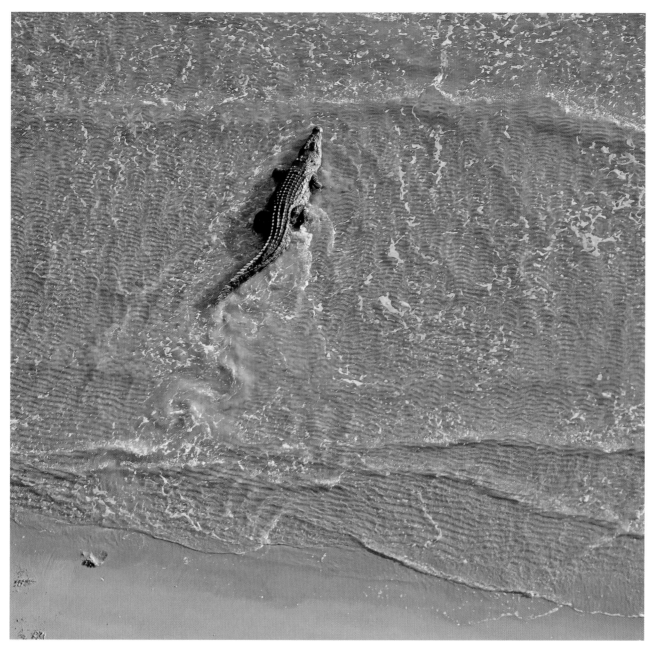

North Queensland › Australia's saltwater crocodiles are the world's largest

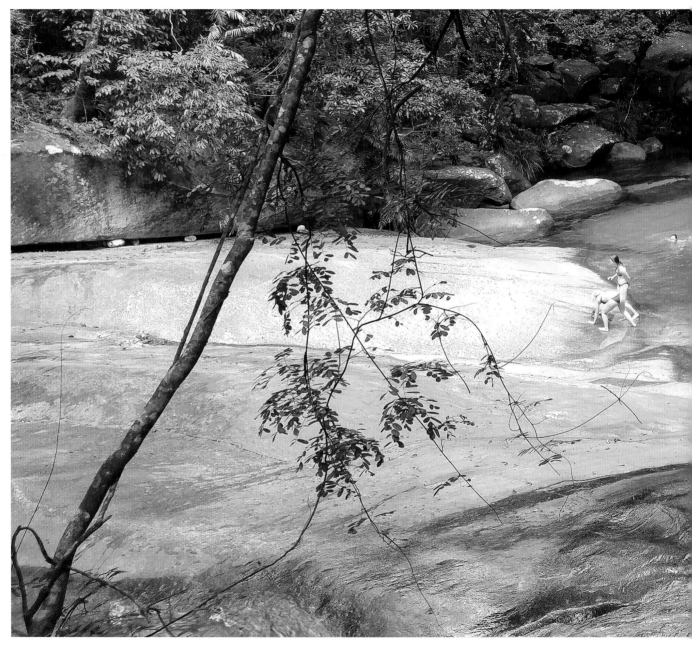

Wooroonooran National Park › Cooling off in the Josephine Falls

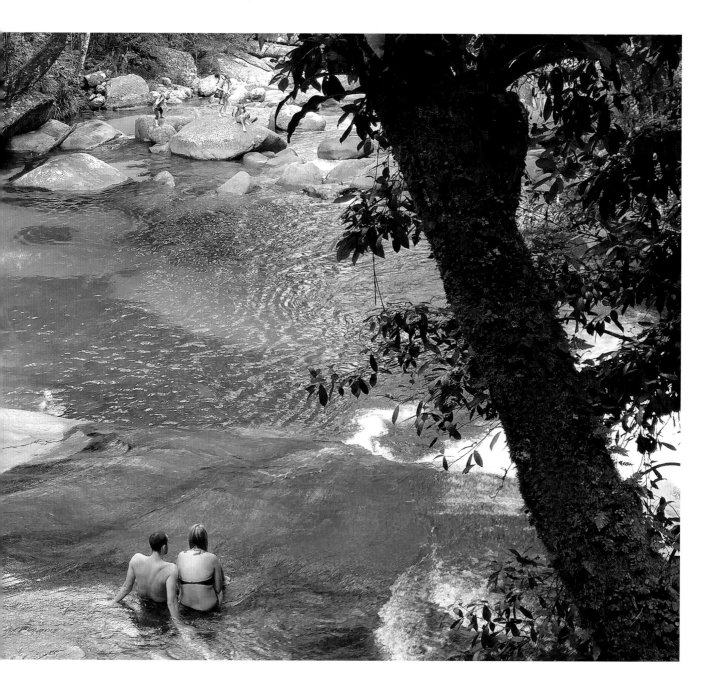

Queensland

Whitsunday Islands › Beaches and bays

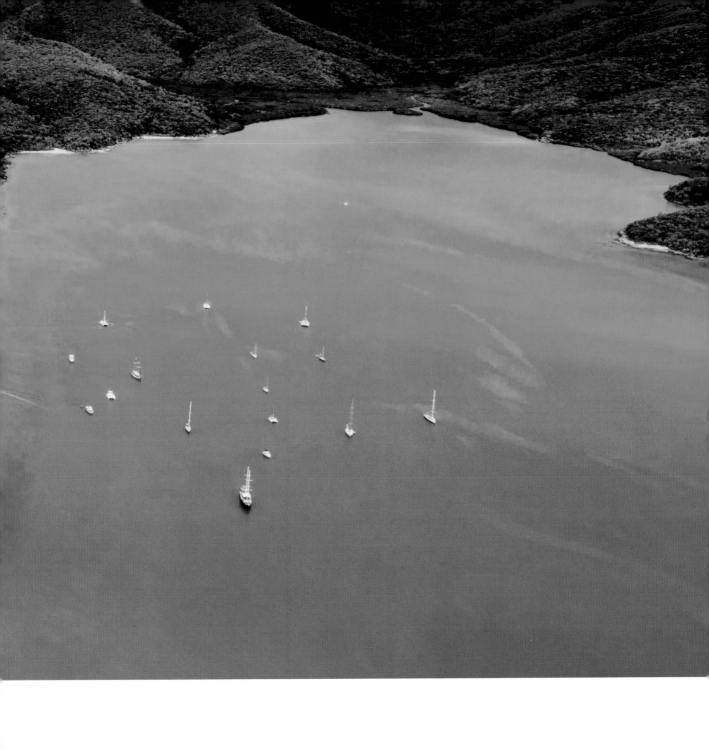

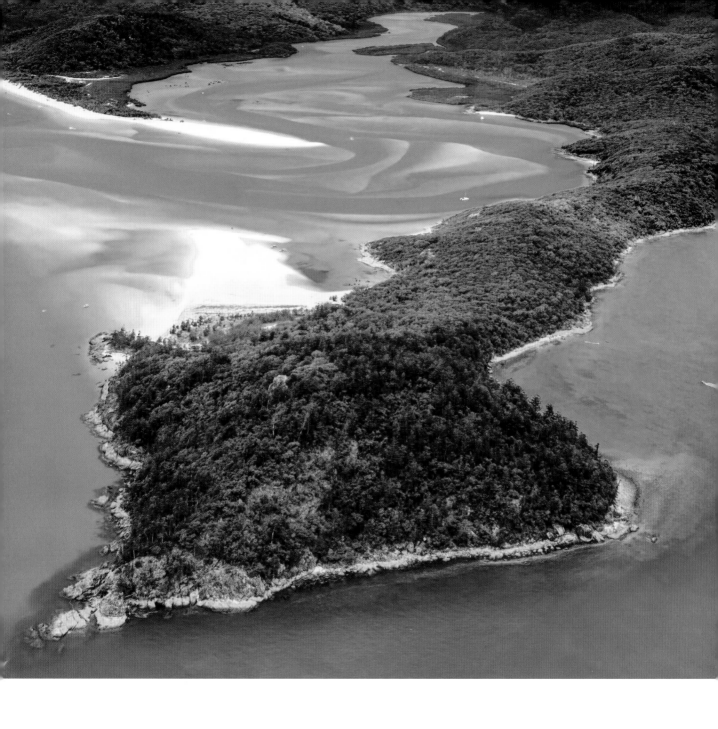

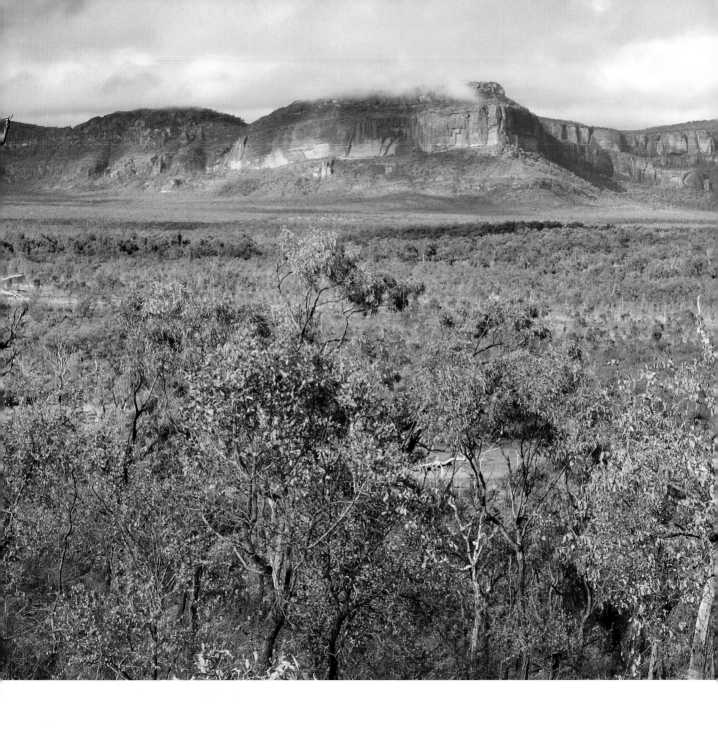

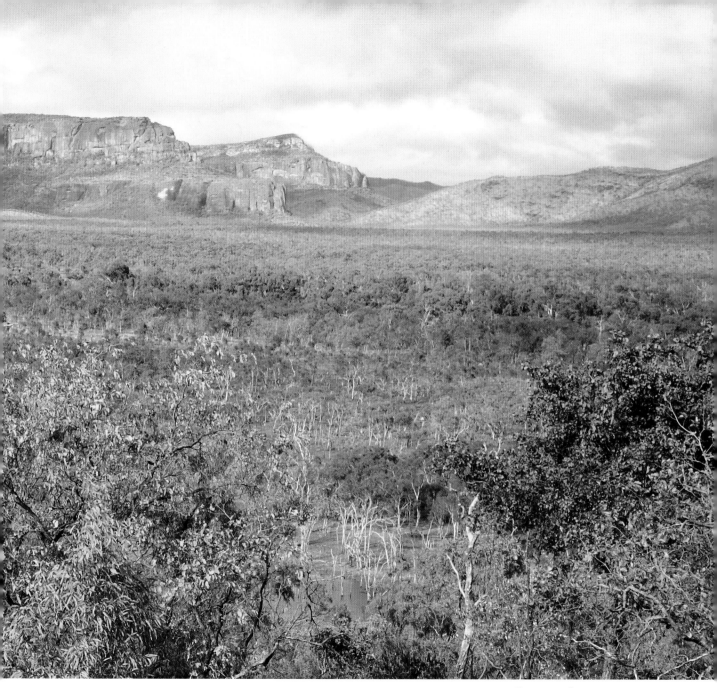

Mount Mulligan › A former mining town

Queensland

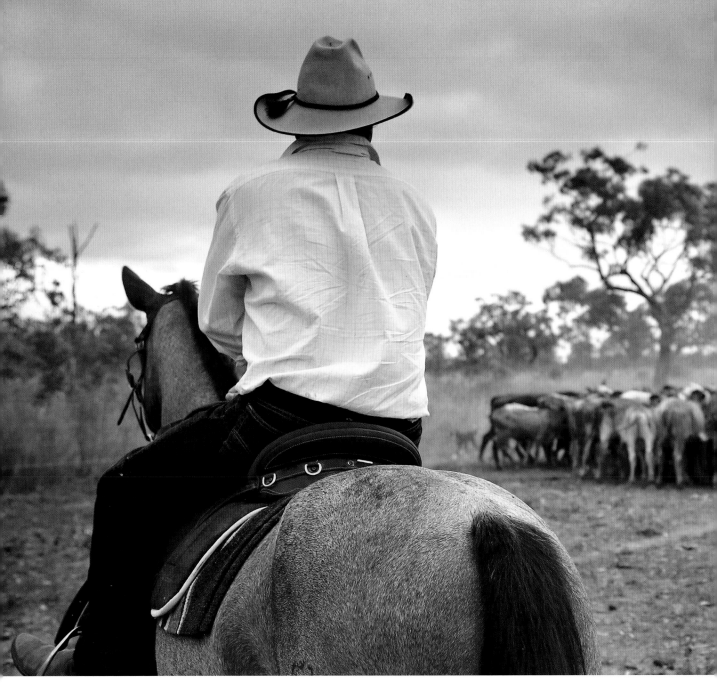

Mount Mulligan › Rounding up cattle

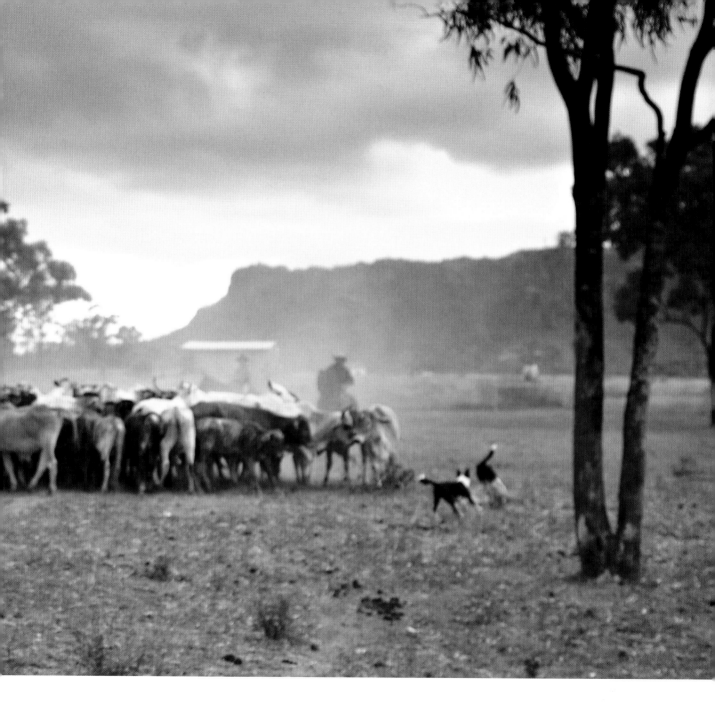

Queensland

Brisbane › Social life at the showgrounds

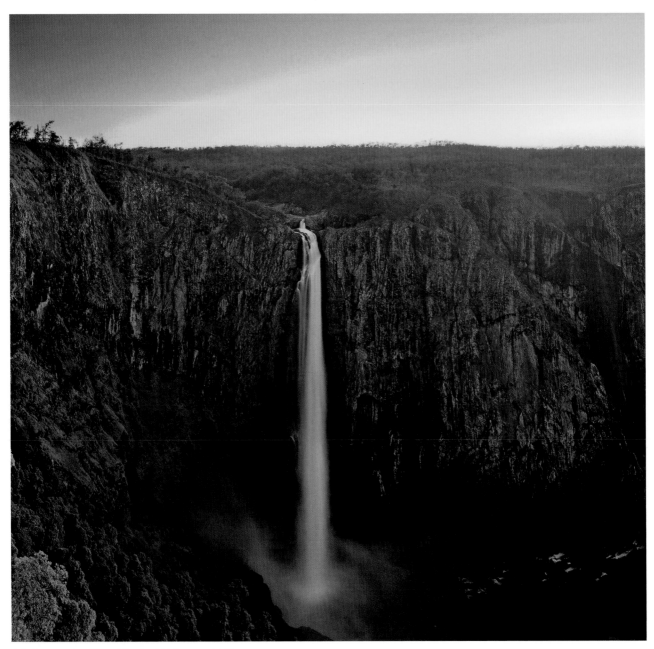

Girringun National Park › Wallaman Falls

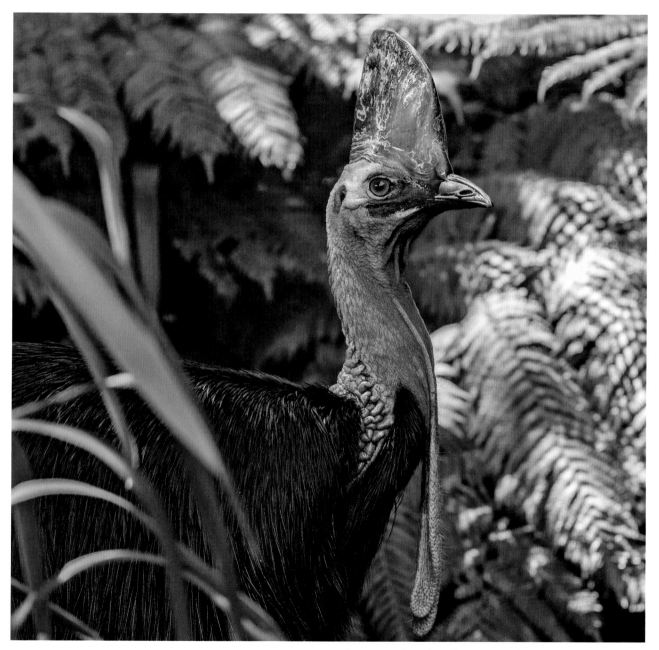

Daintree National Park › Beware the southern cassowary

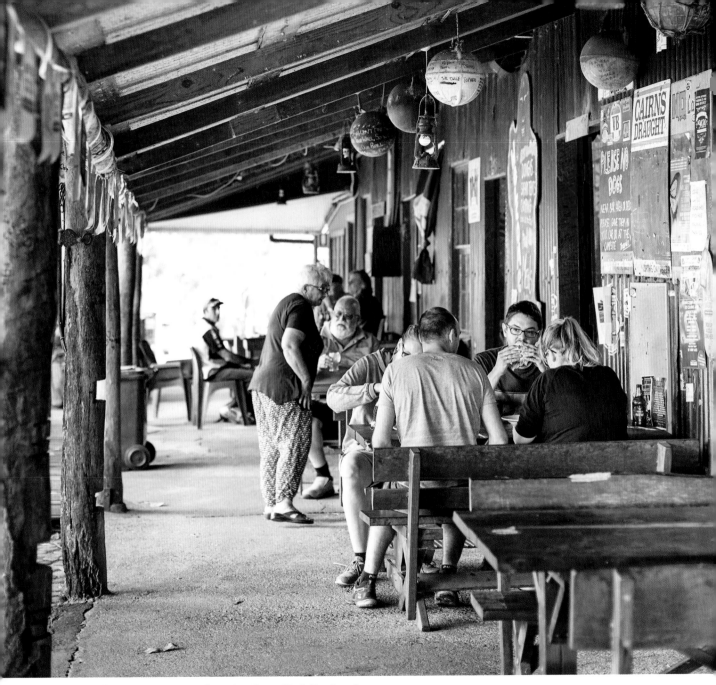

Rossville › The Lions Den Hotel on the Cape York Peninsula

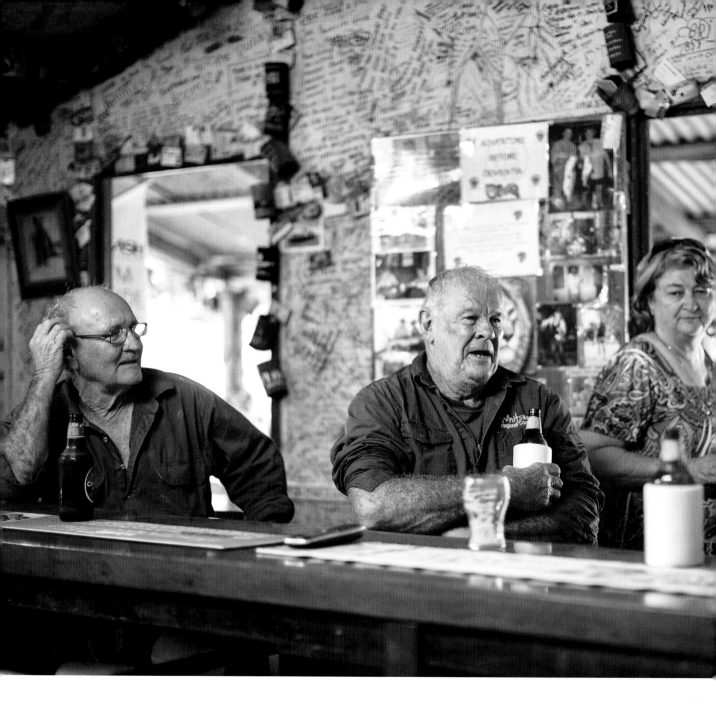

Queensland

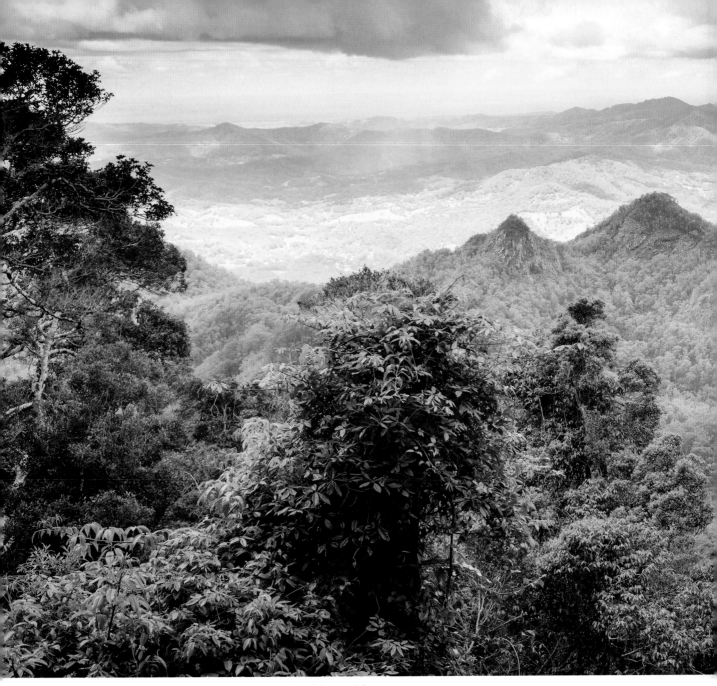

Mt Warning › Mt Warning Rainforest Park, south of the Gold Coast

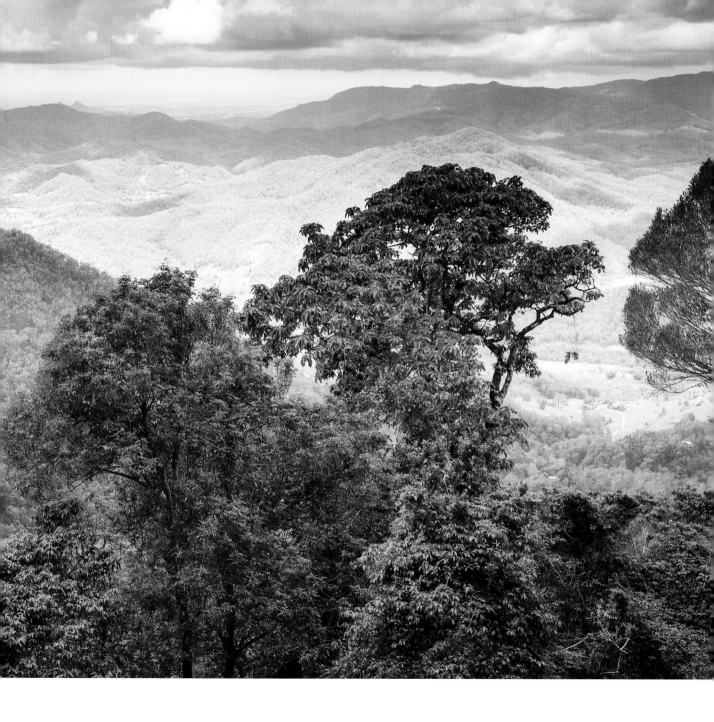

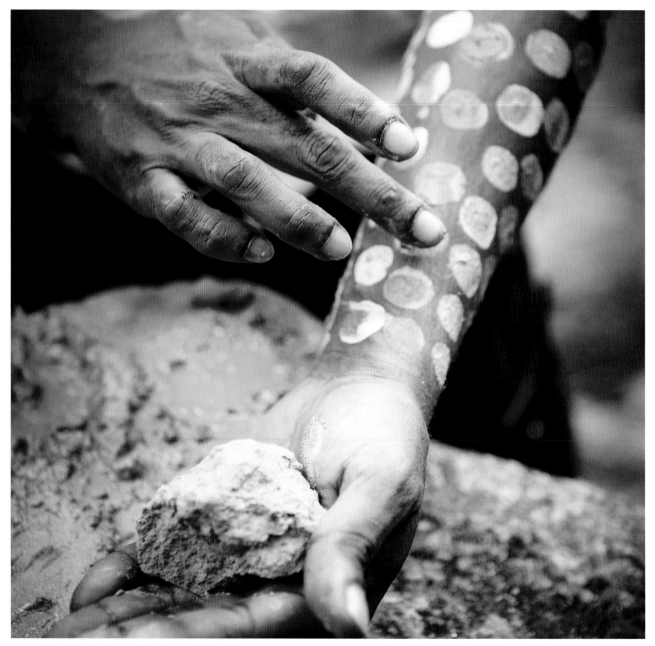

Mossman Gorge › Part of the traditional lands of the Kuku-Yalanji people

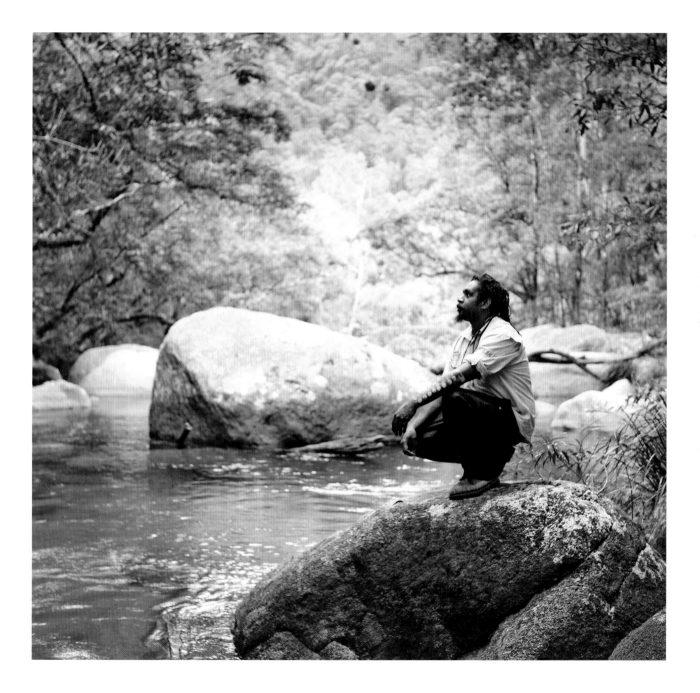

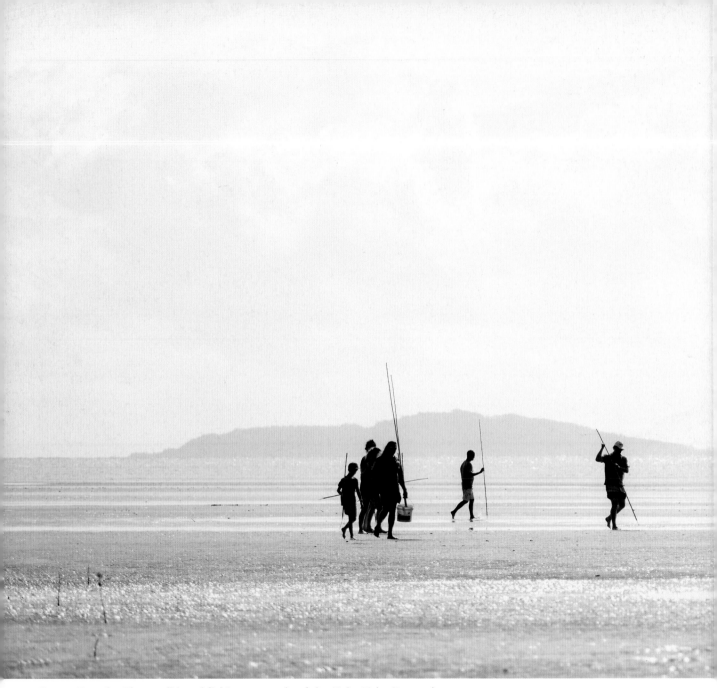

Cooya Beach › The traditional fishing grounds of the Kuku-Yalanji people

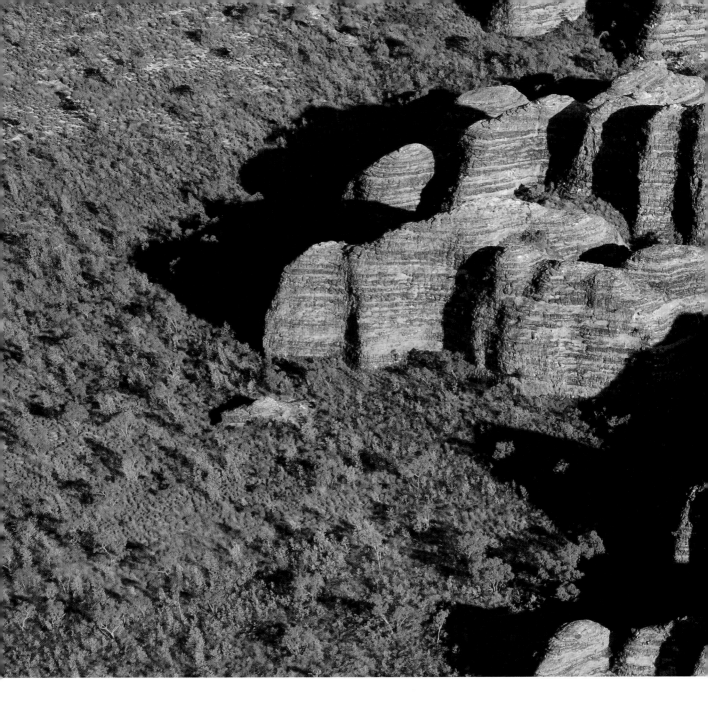

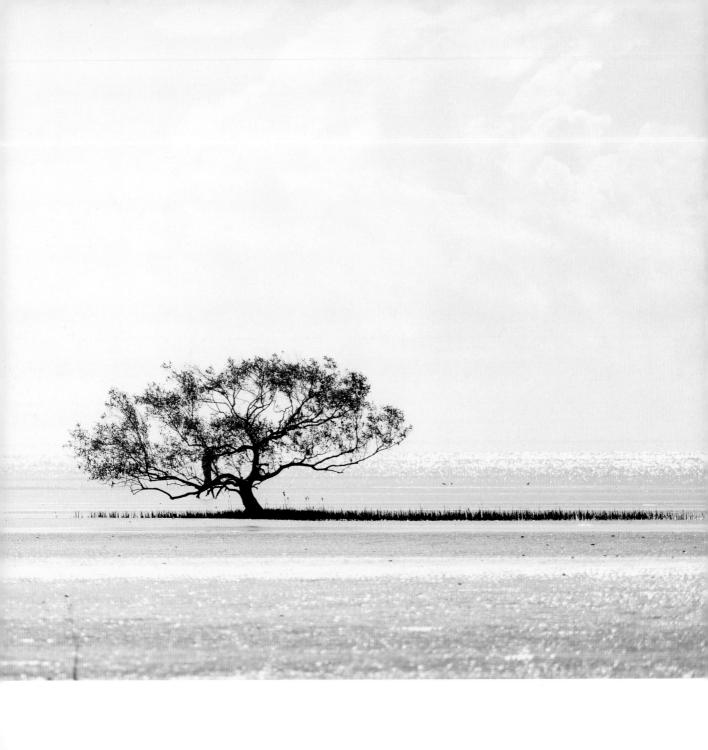

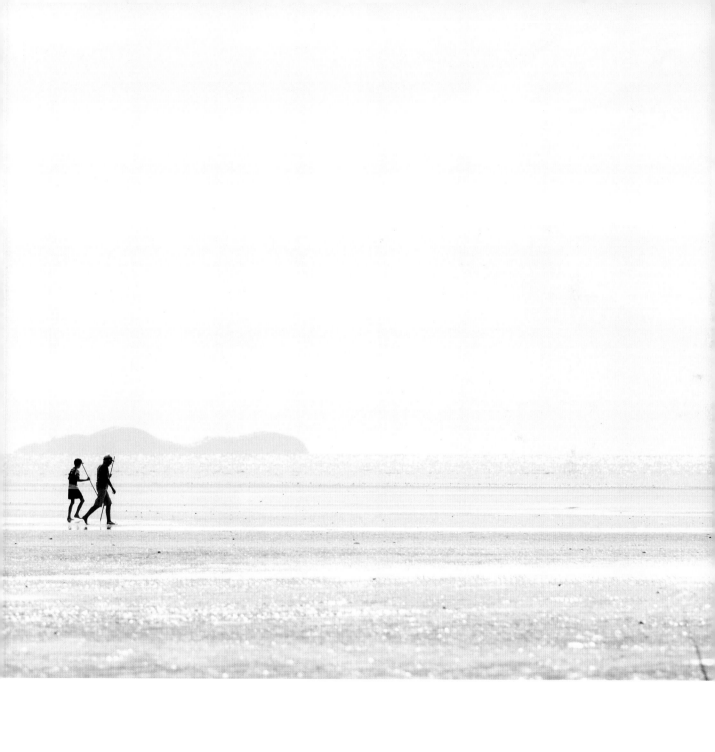

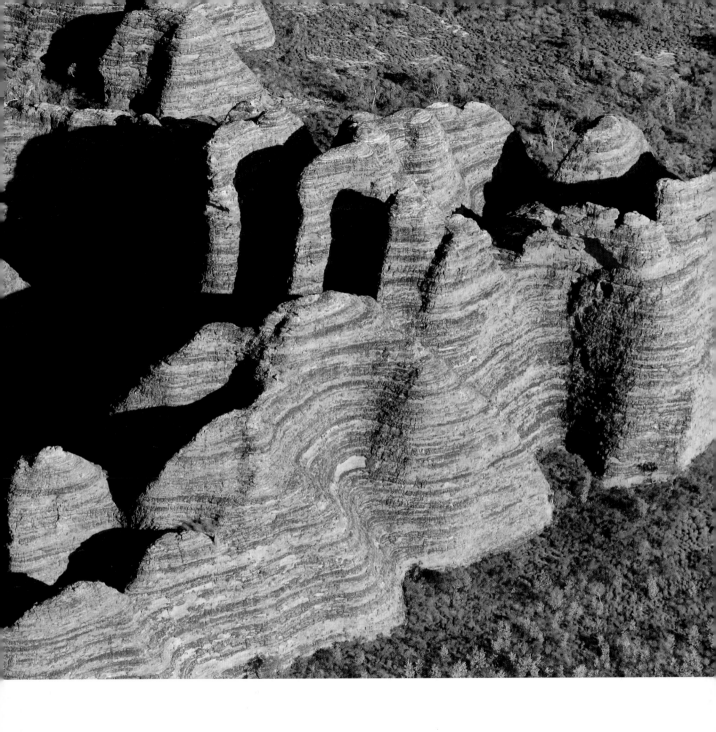

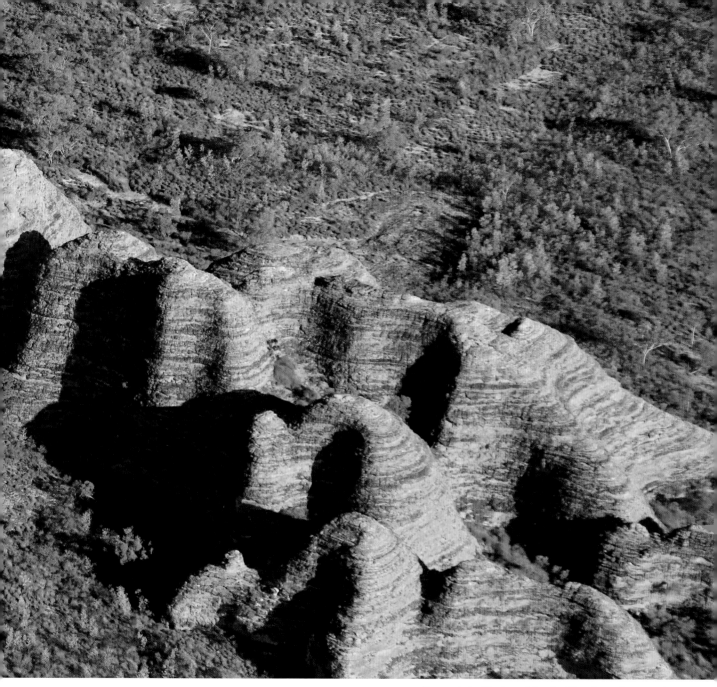

Purnululu National Park › The Bungle Bungles

Western Australia

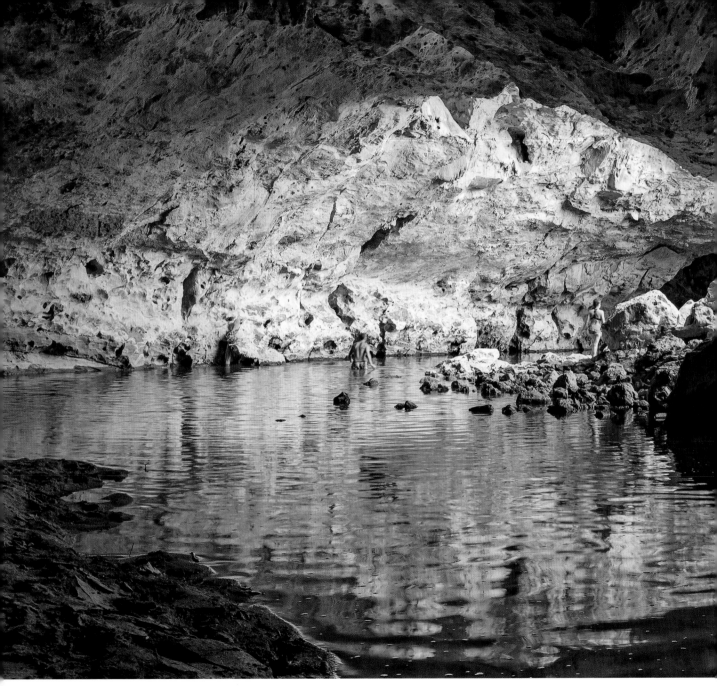

The Kimberley › Tunnel Creek National Park

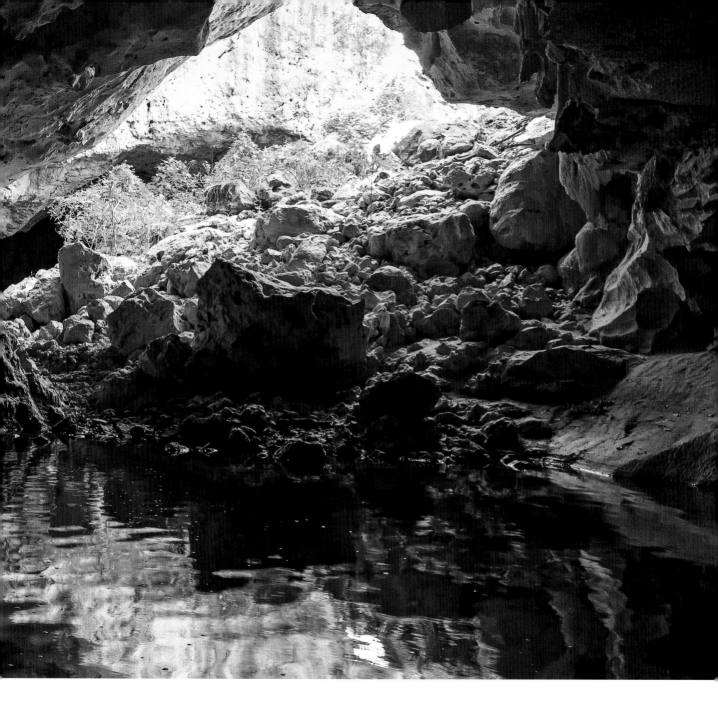

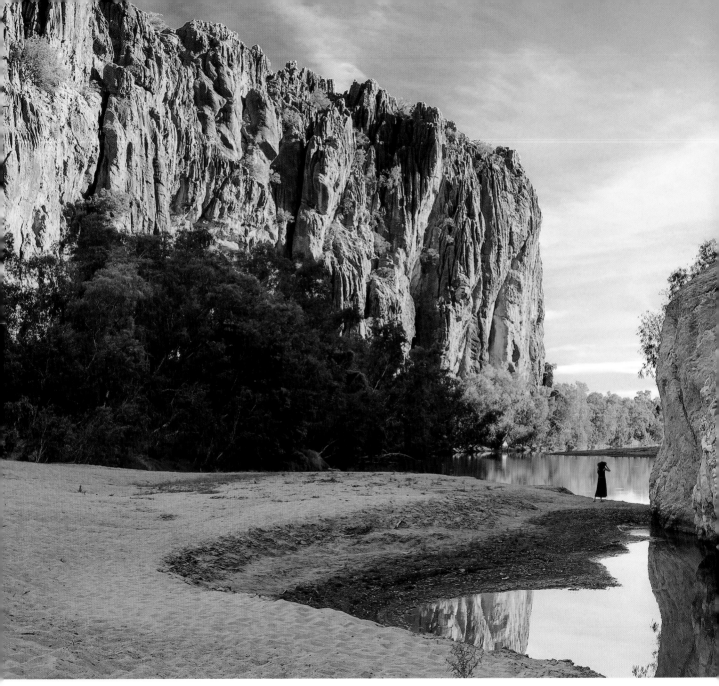

The Kimberley › Windjana Gorge National Park

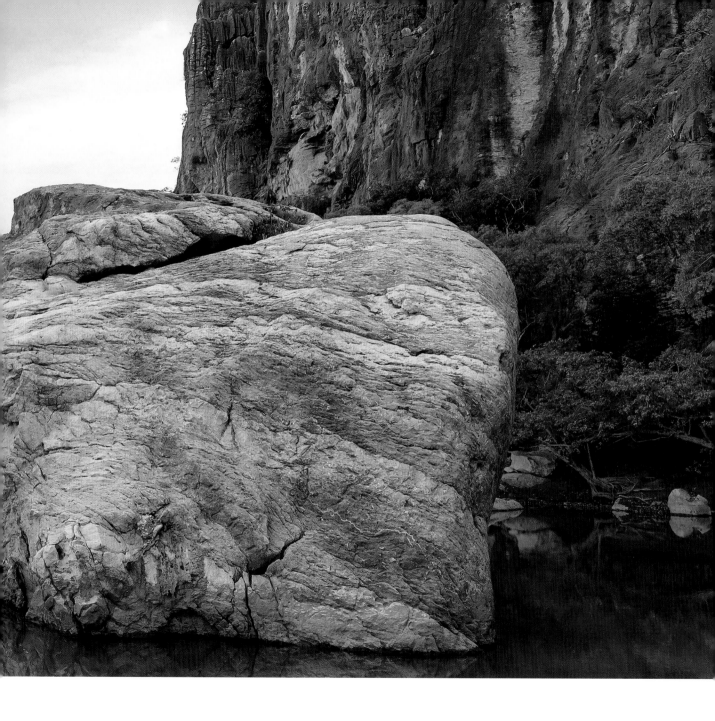

Western Australia

Indian Ocean › Montebello Islands Marine Park

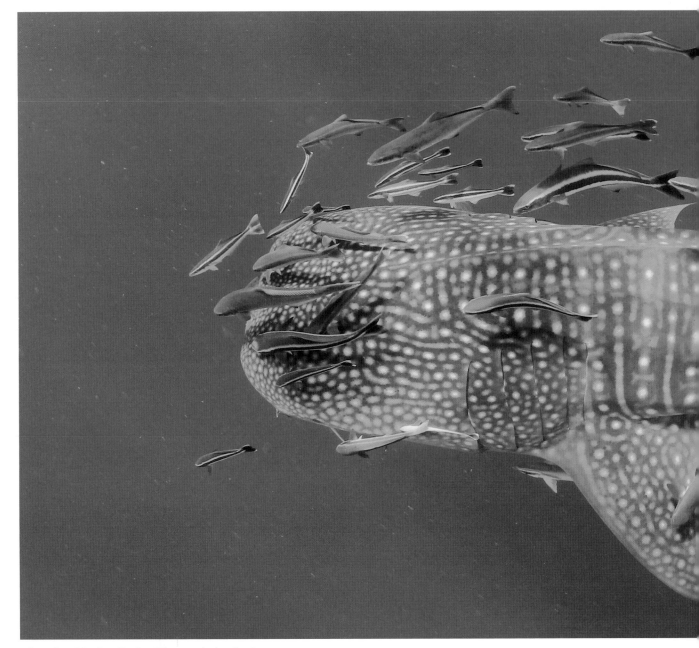

Ningaloo Marine Park › Where whale sharks roam

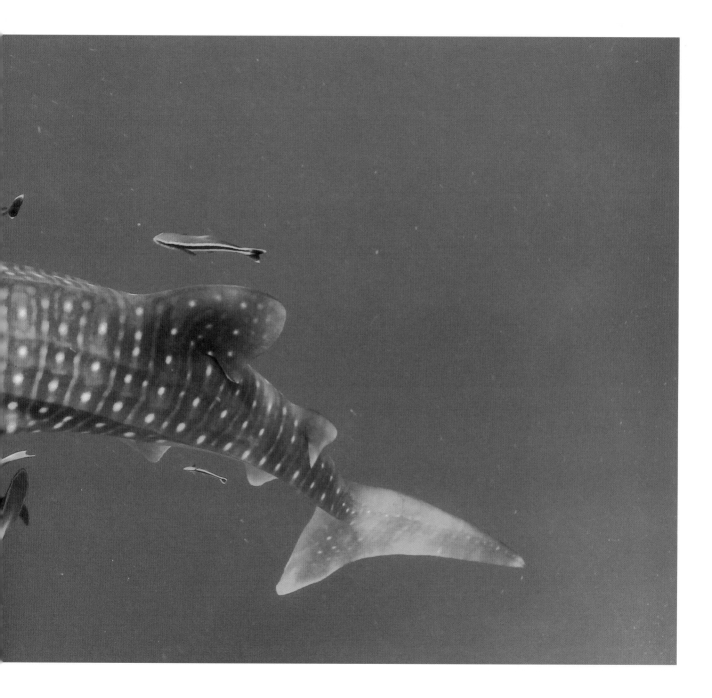

Western Australia

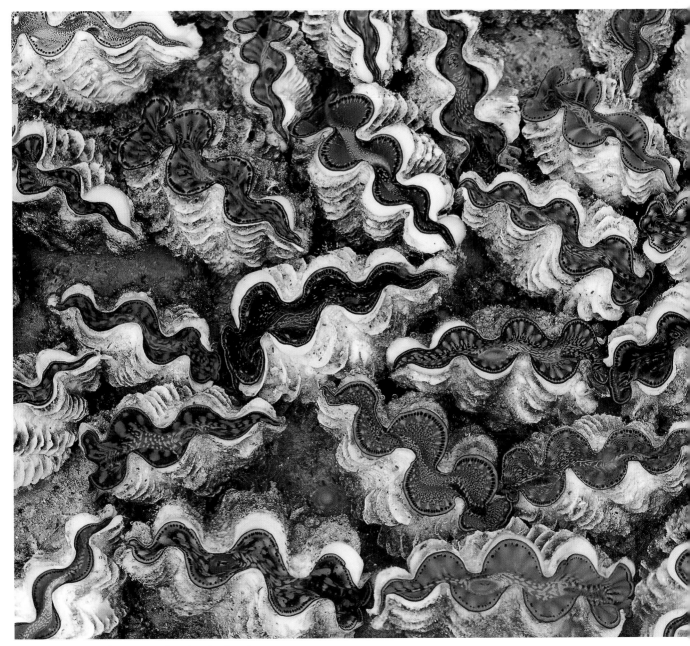

Indian Ocean › The Cocos (Keeling) Islands

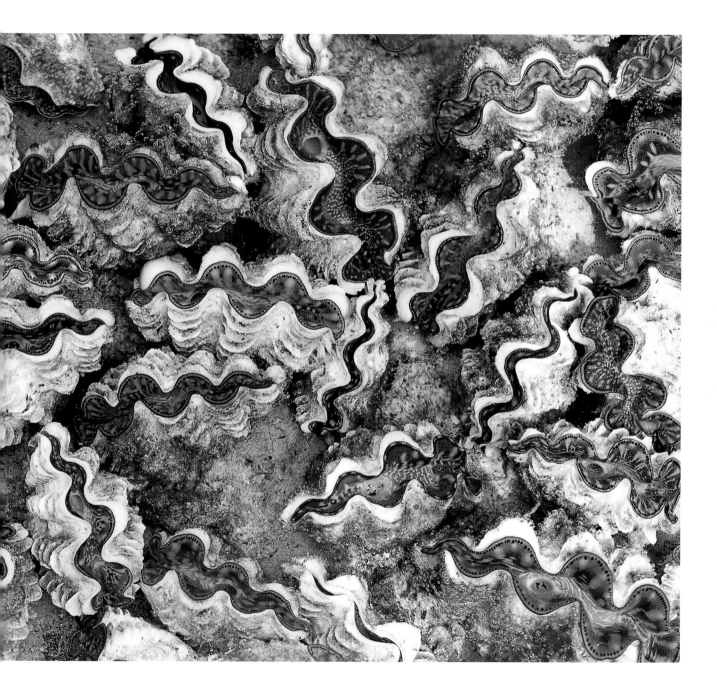

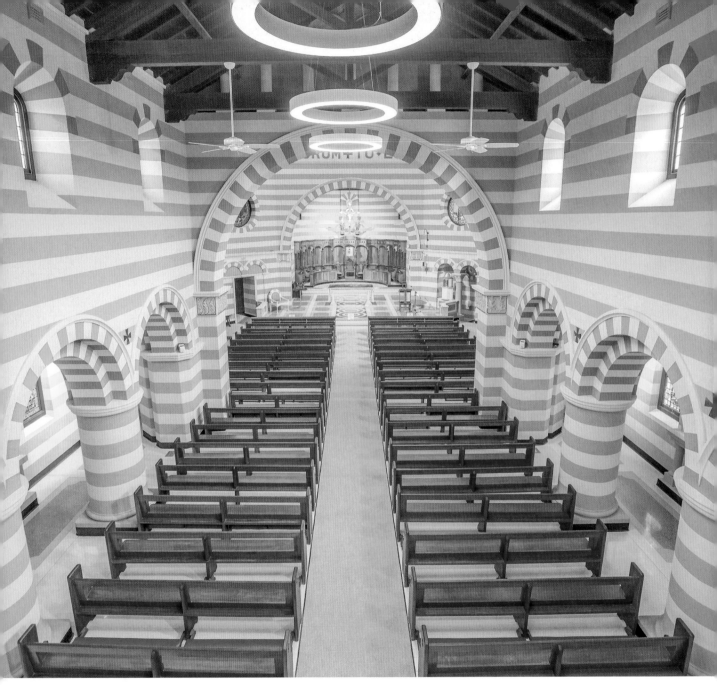

Geraldton › St Francis Xavier cathedral

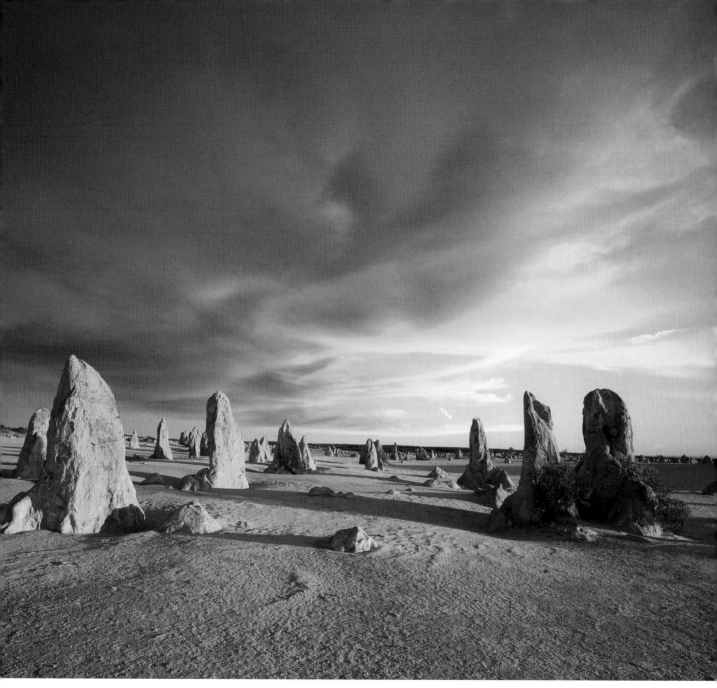

Nambung National Park › The Pinnacles

Western Australia

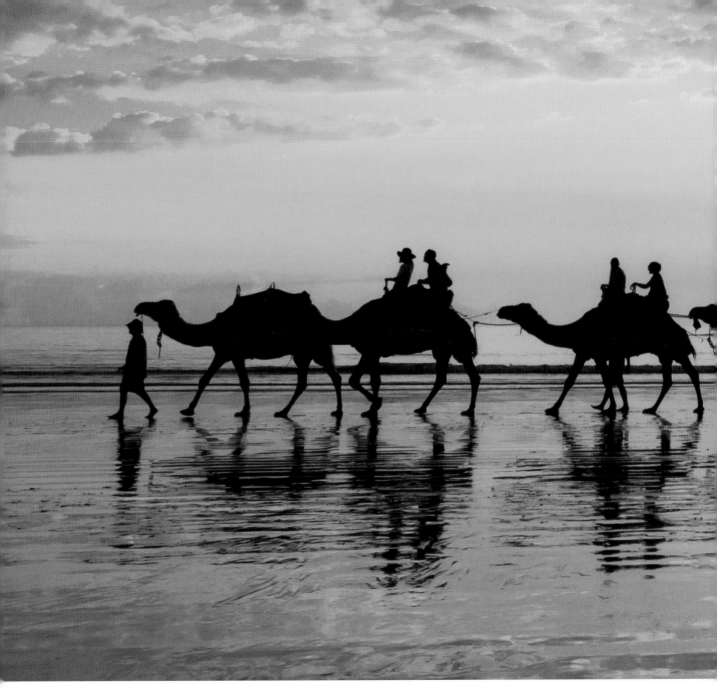

Broome › Camel tours of Cable Beach

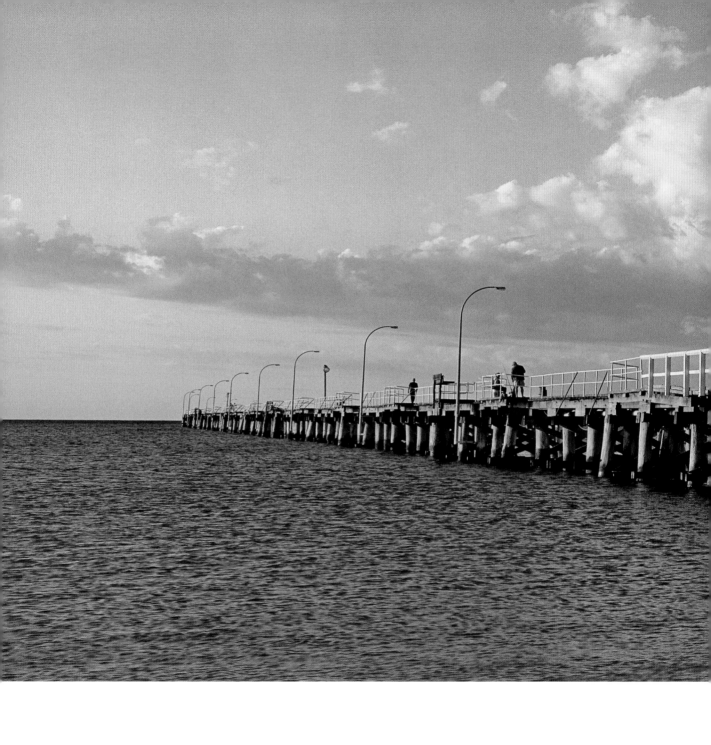

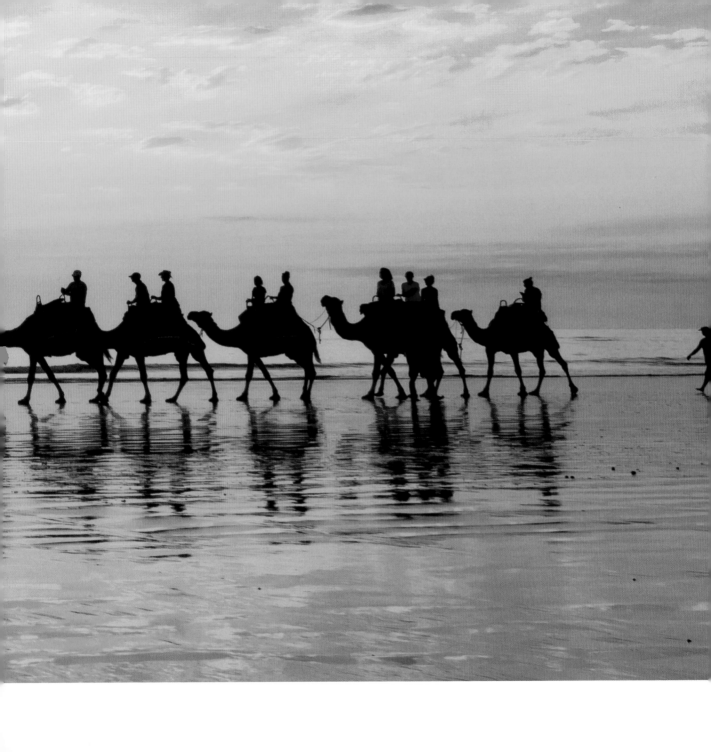

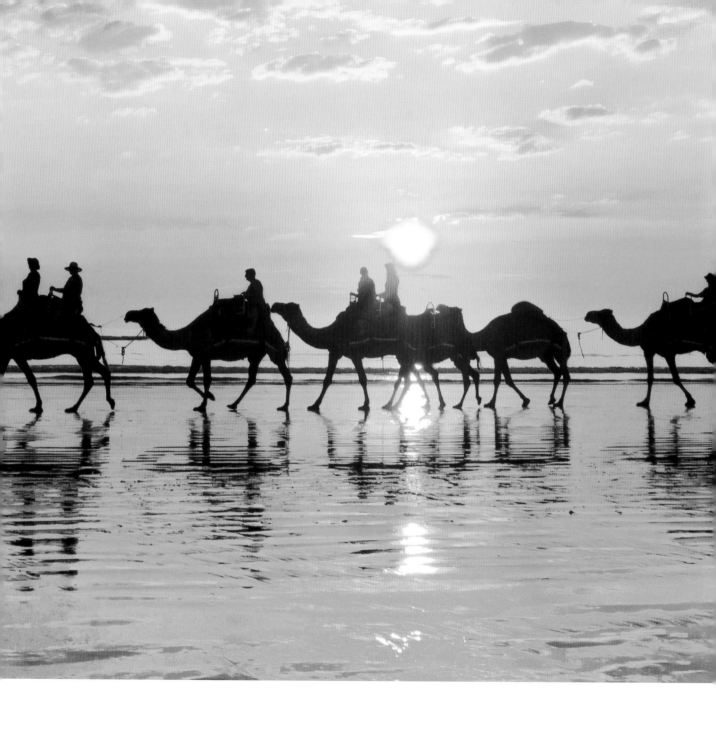

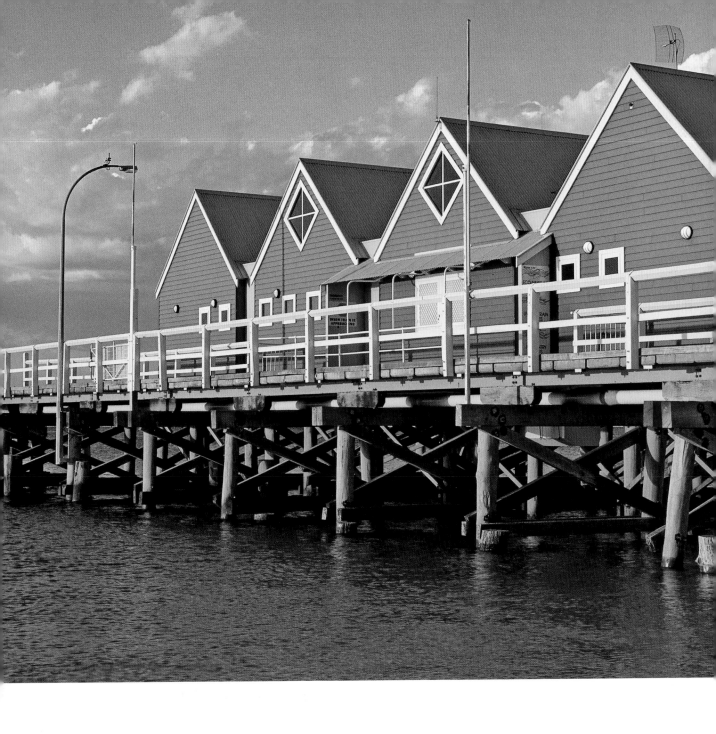

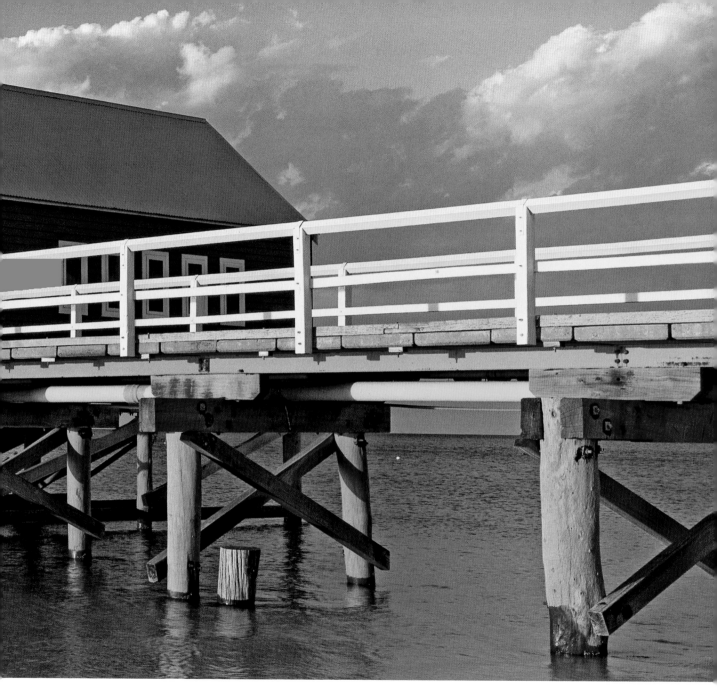

Busselton › The jetty and its underwater observatory

Western Australia

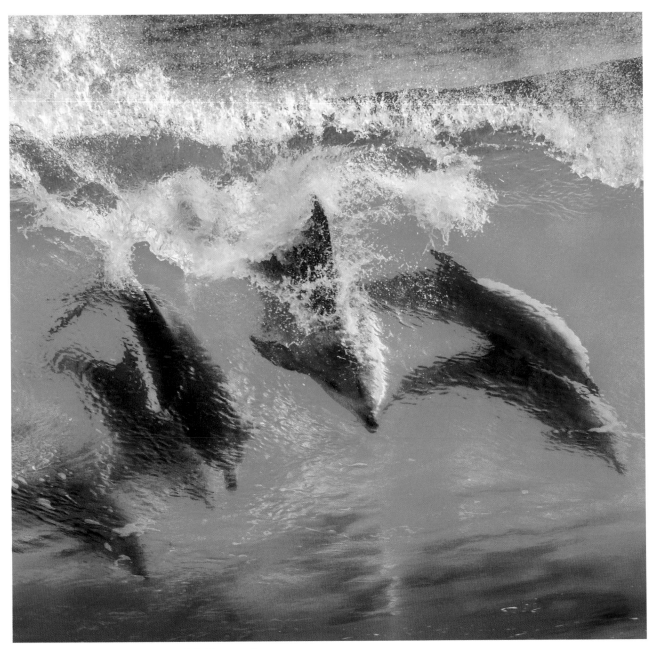

Cape Naturaliste › Bottlenose dolphins surfing

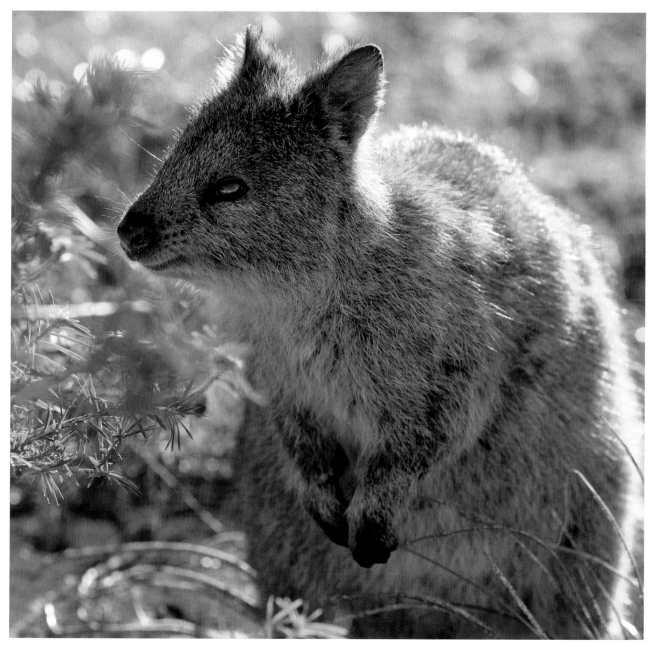

Rottnest Island › The indigenous quokka

Western Australia

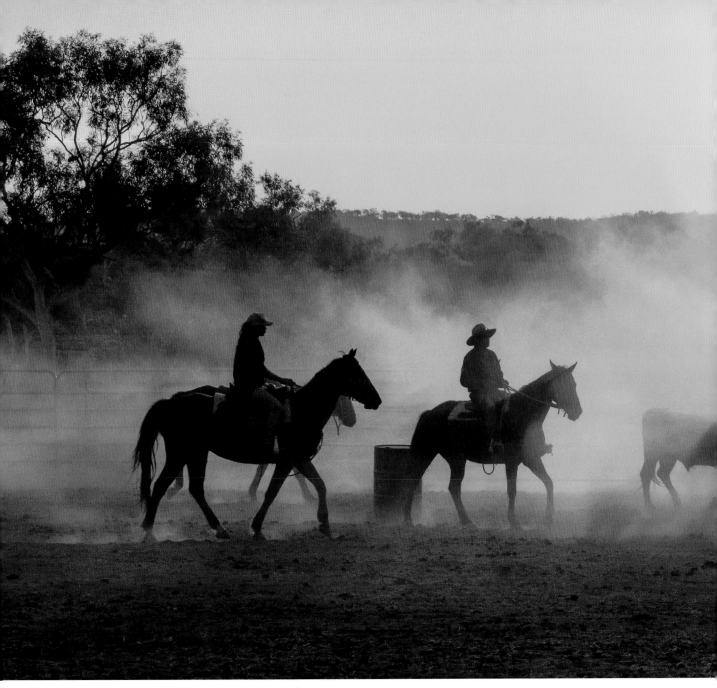

The Kimberley › Cattle are mustered from April

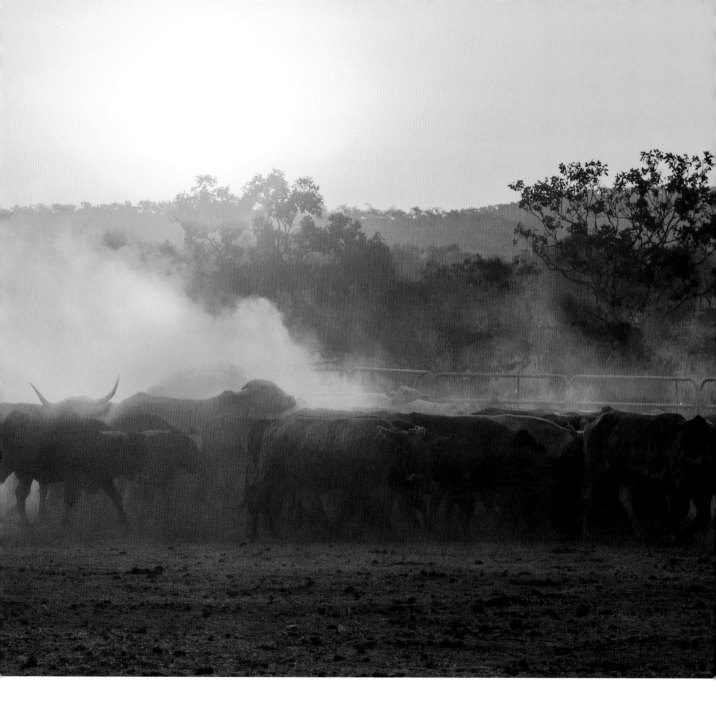

Western Australia

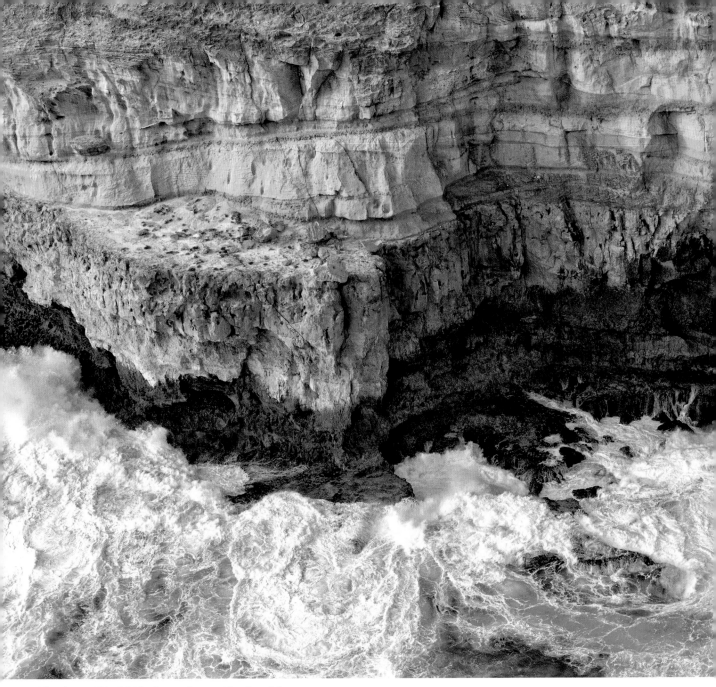

Shark Bay World Heritage Area › Monkey Mia

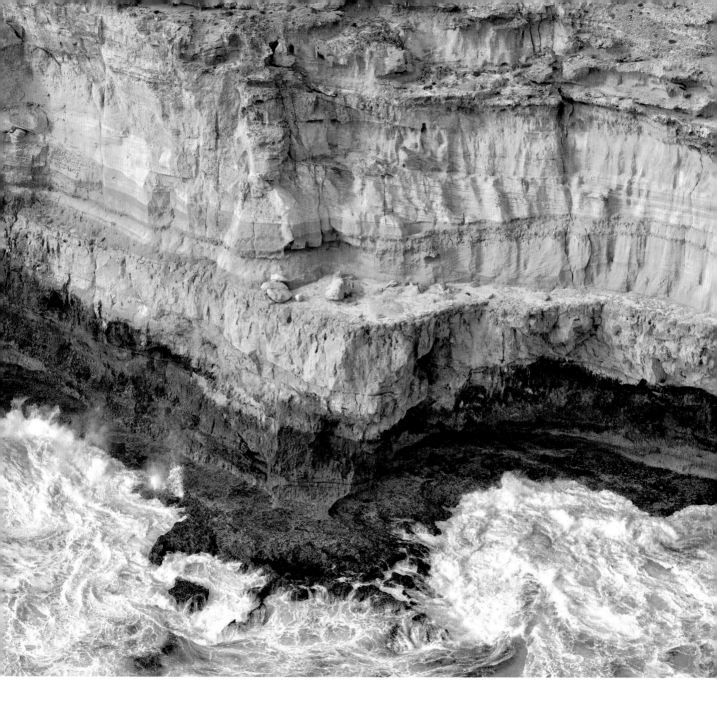

Western Australia

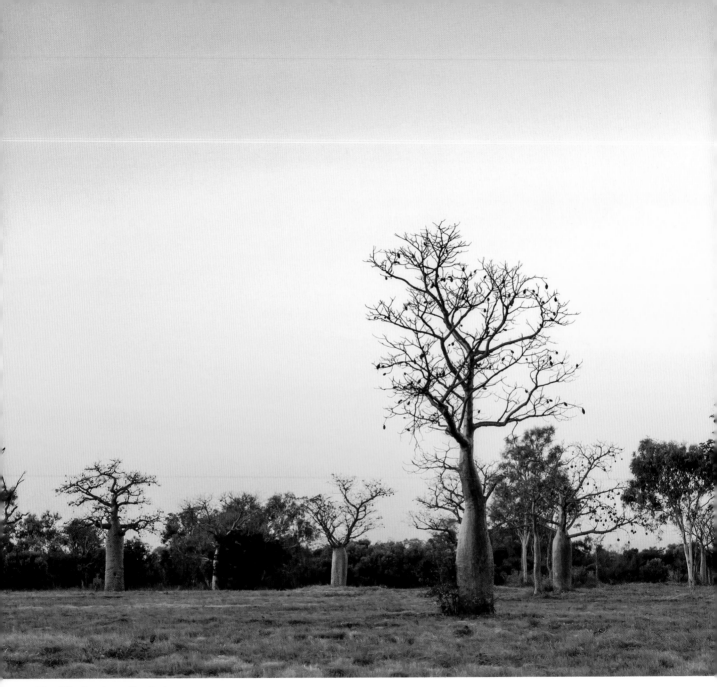

The Kimberley › Baobab trees

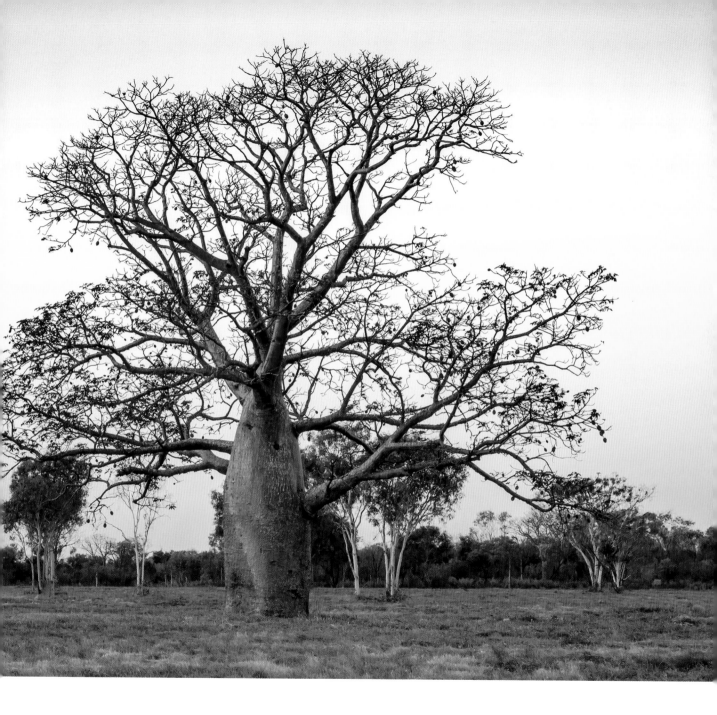

Western Australia

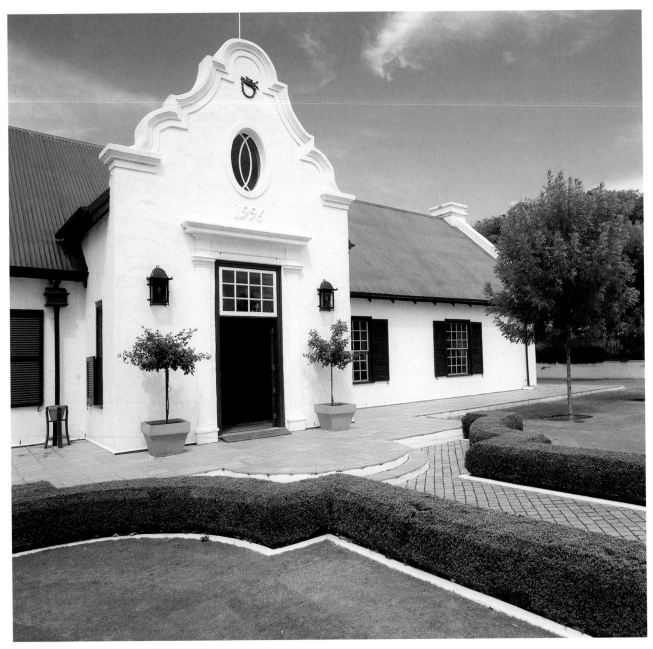

Margaret River › Voyager Estate winery

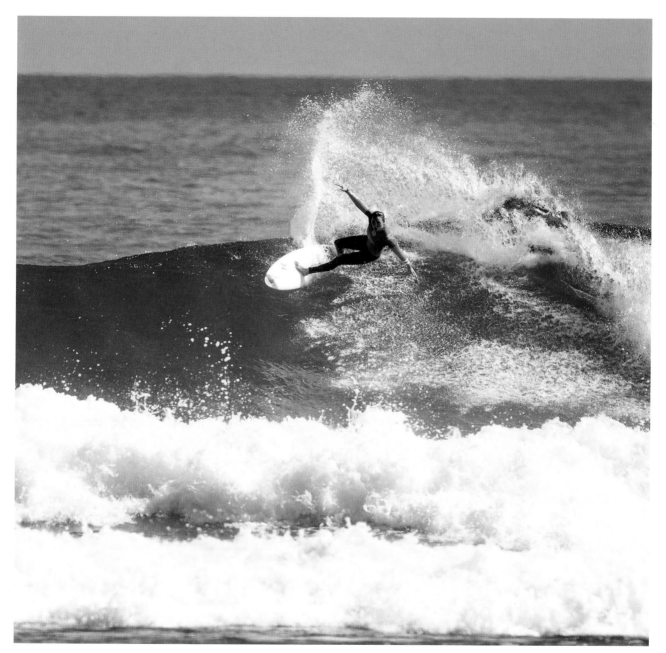

Margaret River › Surfing the Main Break

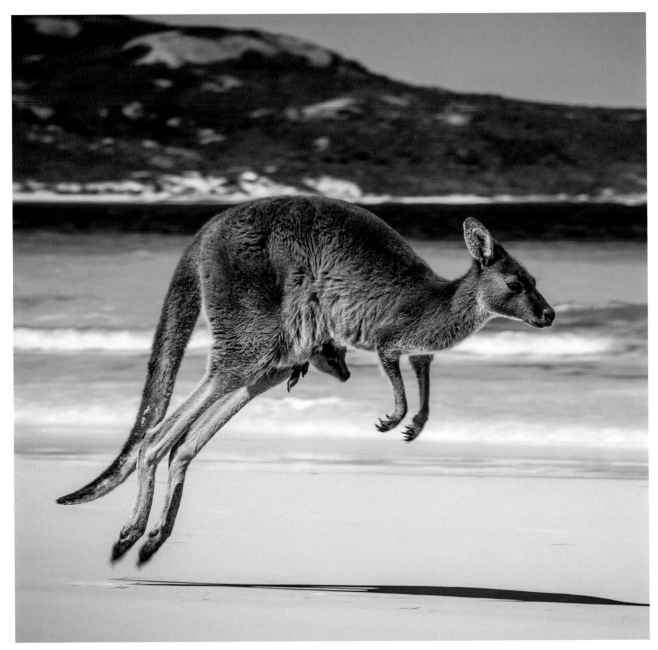

Esperance › Lucky Bay

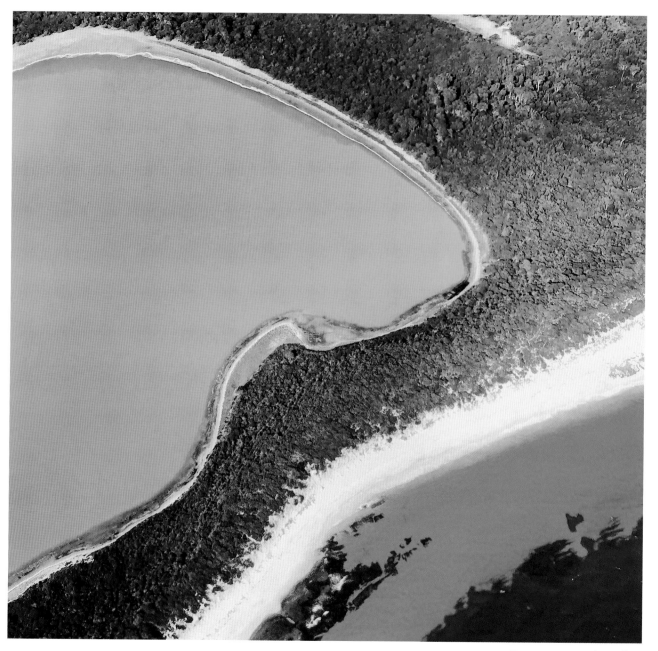

Esperance › Lake Hillier

Western Australia

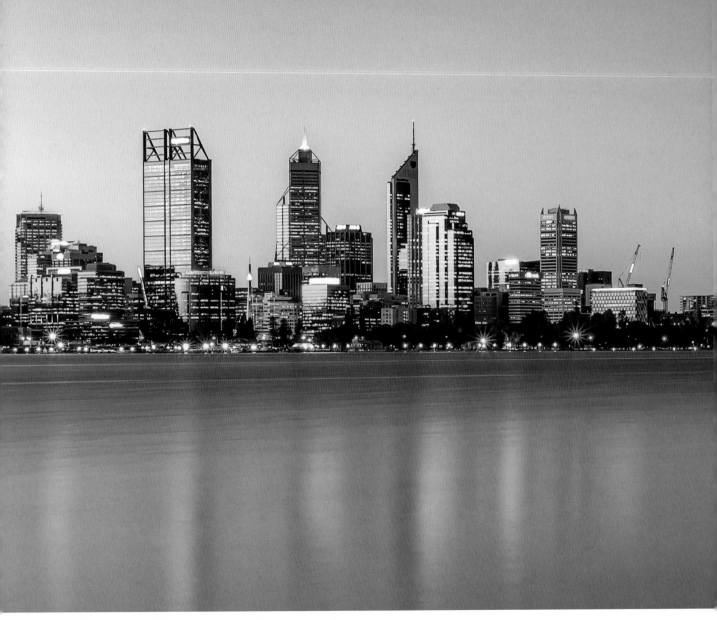

Perth › The skyline of Western Australia's state capital

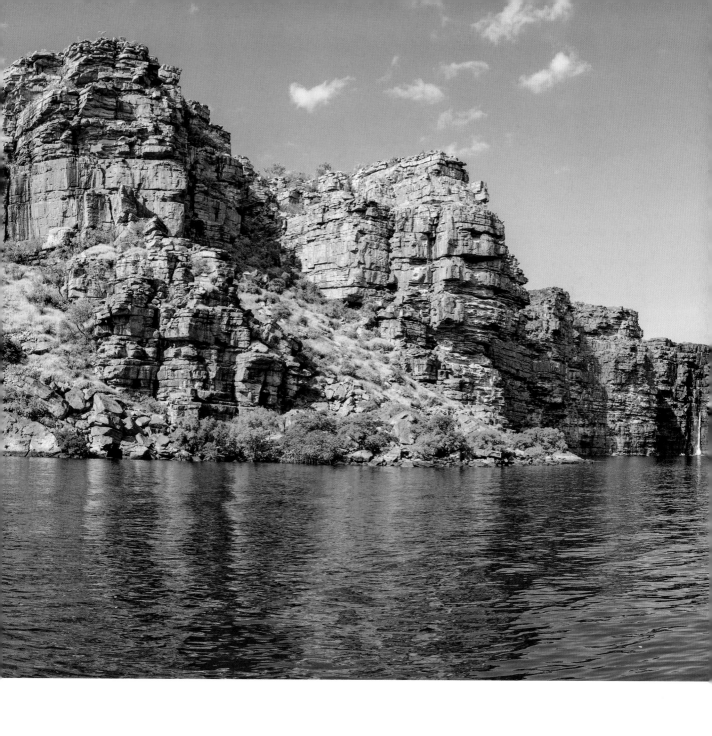

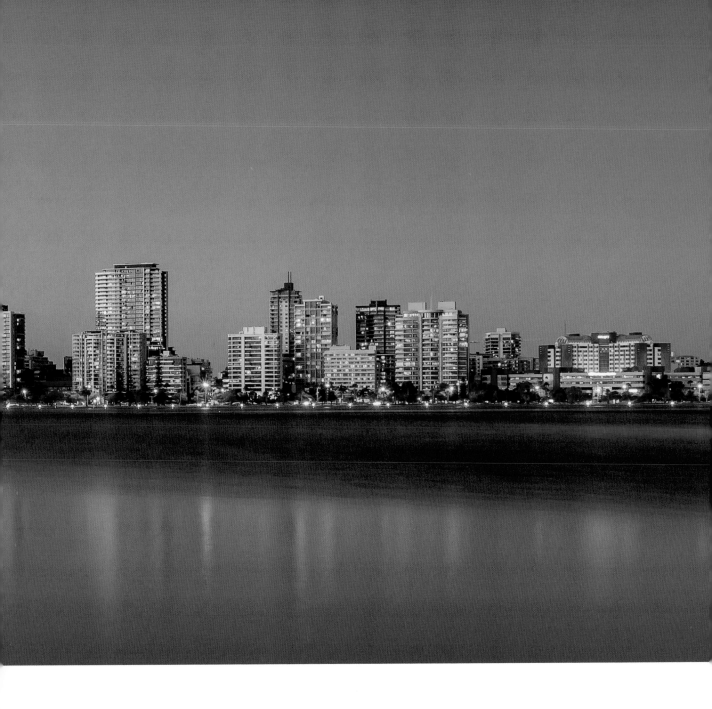

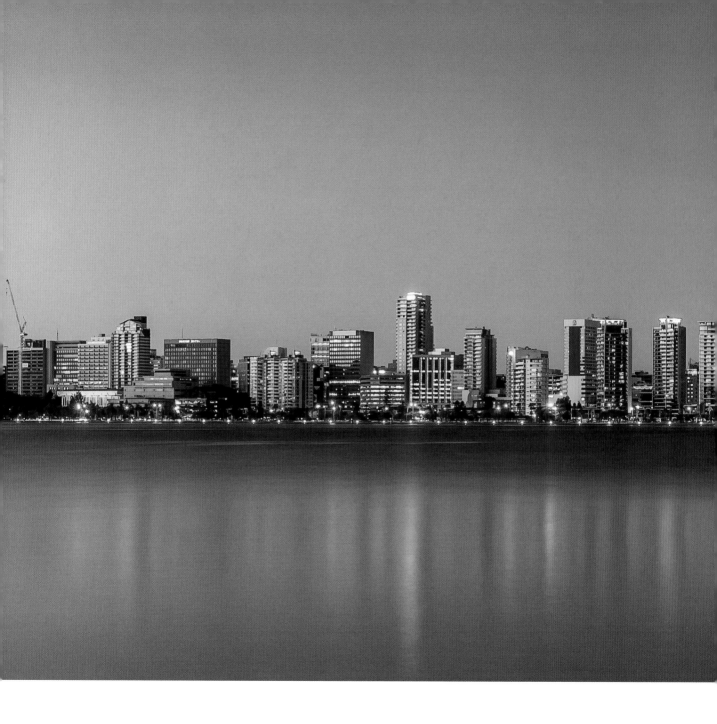

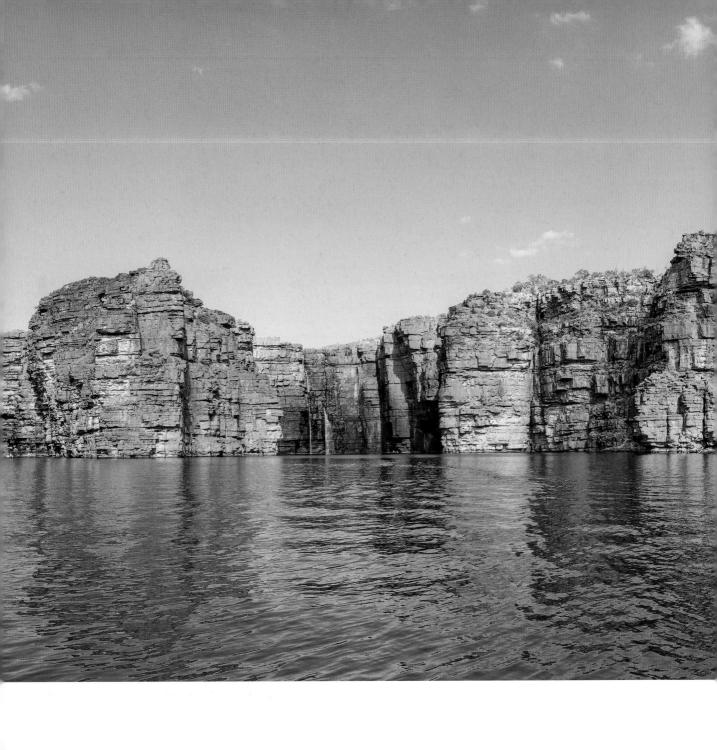

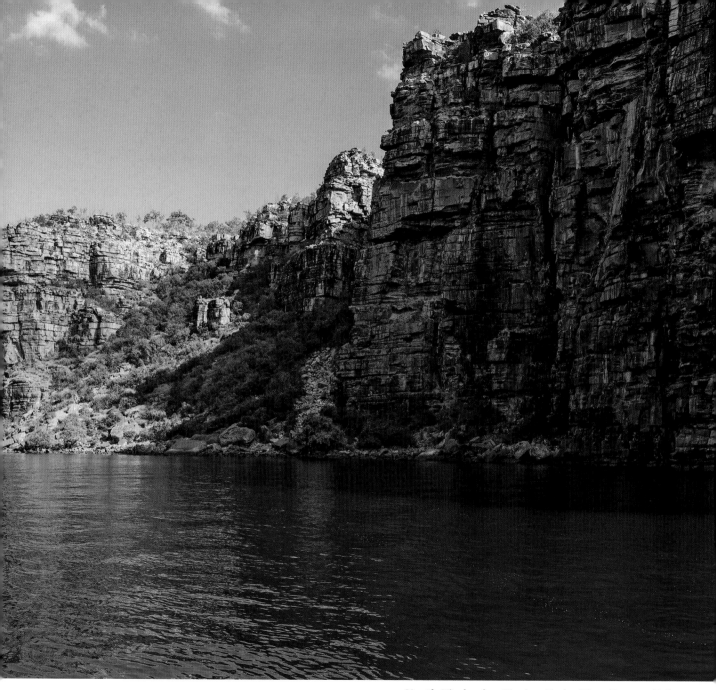

North Kimberley Marine Park › King George Falls

Western Australia

King Leopold Ranges › Mt Hart Homestead

Western Australia

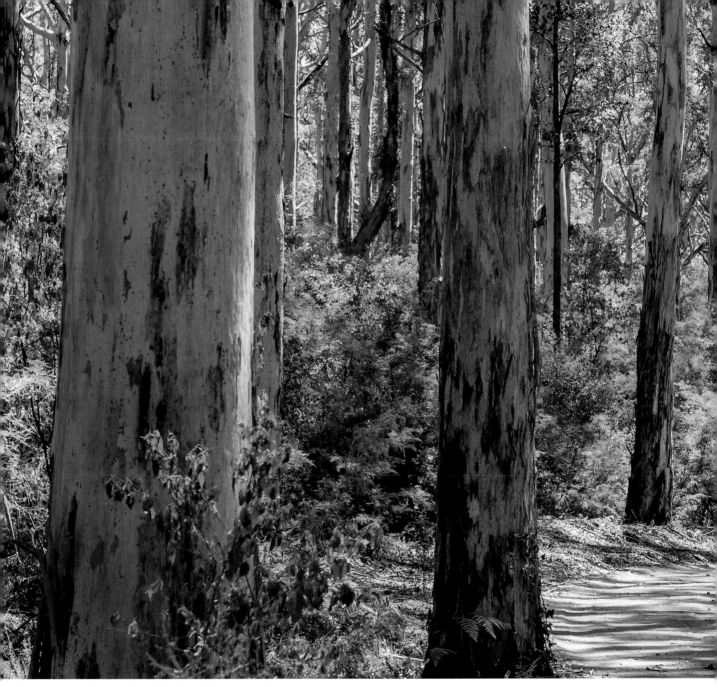

Leeuwin-Naturaliste National Park › Karri trees in Boranup forest

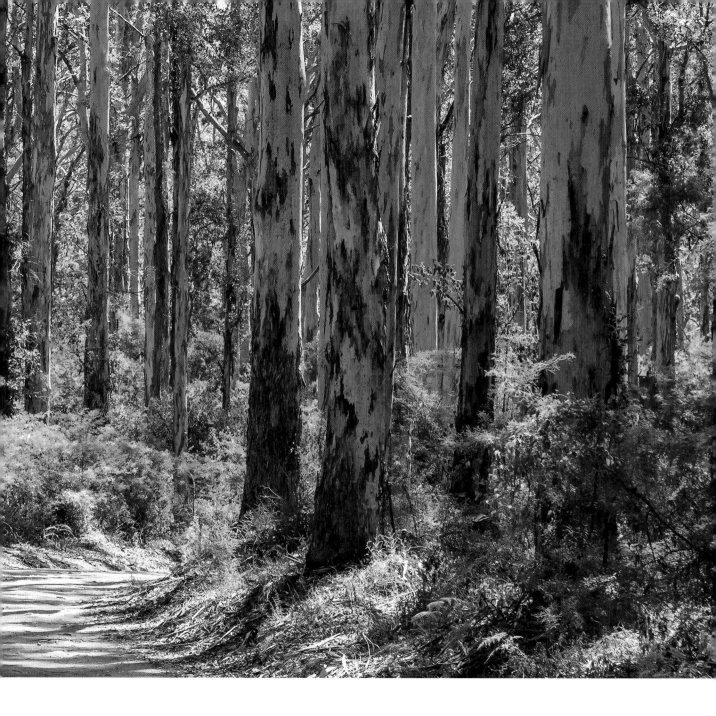

Western Australia

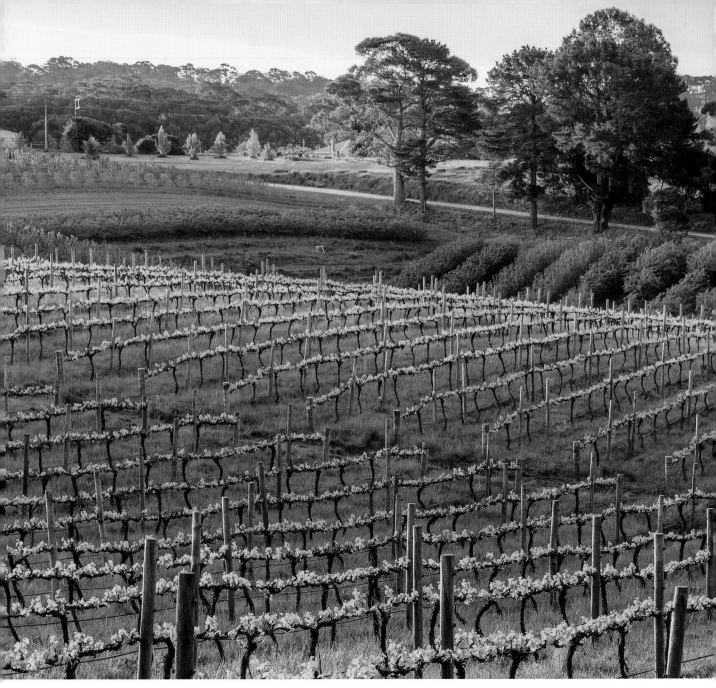

South Australia › Wine country

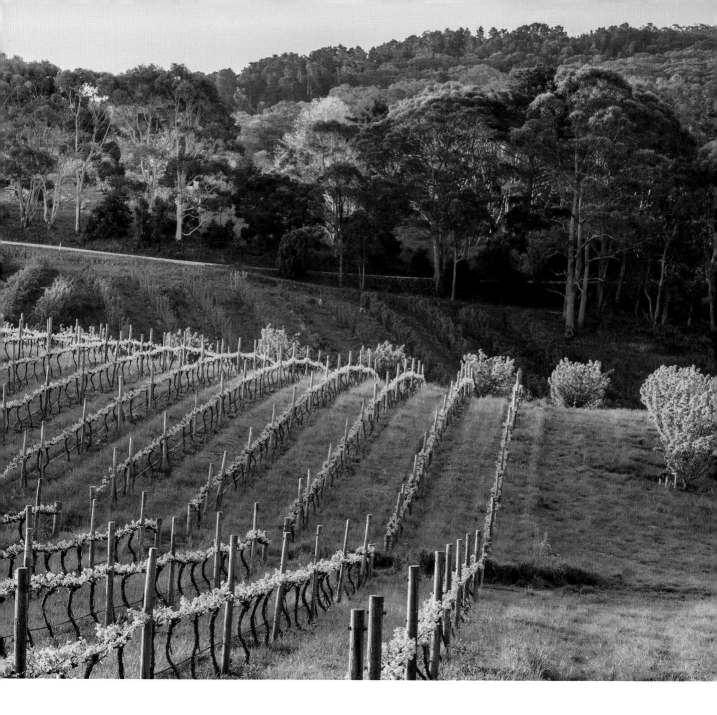

South Australia

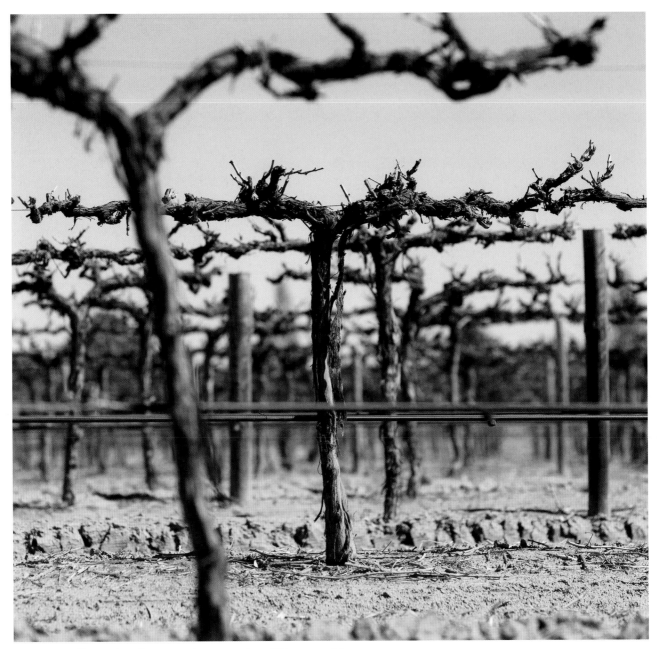

Barossa Valley › Vines here can be more than 150 years old

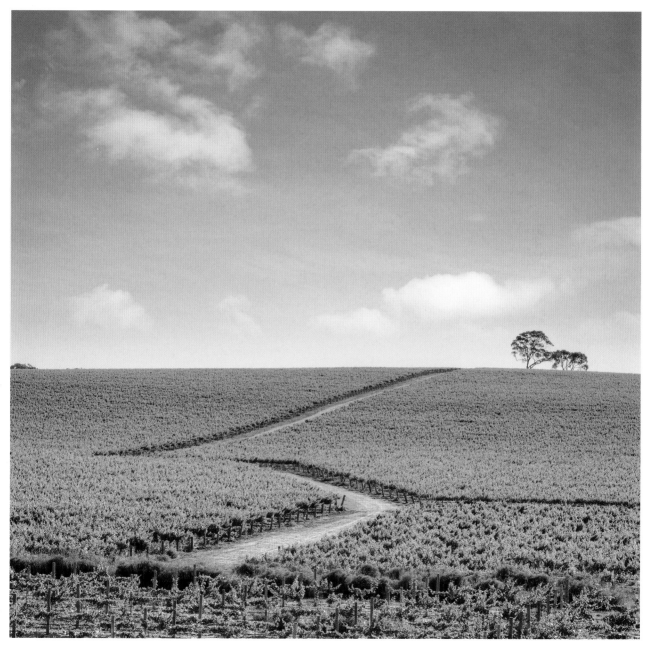

Clare Valley › Producer of world-class riesling

South Australia

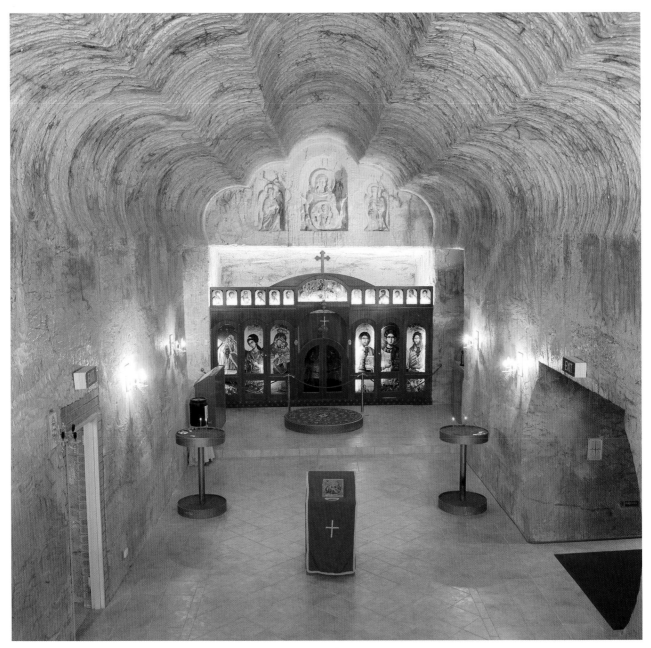

Coober Pedy › The Serbian Orthodox Church

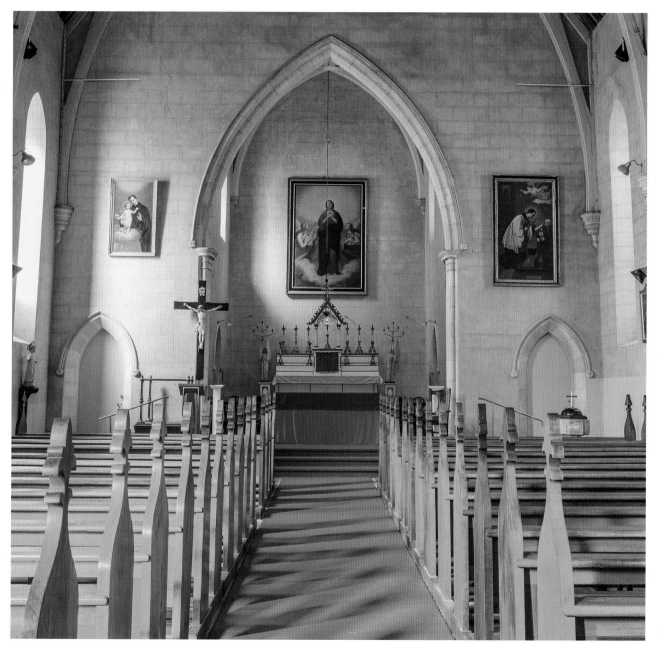

Clare Valley › St Aloysius Church in Sevenhill Cellars winery

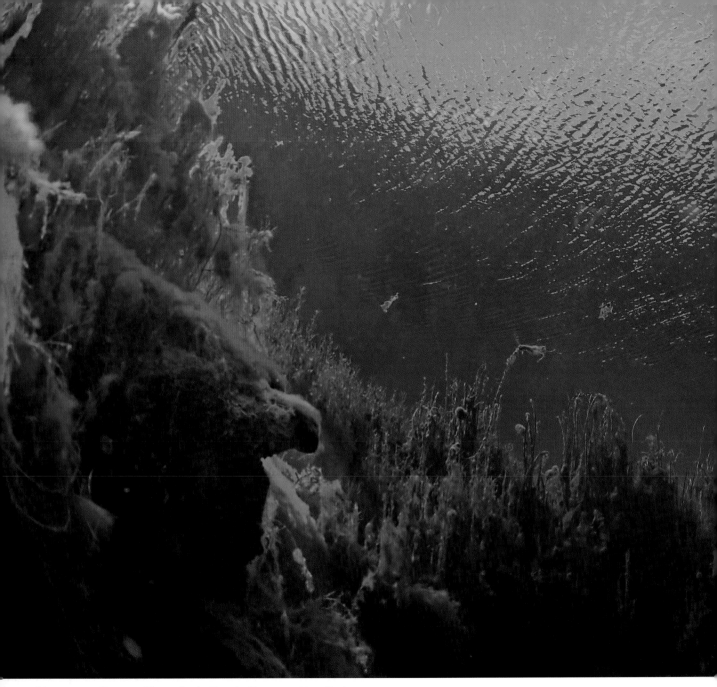

Limestone Coast › Piccaninnie Ponds Conservation Park

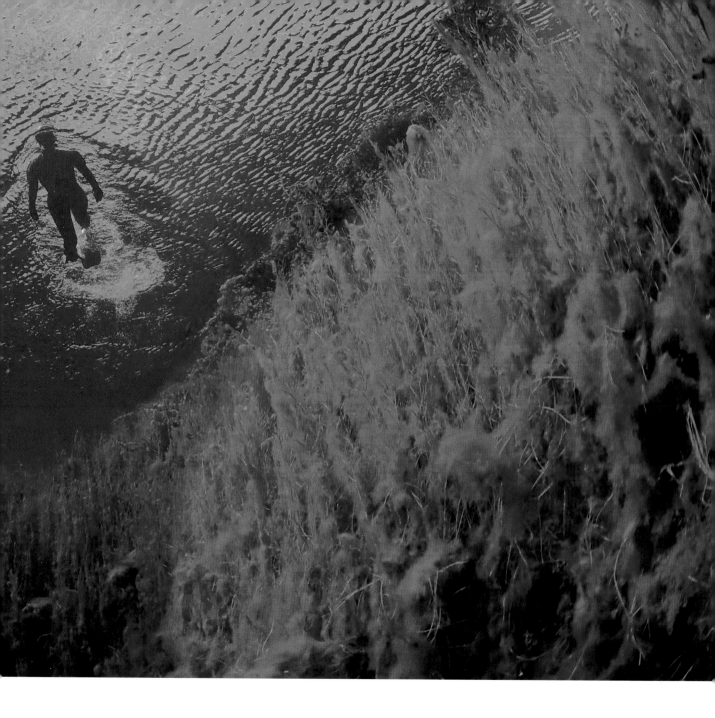

South Australia

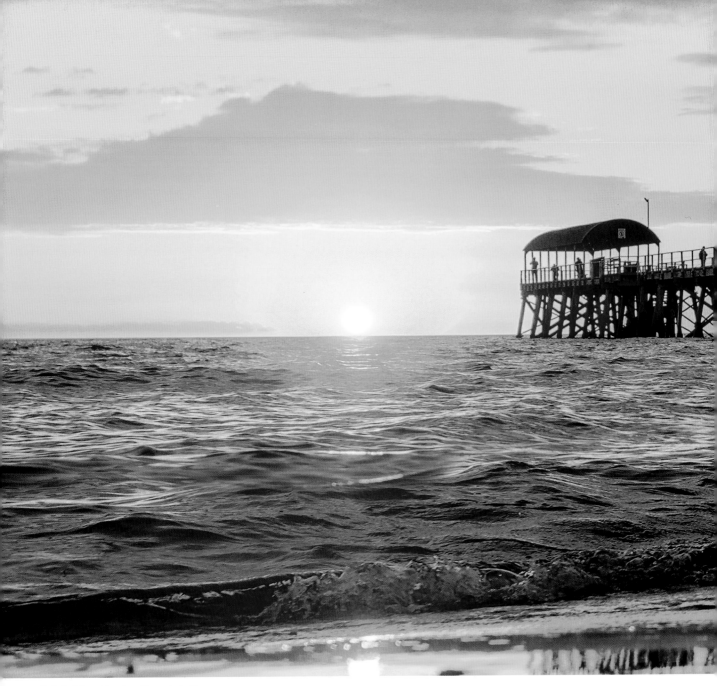

Adelaide › Henley Beach jetty

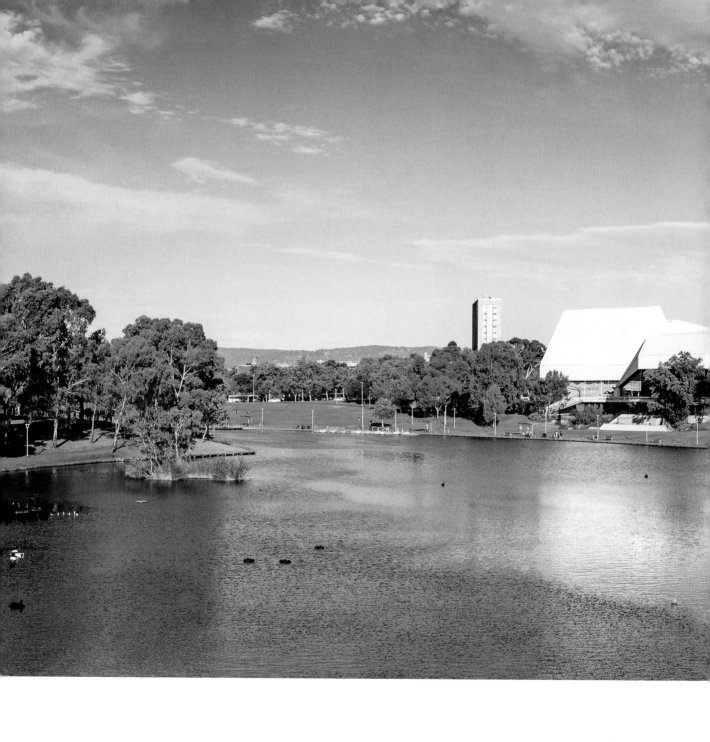

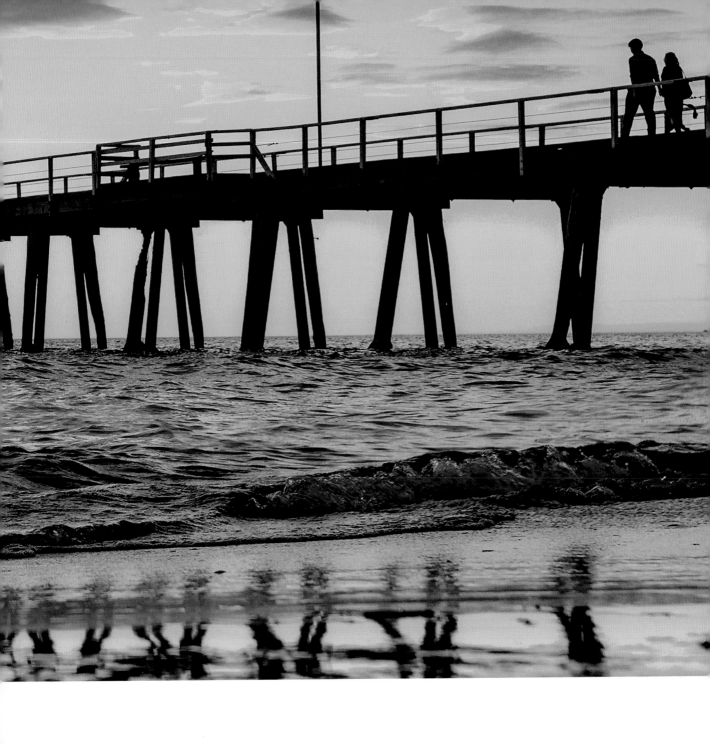

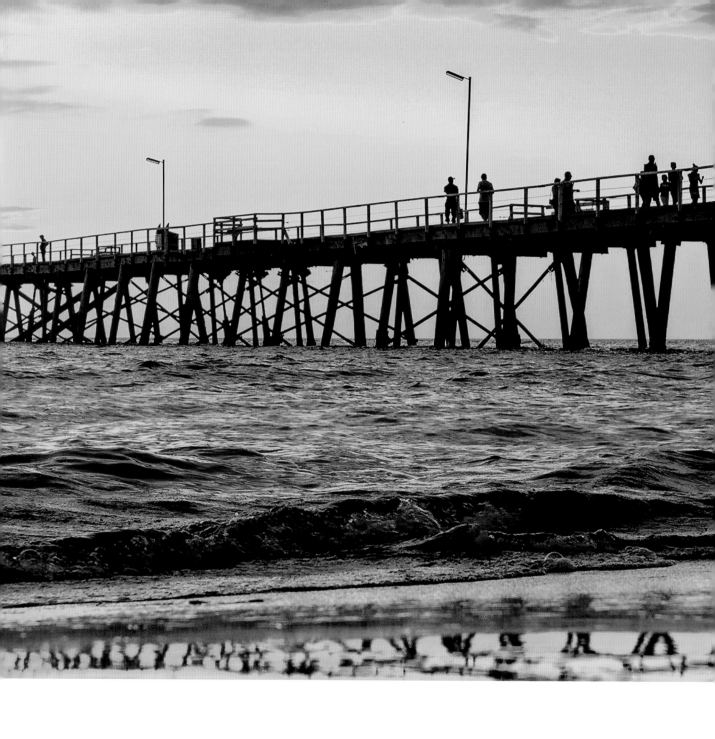

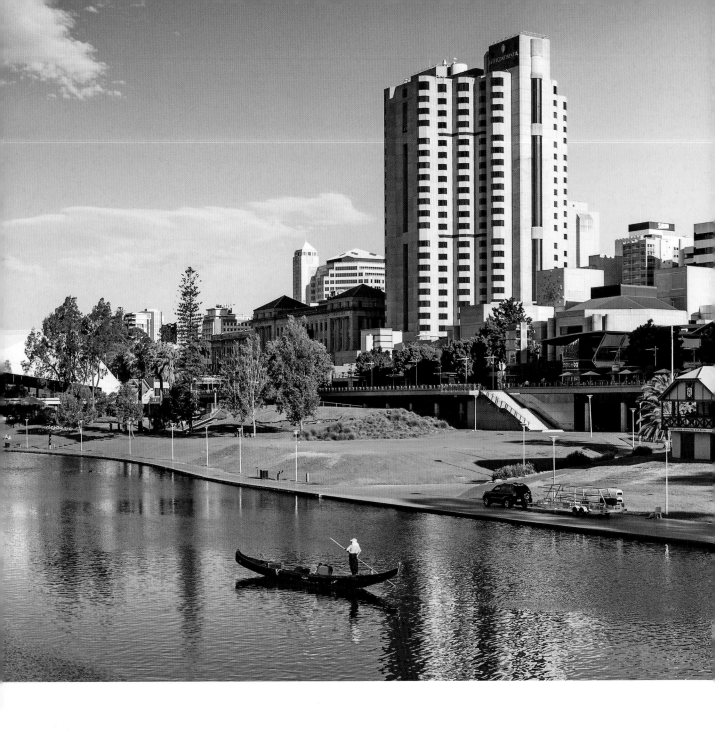

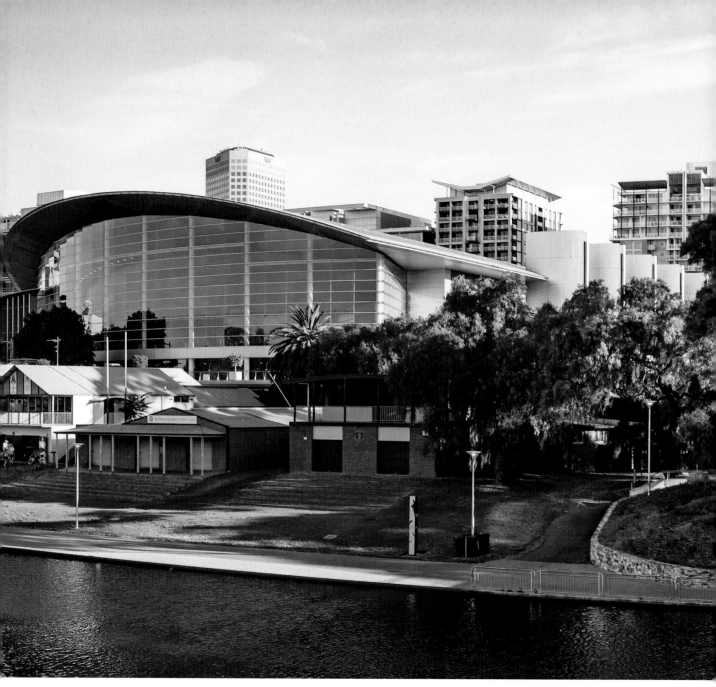

Adelaide › The River Torrens

South Australia

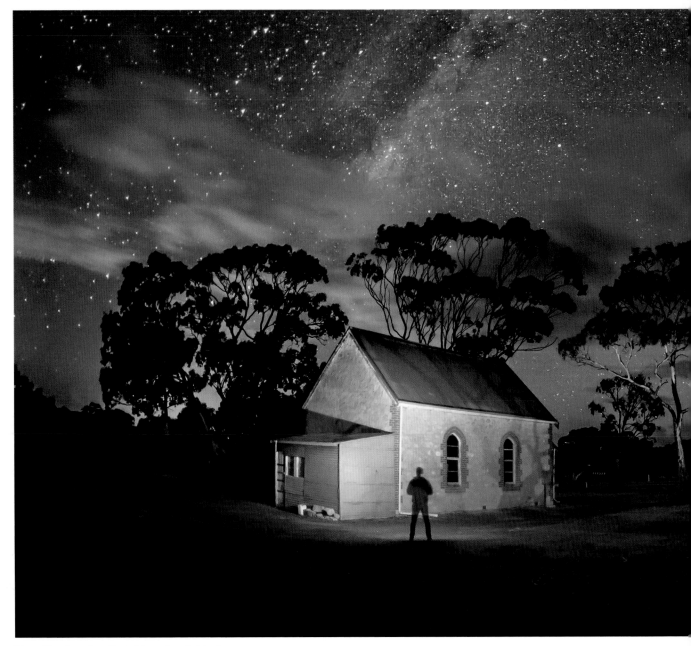

Eyre Peninsula › Port Lincoln night sky

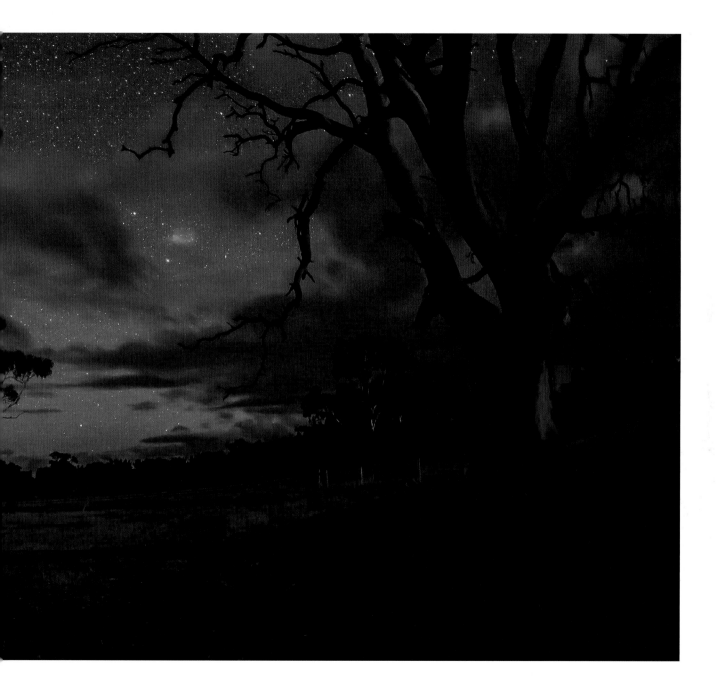

South Australia

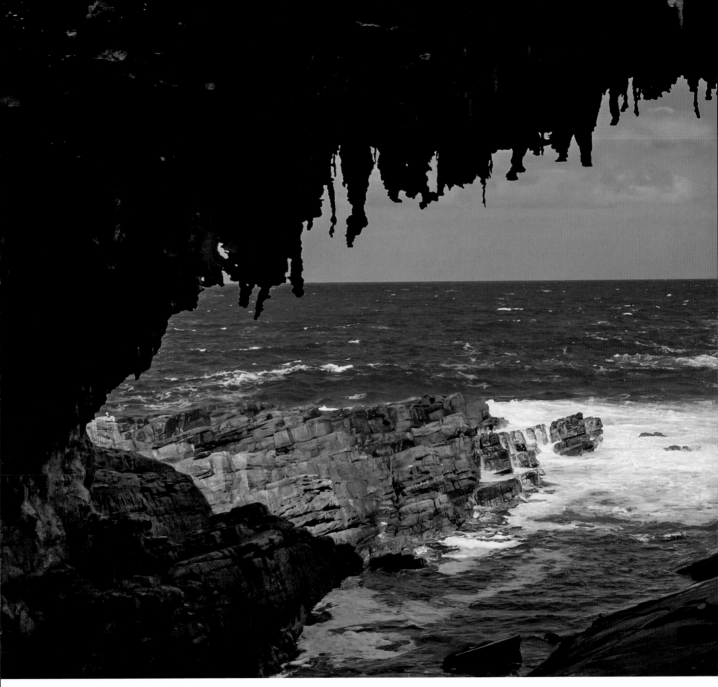

Flinders Chase National Park › Admirals Arch on Kangaroo Island

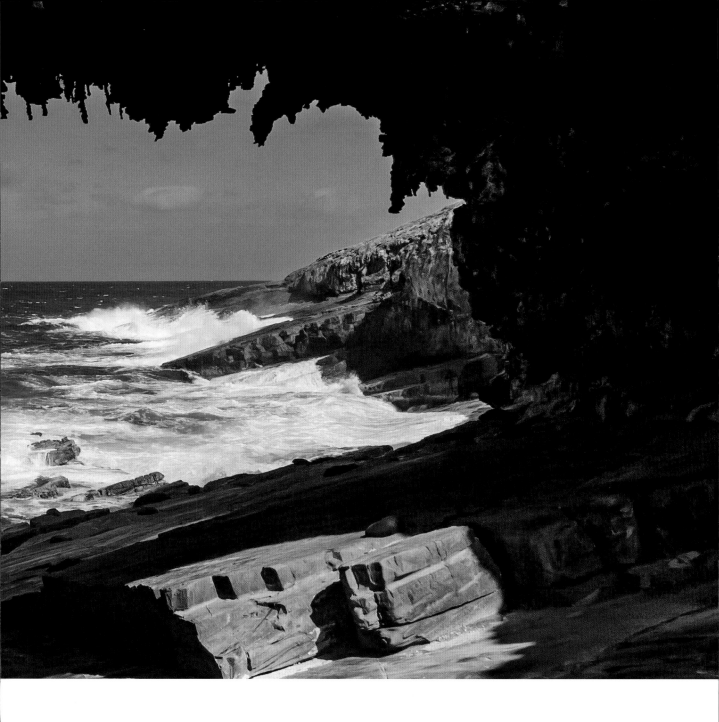

South Australia

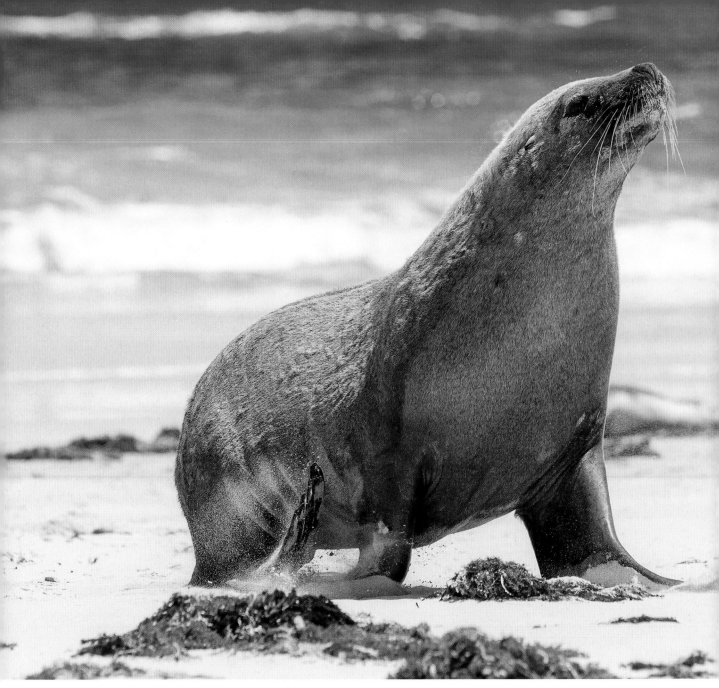

Kangaroo Island › Seal Bay Conservation Park

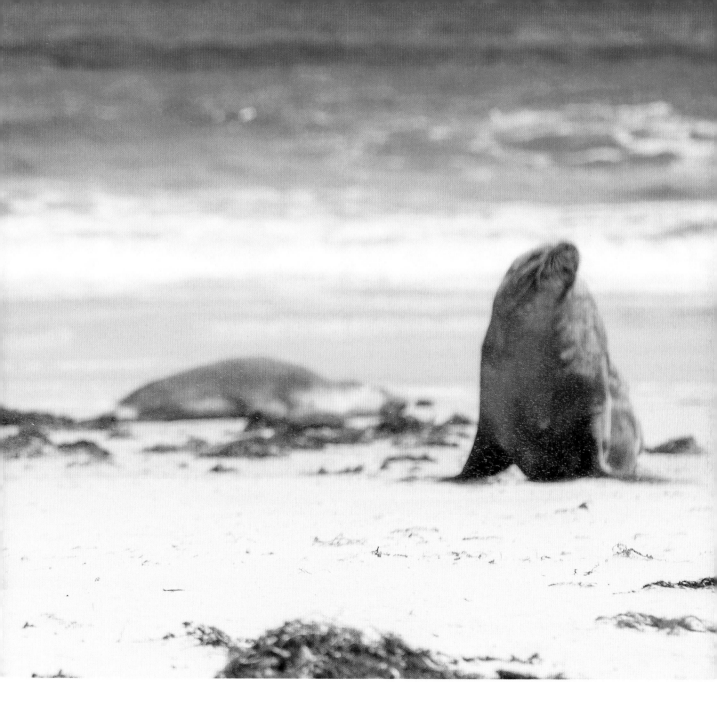

South Australia

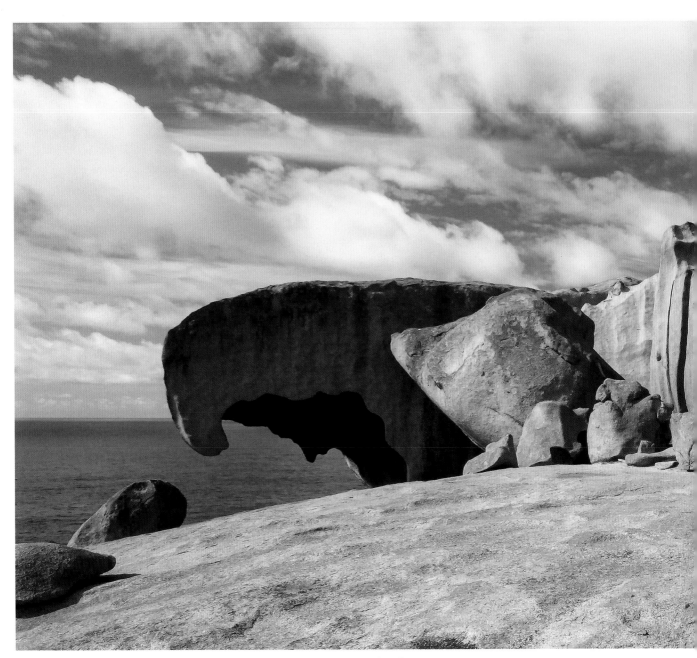

Flinders Chase National Park › Remarkable Rocks on Kangaroo Island

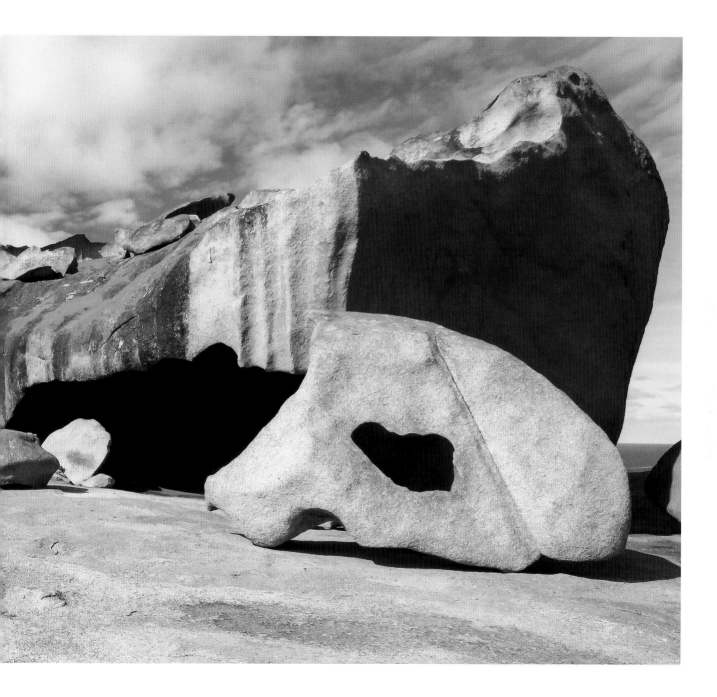

South Australia

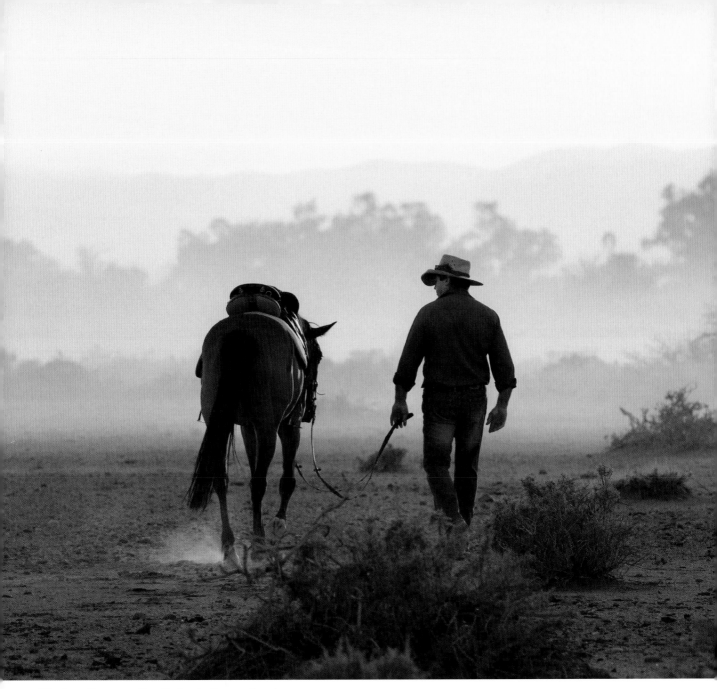

Flinders Ranges › South Australian outback

South Australia

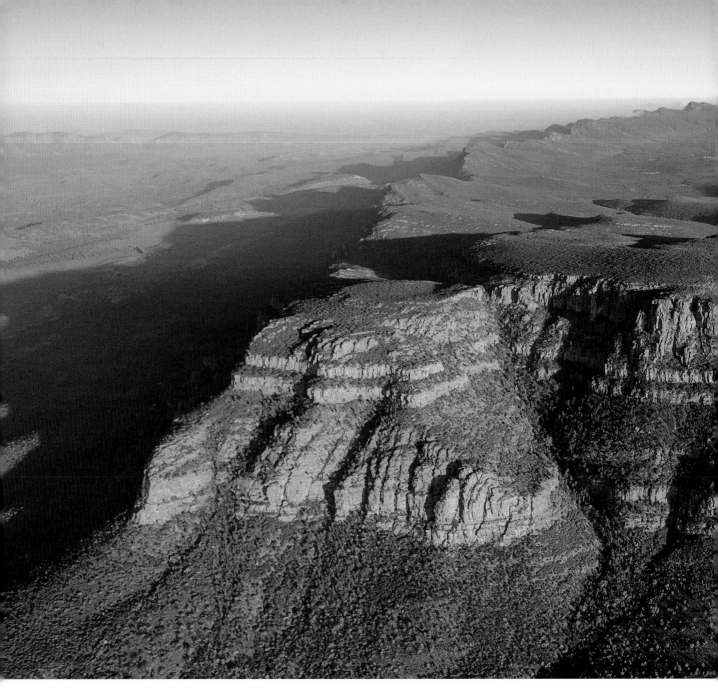

Flinders Ranges › Ikara (Wilpena Pound)

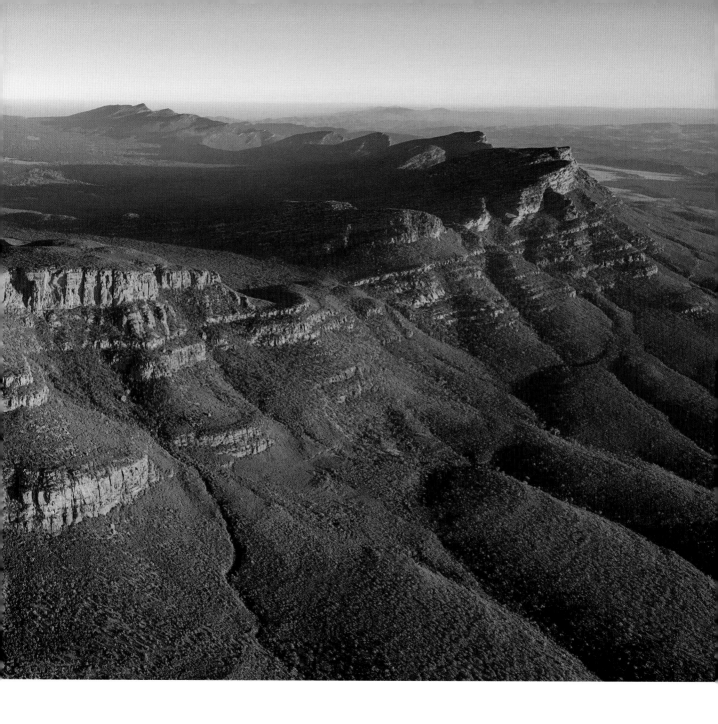

South Australia

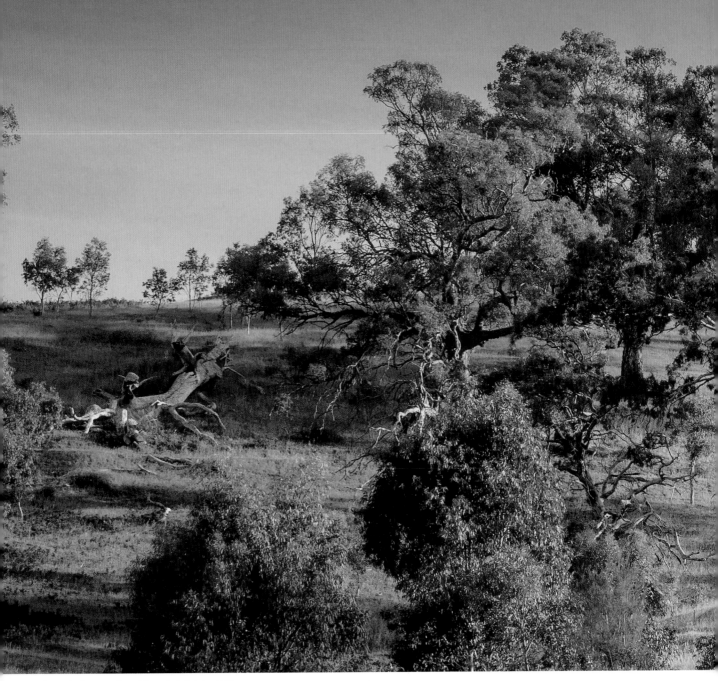

South Australia › The Adelaide Hills

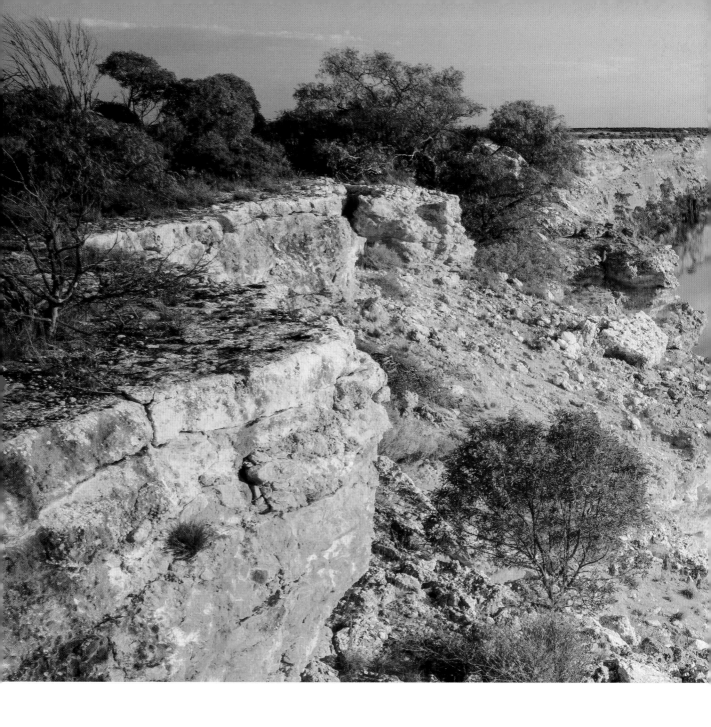

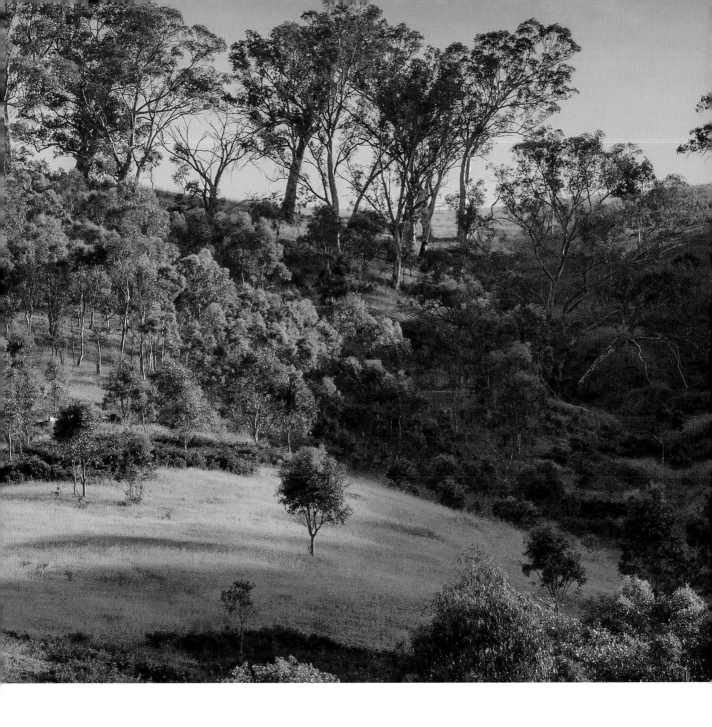

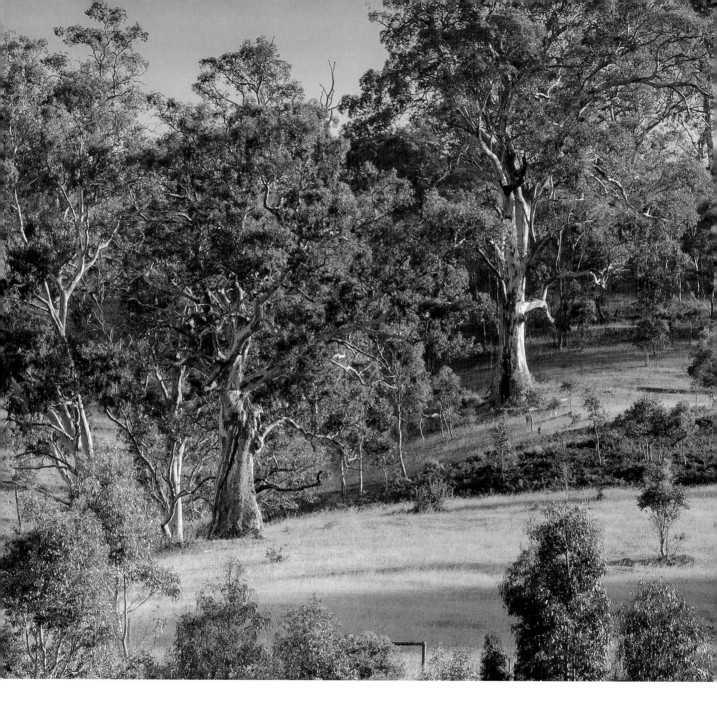

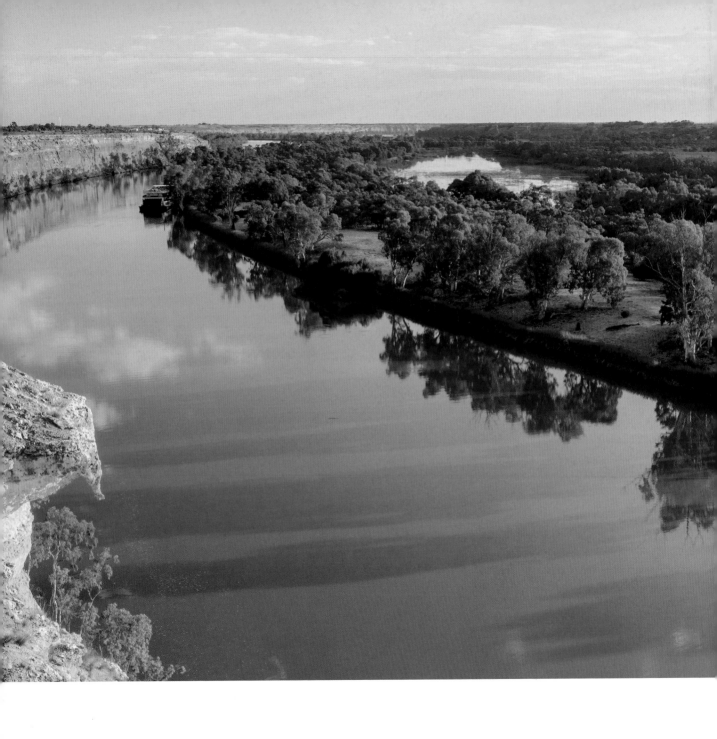

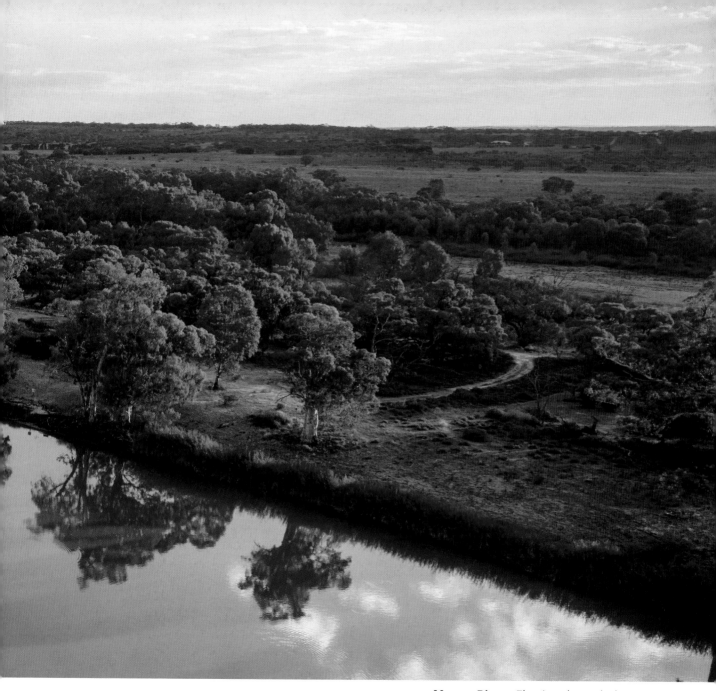

Murray River › Flowing through three states

South Australia

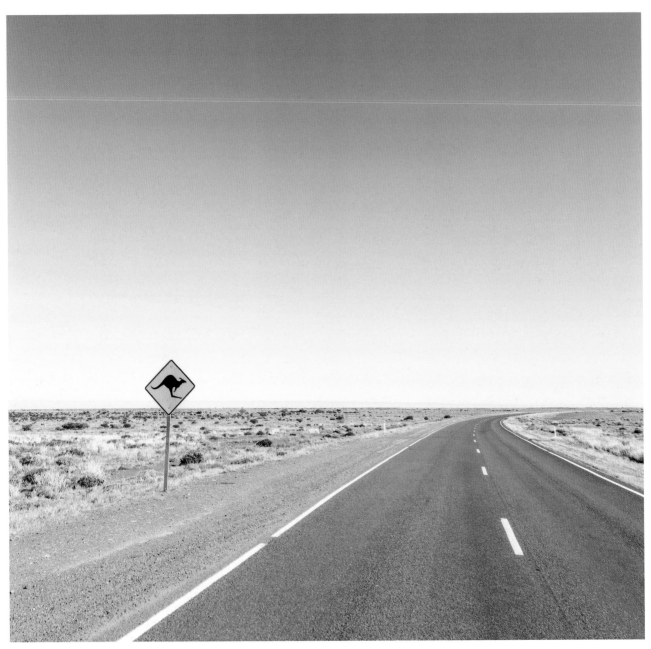

Coober Pedy › Road wildlife

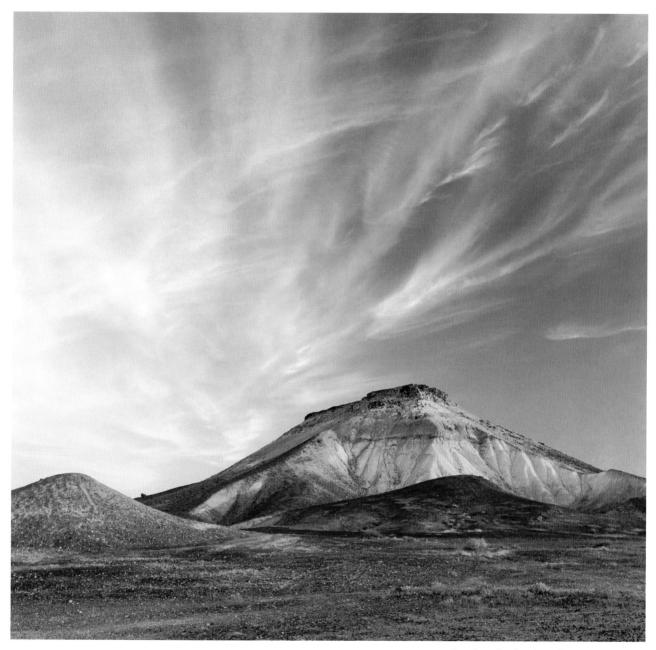

Coober Pedy › Breakaways Reserve

South Australia

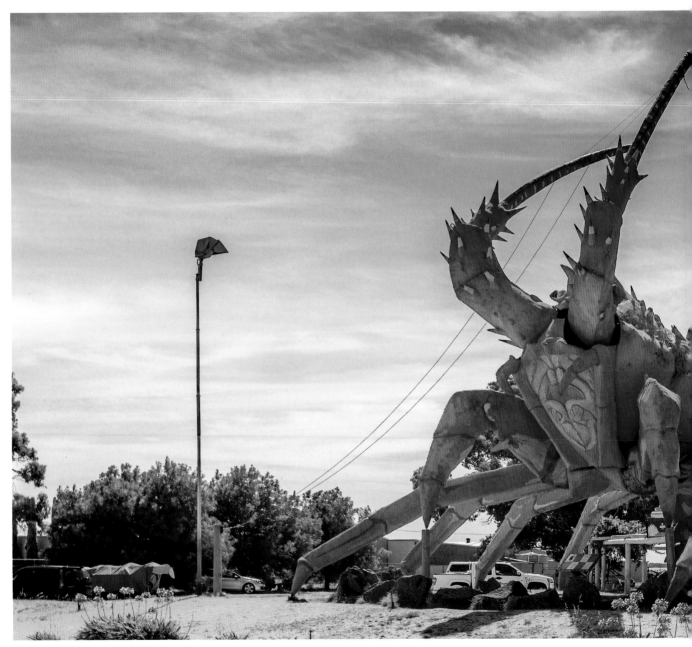

Kingston SE › Larry the (big) Lobster

South Australia

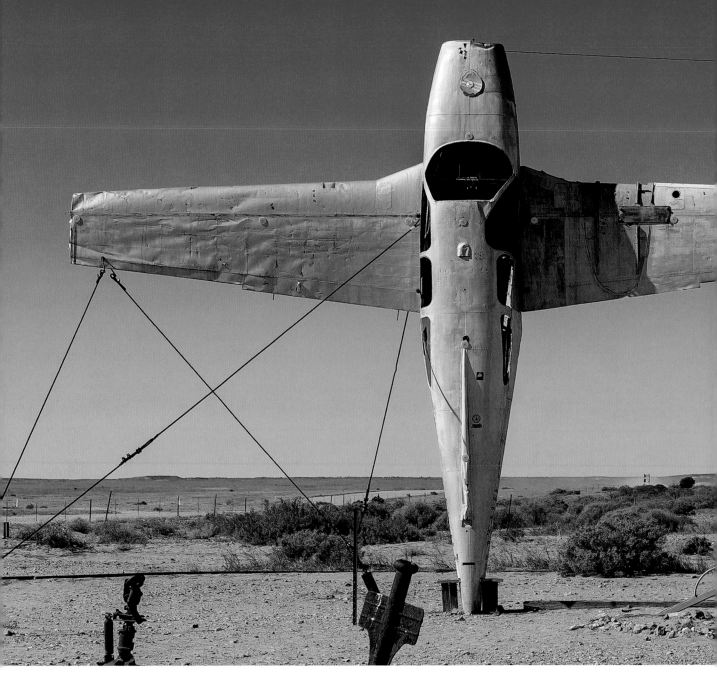

Oodnadatta Track › Planehenge by Robin Cooke at Mutonia Sculpture Park

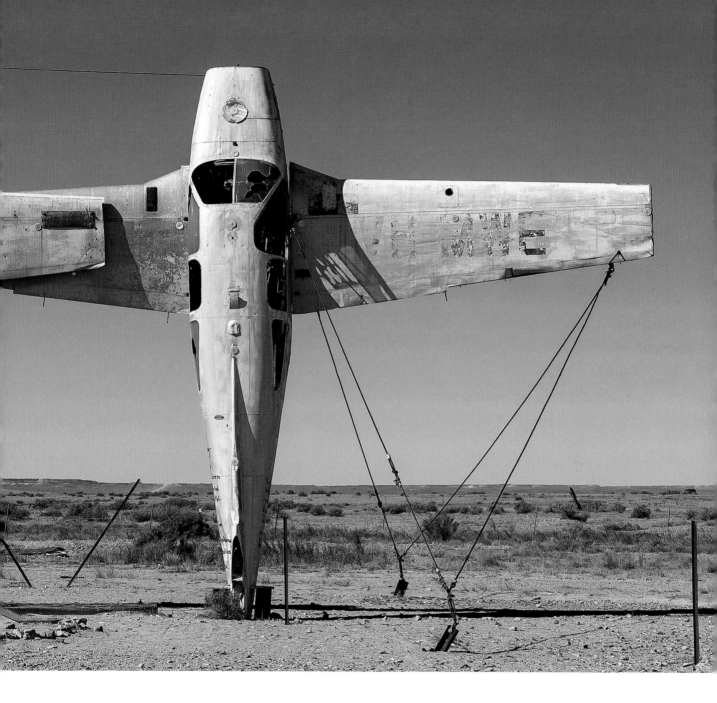

Hahndorf › Founded by Lutherans in the Adelaide Hills

South Australia

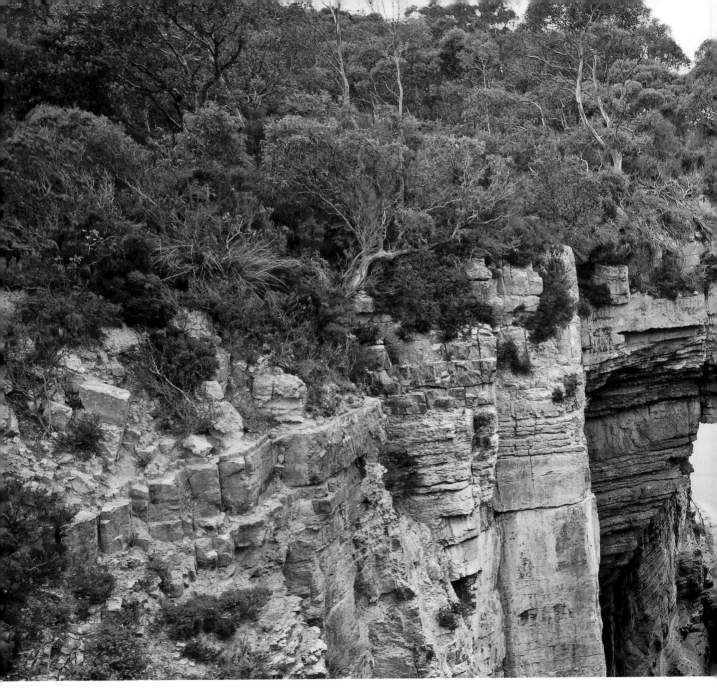

Tasman National Park › Tasman Arch

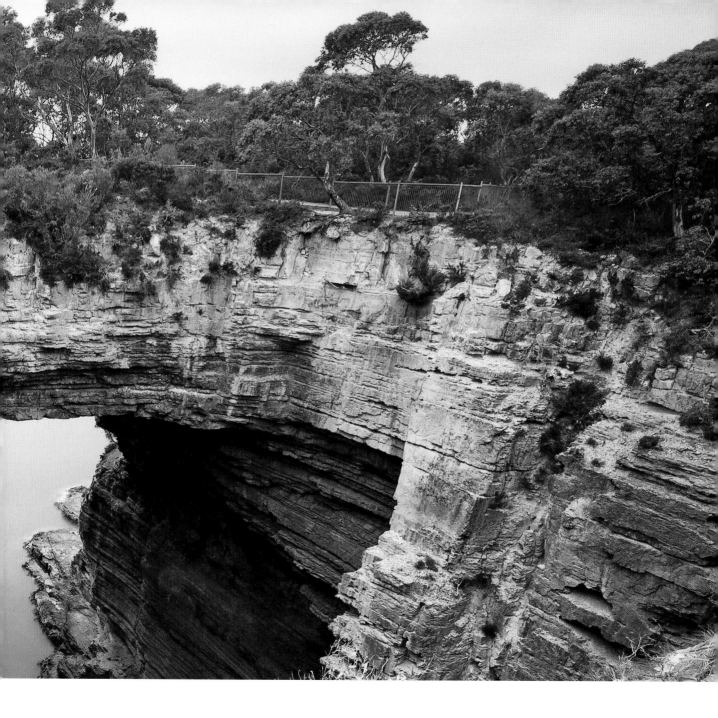

Tasmania

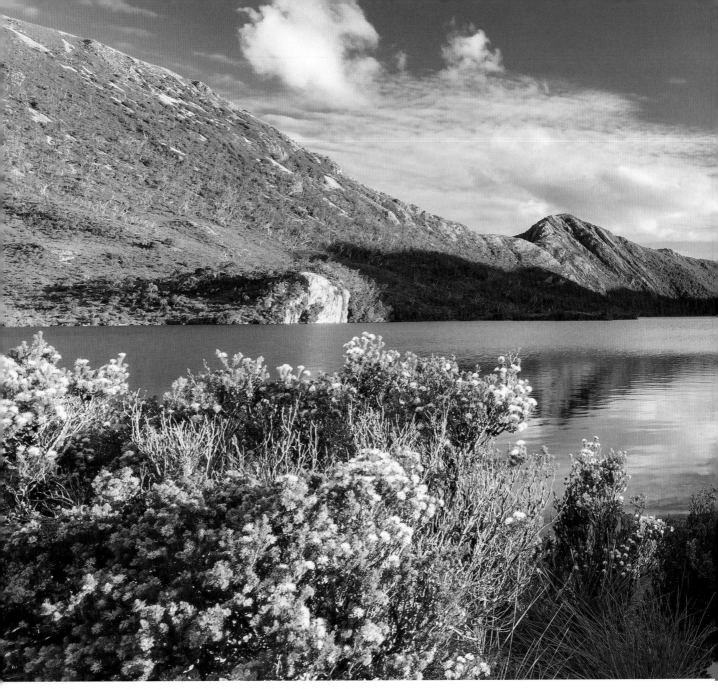

Cradle Mountain–Lake St Clair National Park › Dove Lake

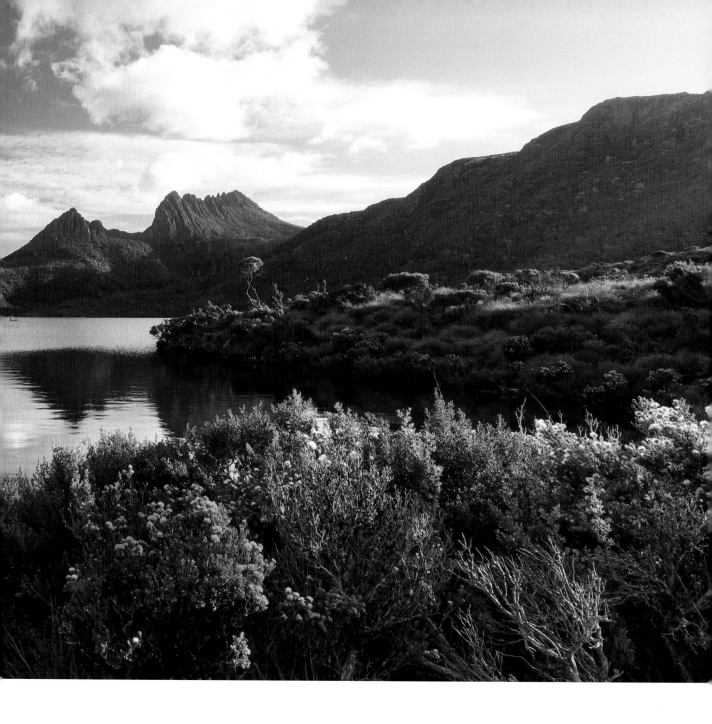

Tasmania

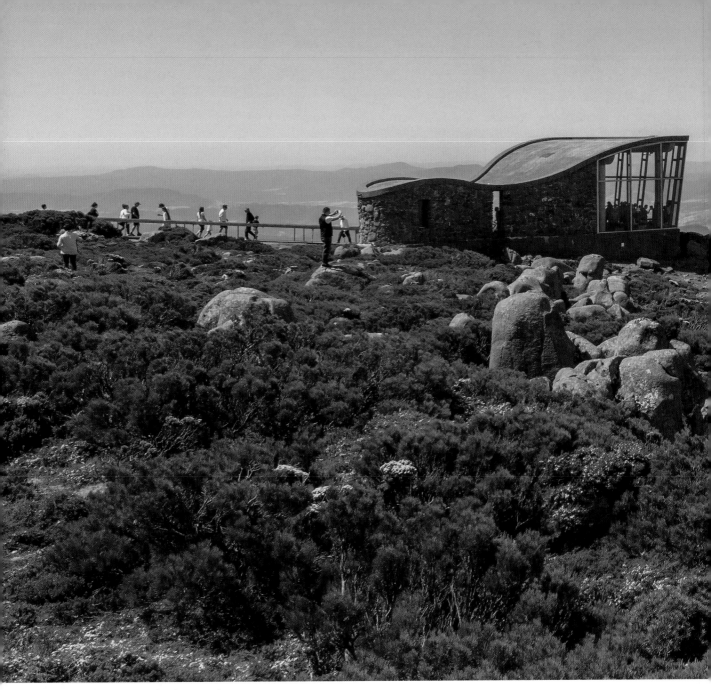

Mt Wellington › Overlooking Hobart

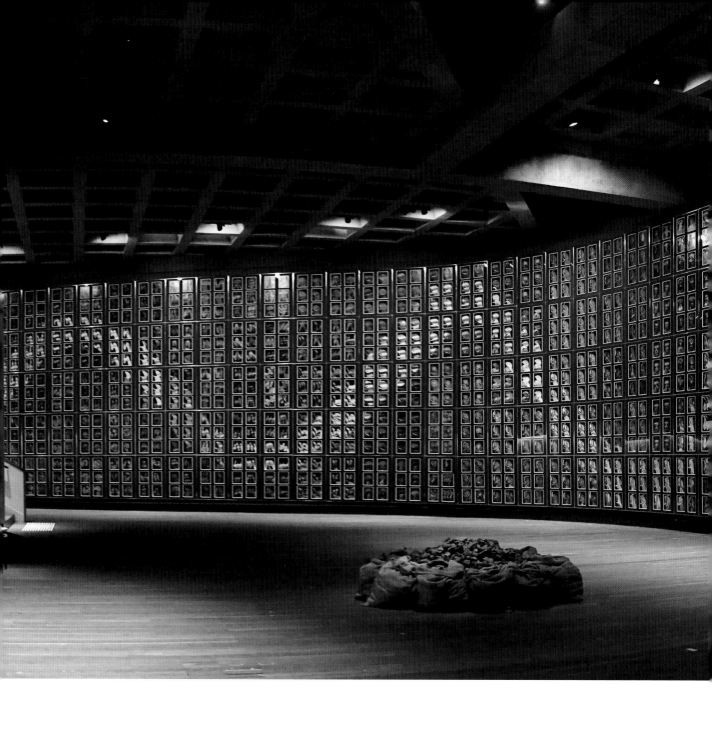

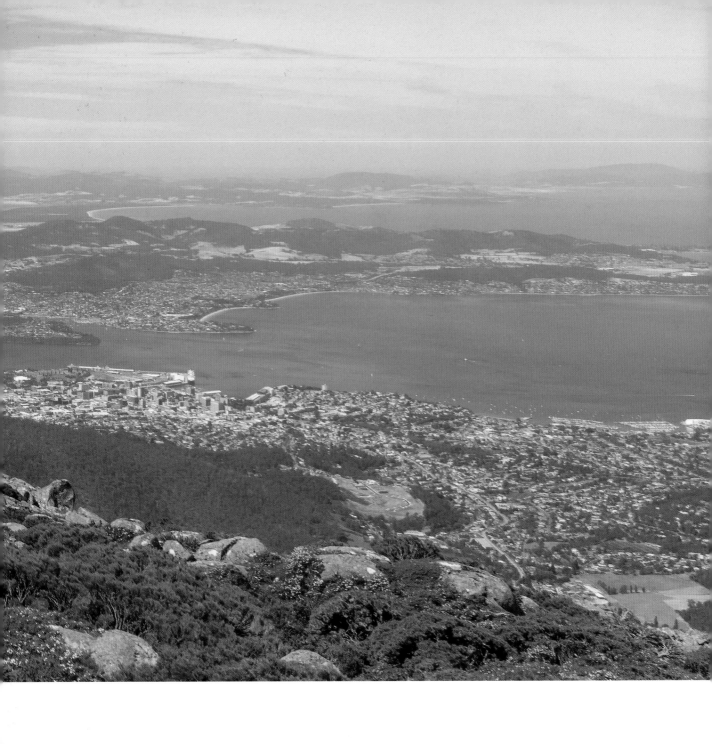

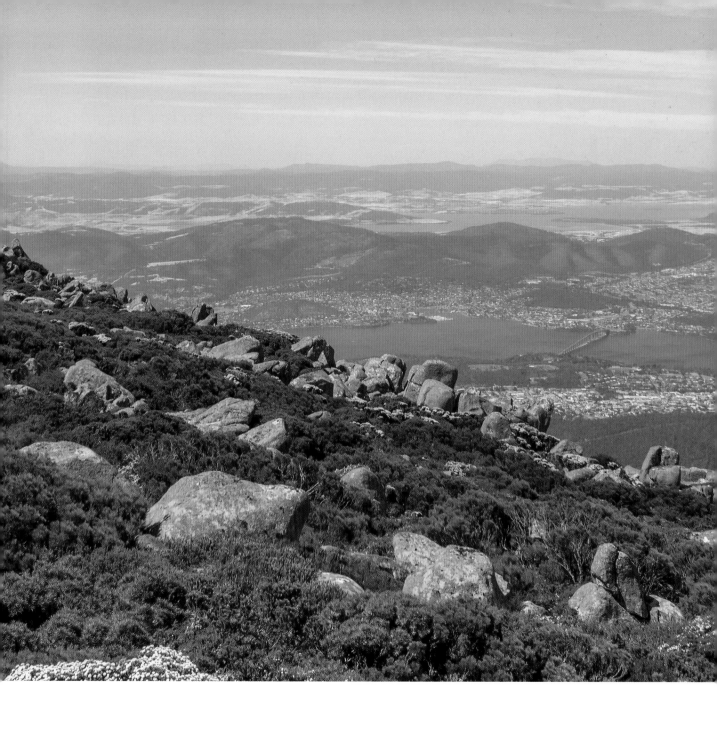

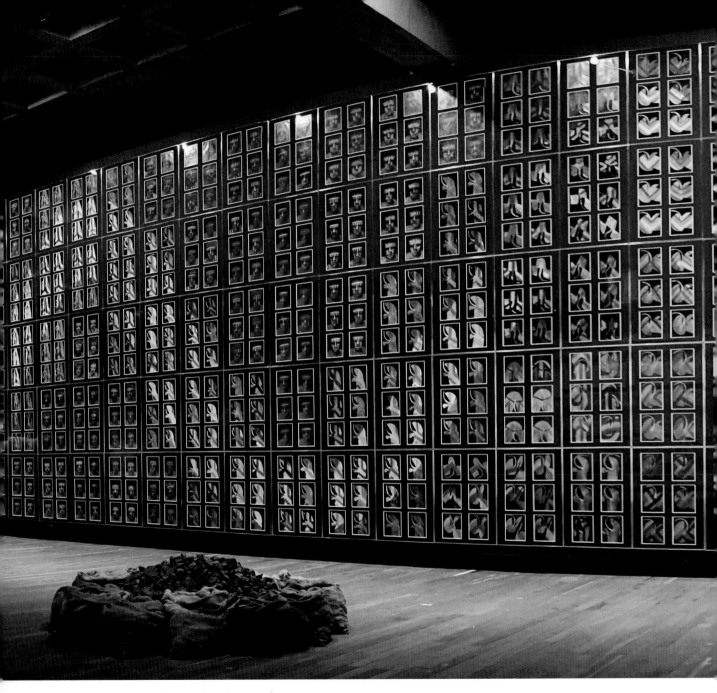

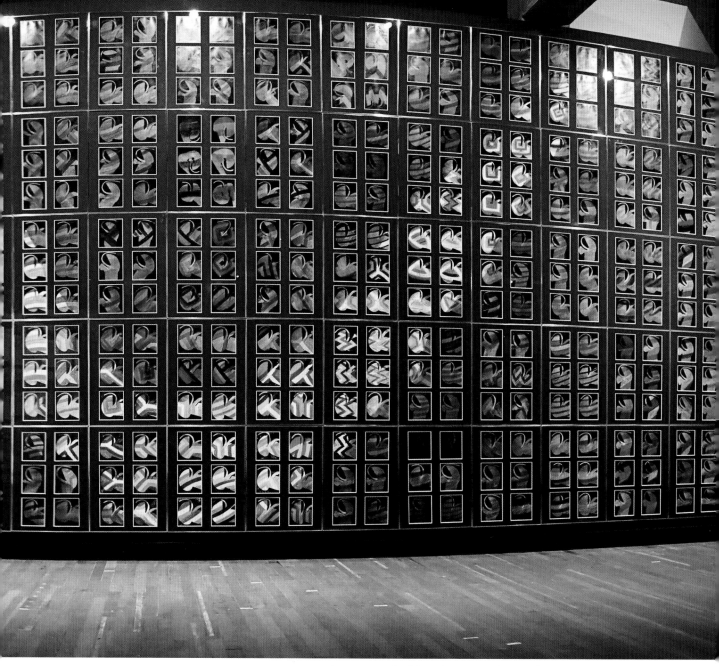

Museum of Old and New Art (MONA) › *Snake* by Sidney Nolan

Tasmania

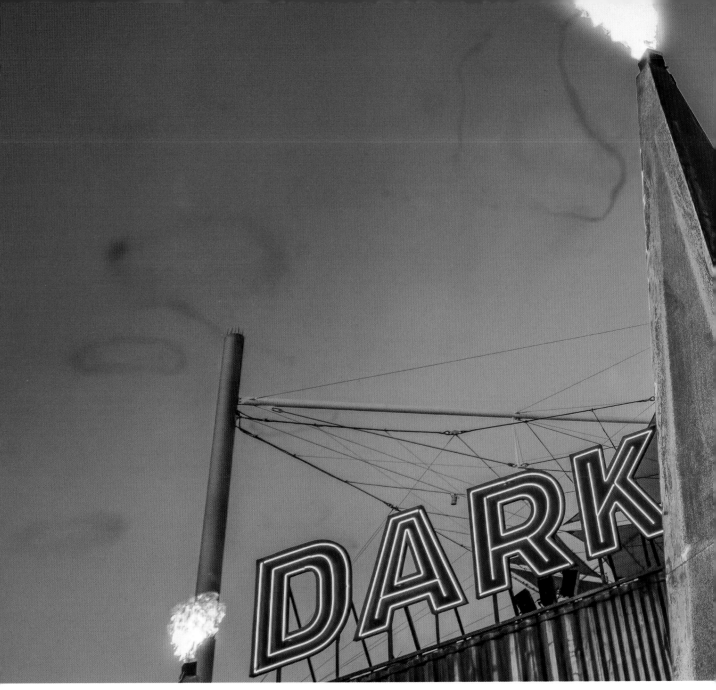

Hobart › Winter's Dark MOFO festival

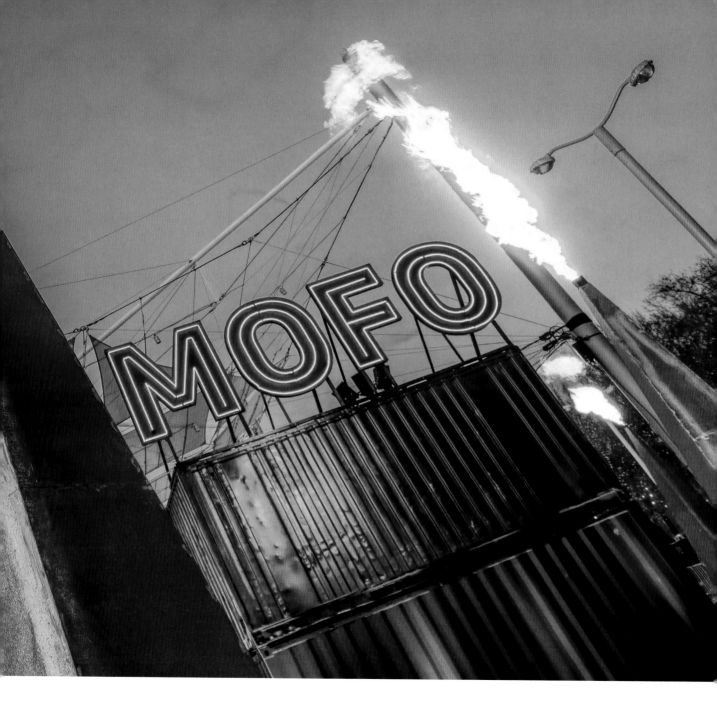

Tasmania

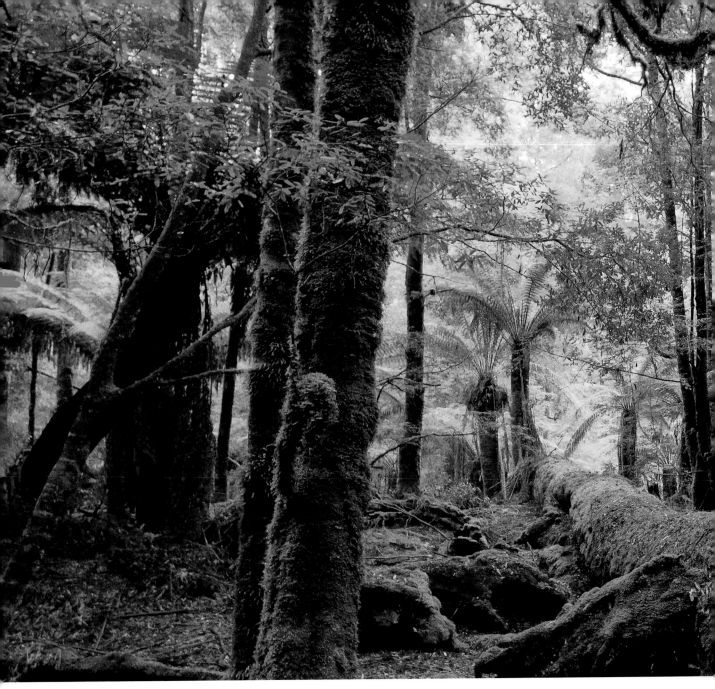

The Tarkine › Northwest wilderness

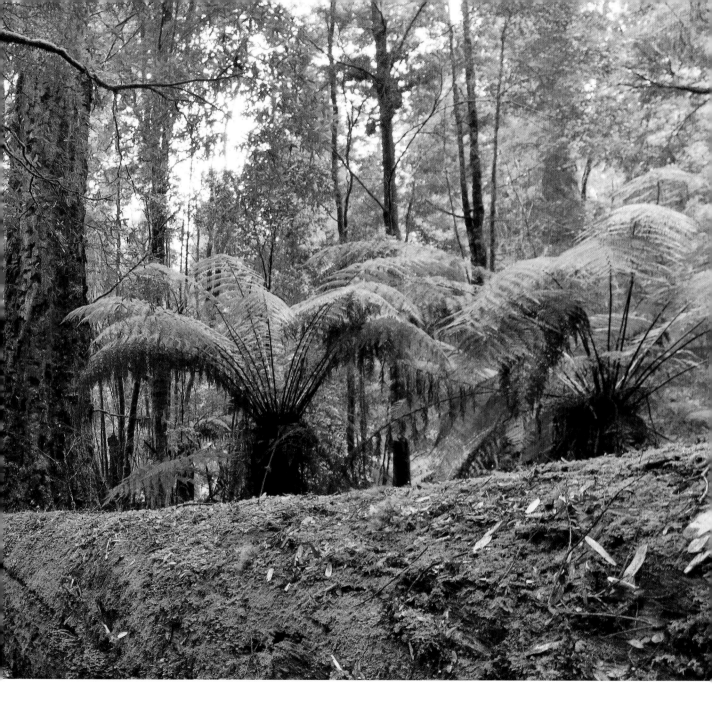

Tasmania

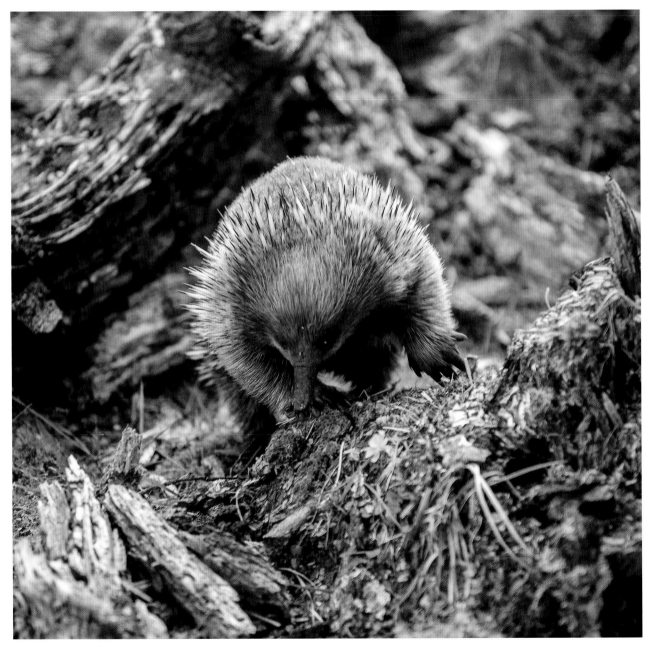

Tasmanian echidna › Meet a monotreme

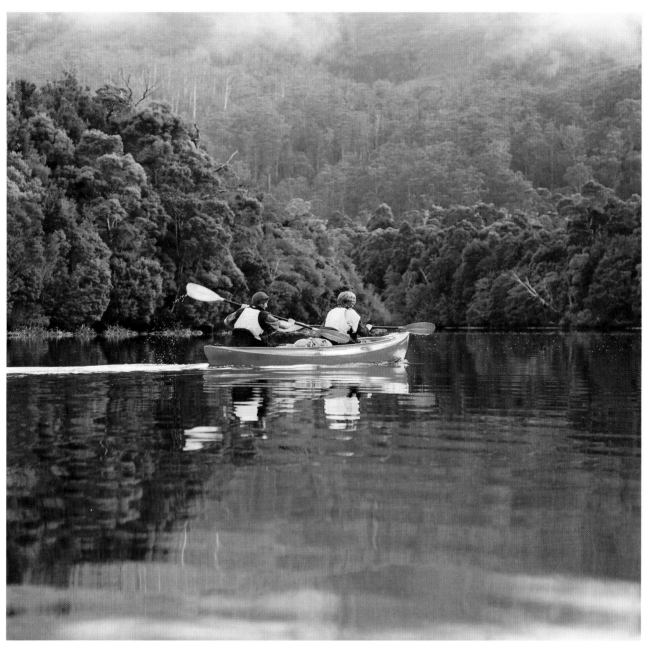

The Tarkine › Paddling the Pieman River

Tasmania

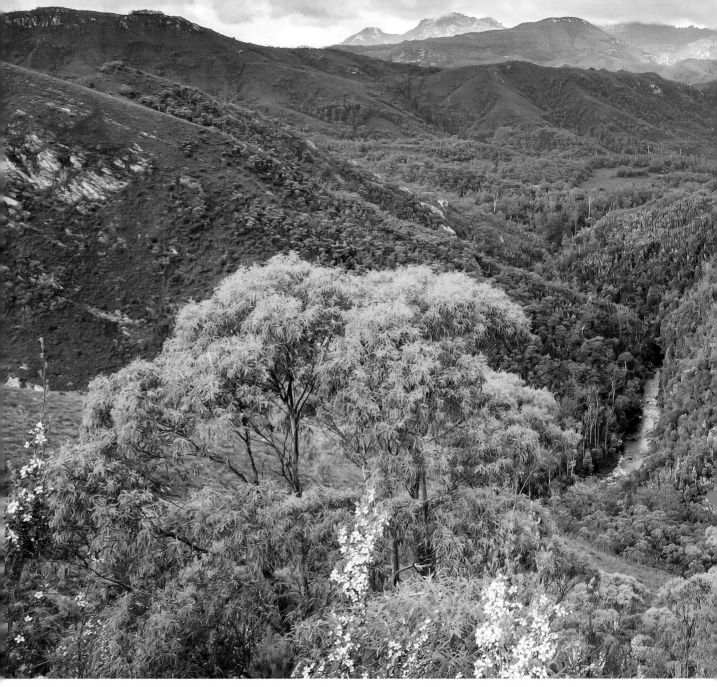

Franklin-Gordon Wild Rivers National Park › Part of the Tasmanian Wilderness World Heritage Area

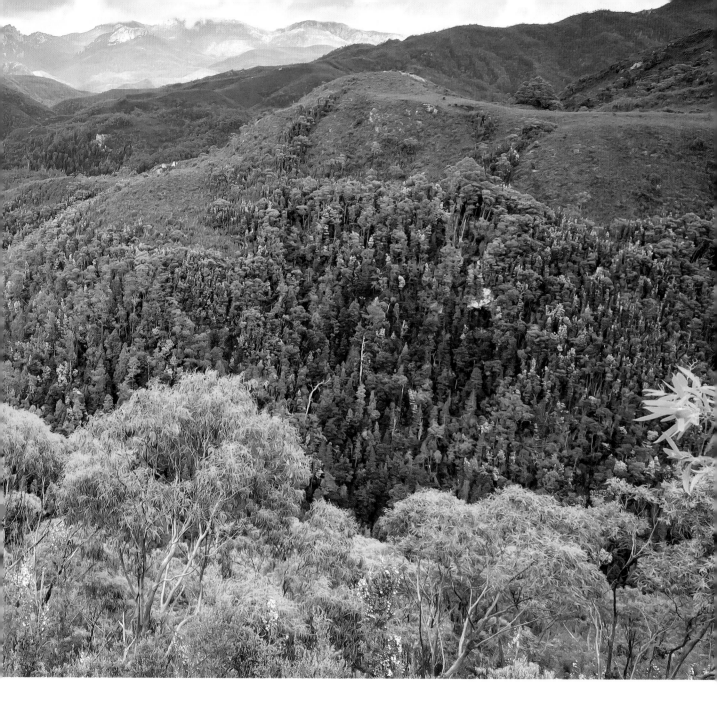

Tasmania

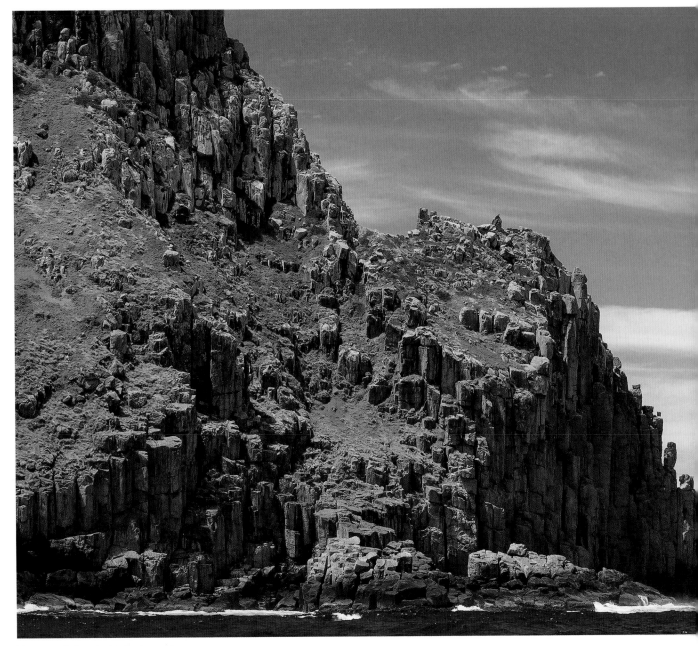

Tasman Island › Dolerite columns

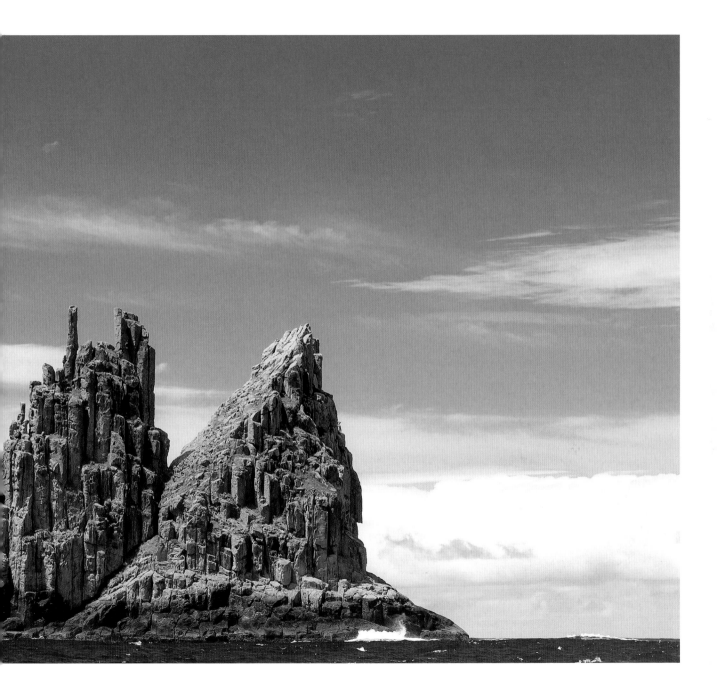

Tasmania

Cape Huay › Climbing the Totem Pole

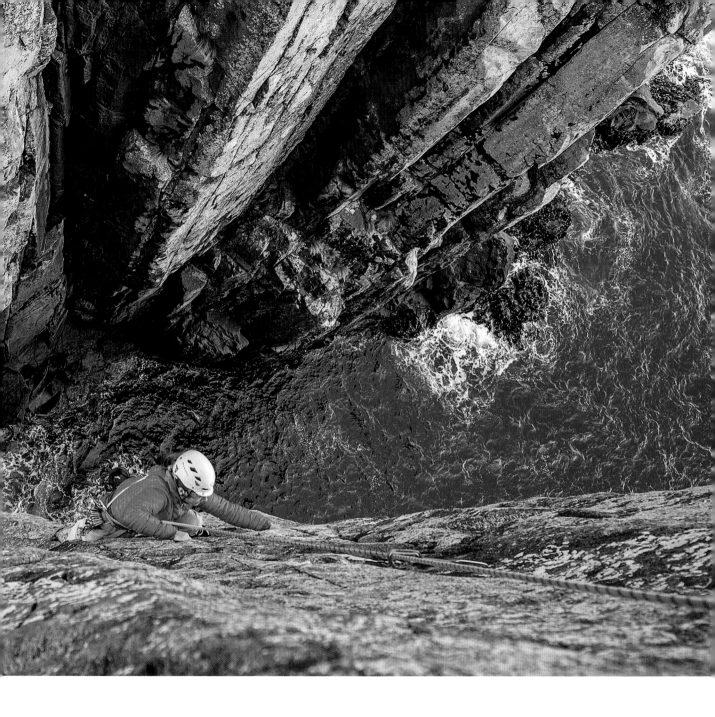

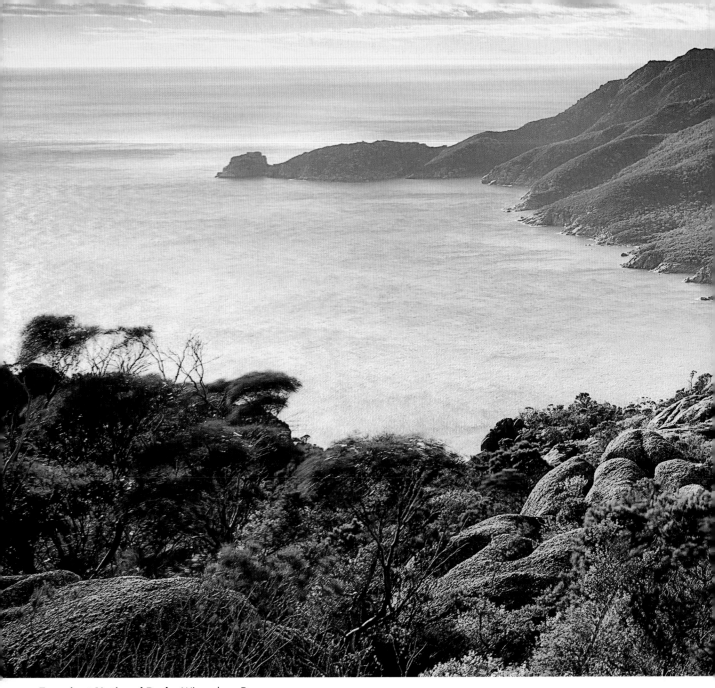

Freycinet National Park › Wineglass Bay

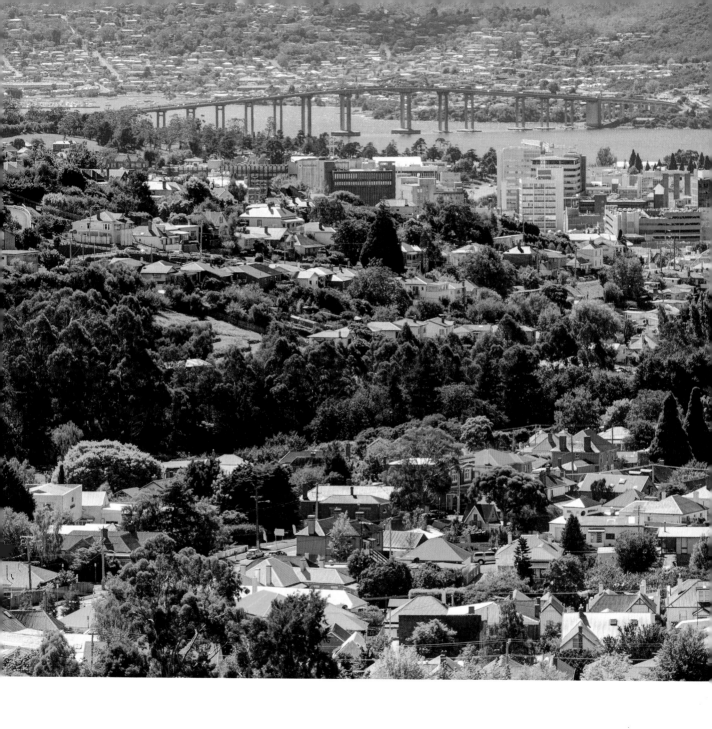

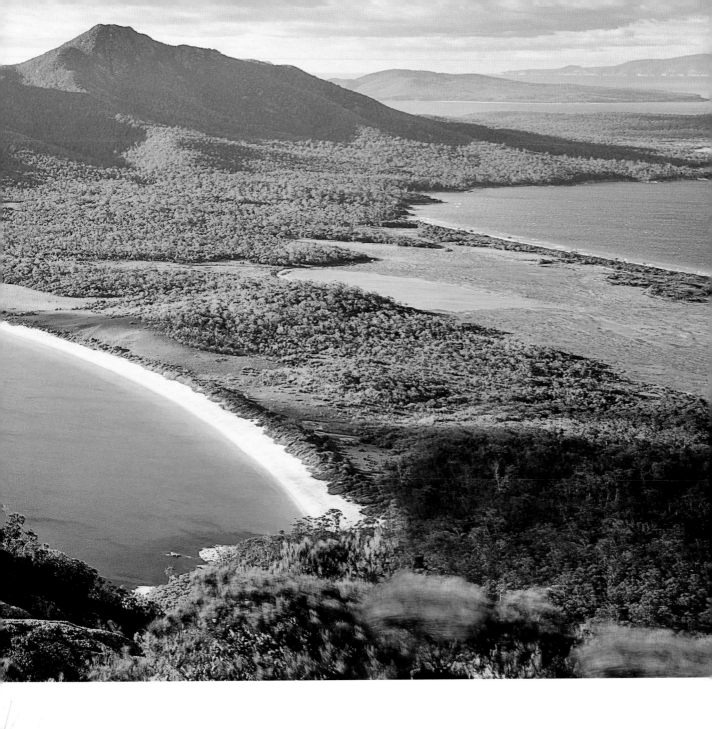

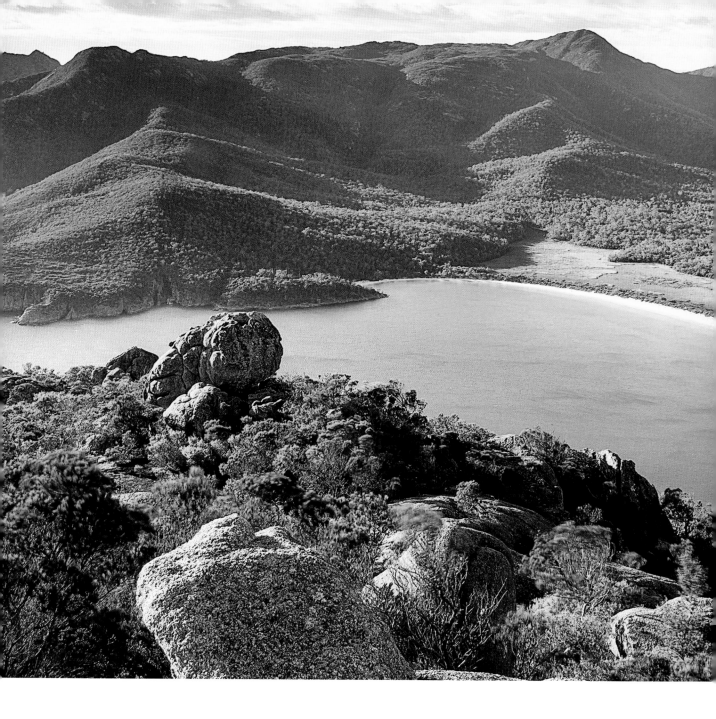

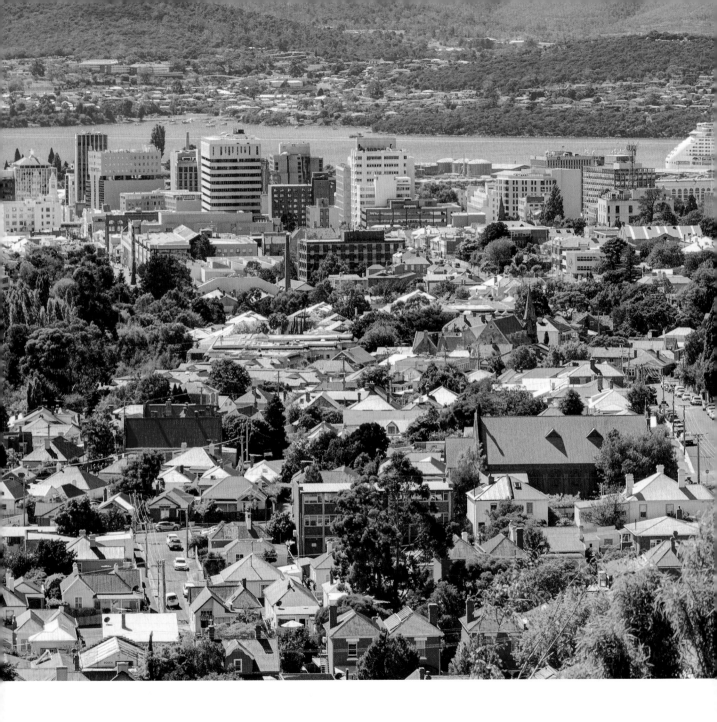

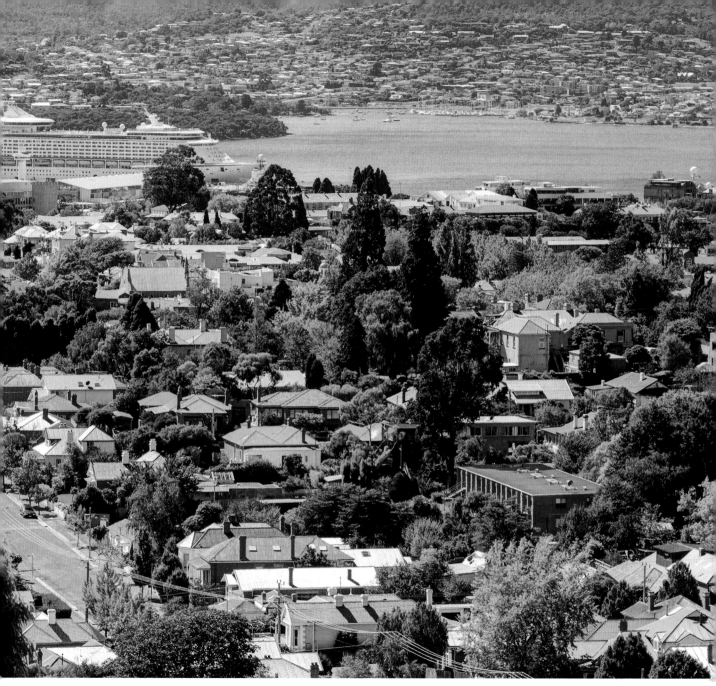

Hobart › Small-scale state capital

Tasmania

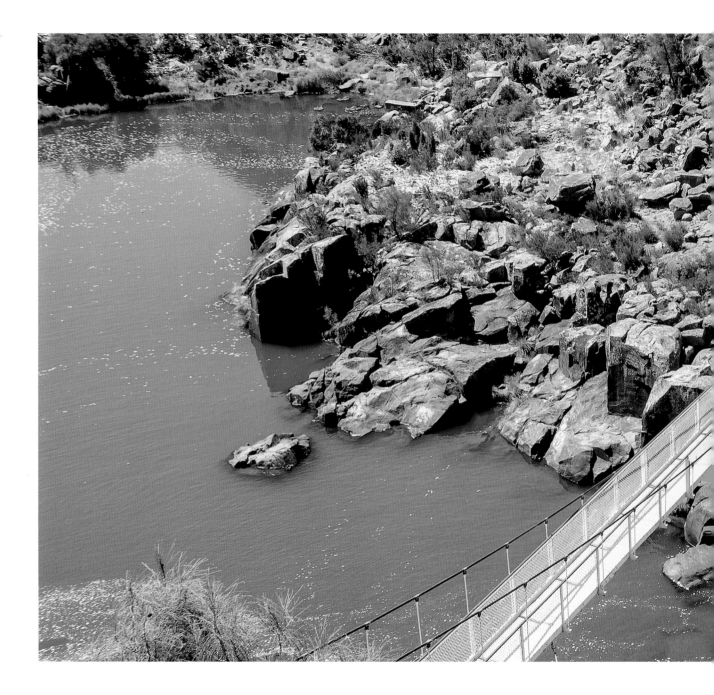

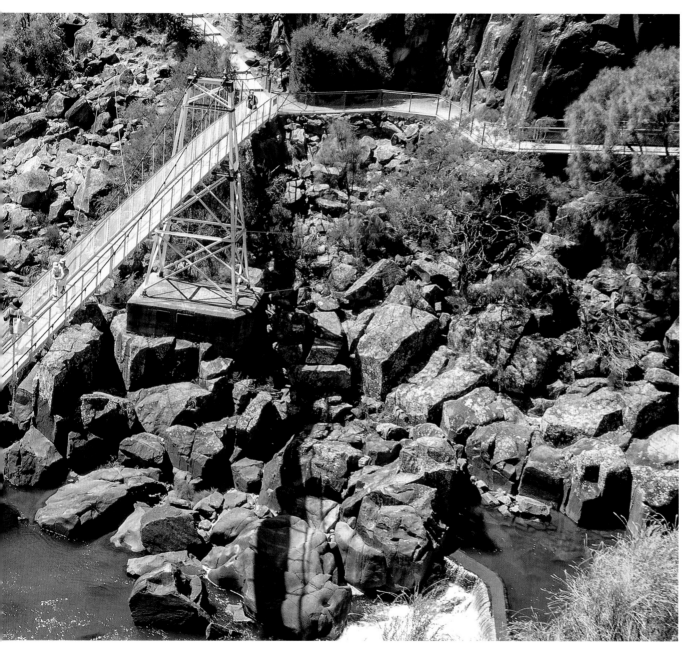

Cataract Gorge › Across the South Esk River

Tasmania

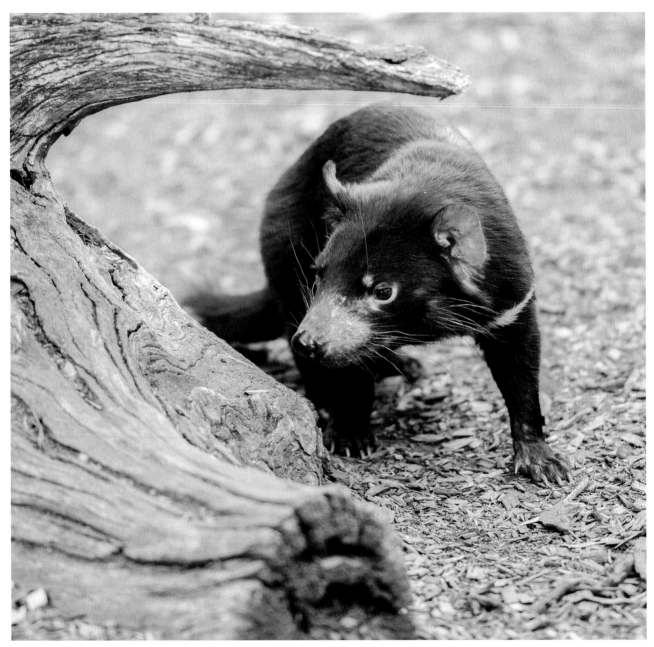

The Tasmanian Devil Conservation Park › Saving the devil

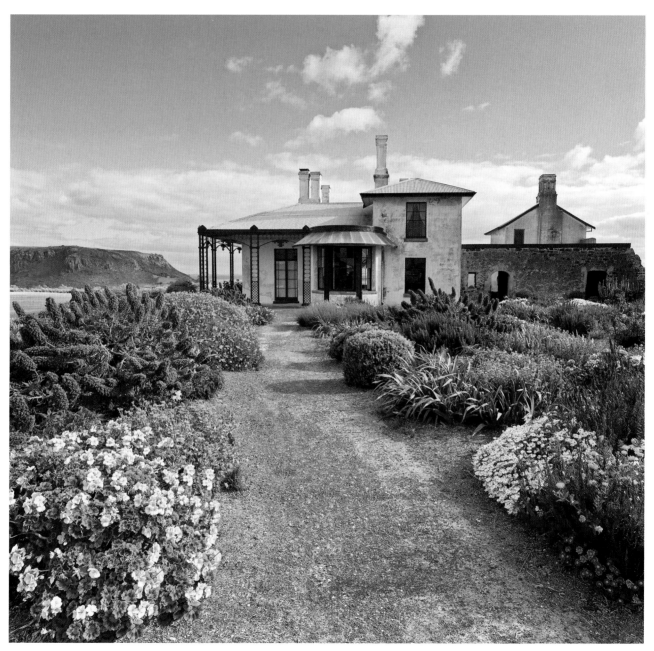

Stanley › Highfield Estate

Tasmania

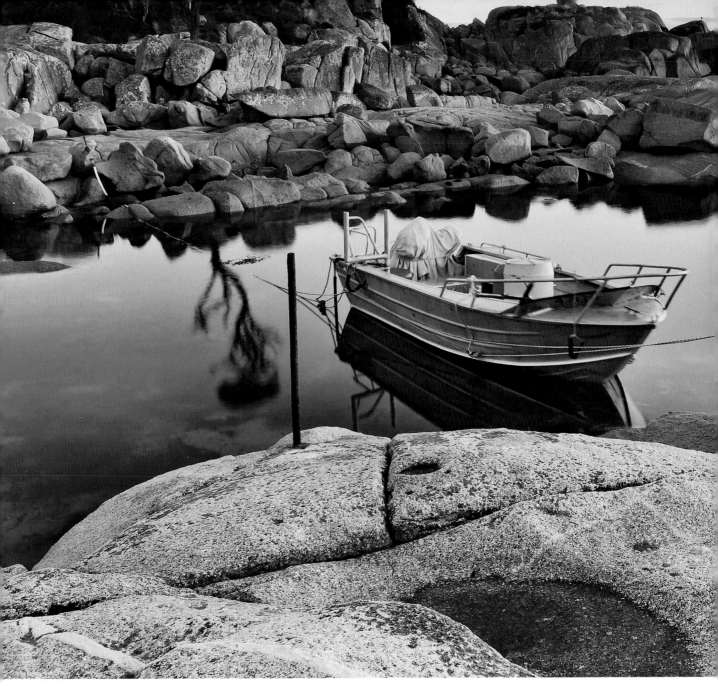

Bay of Fires Conservation Area › Binalong Bay

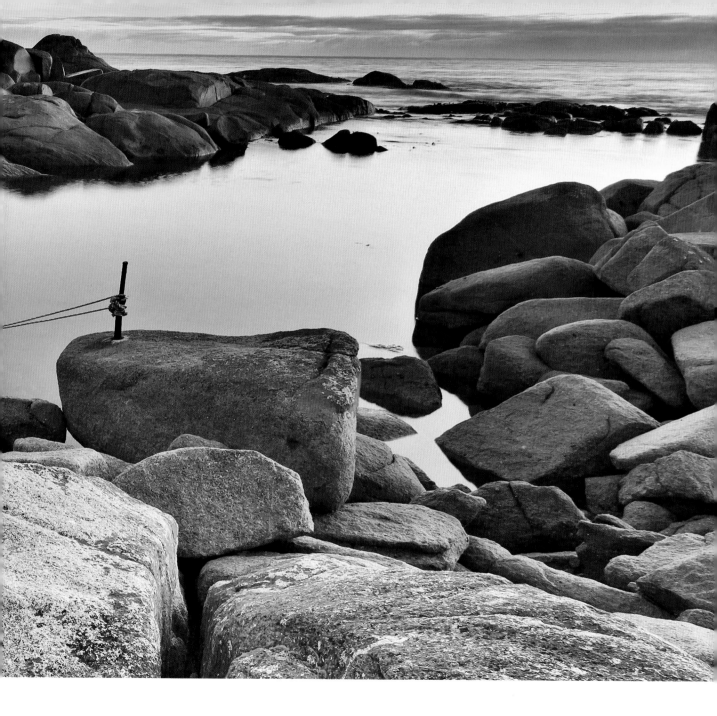

Tasmania

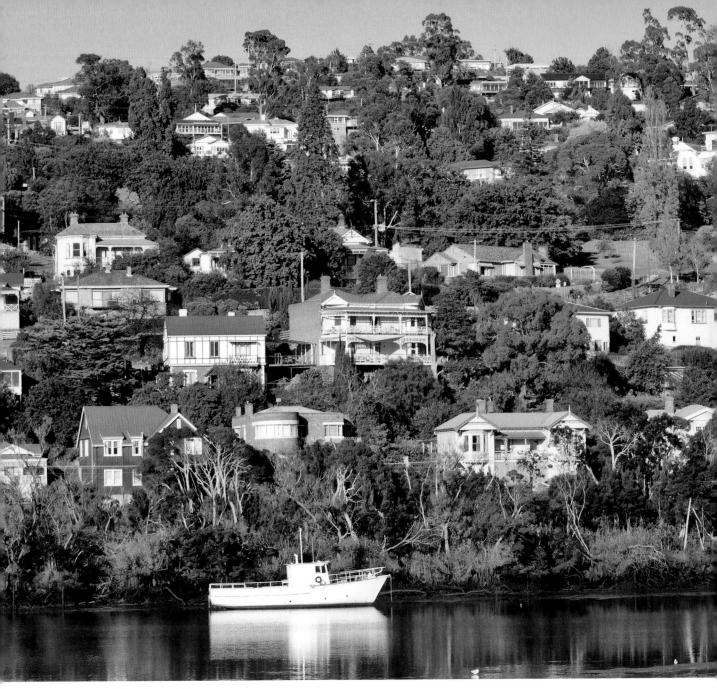

Launceston › The Tamar River

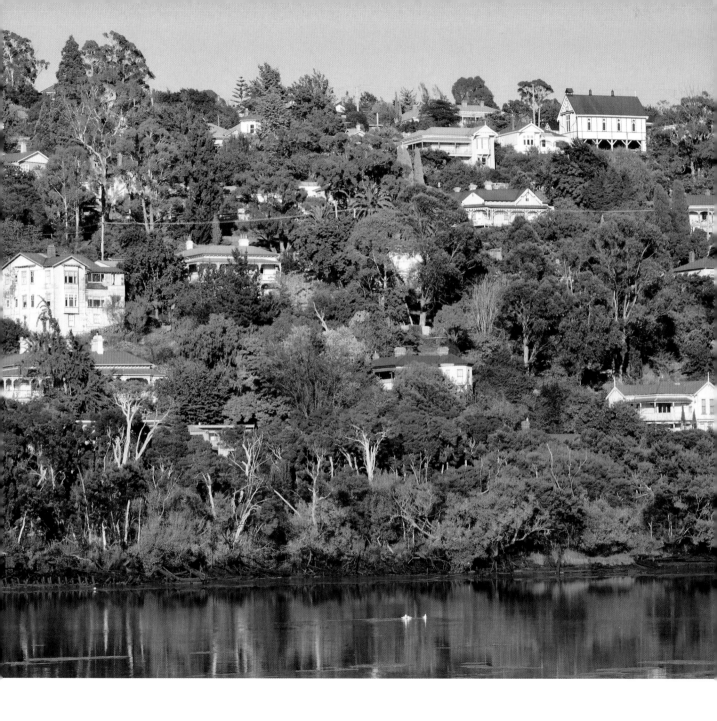

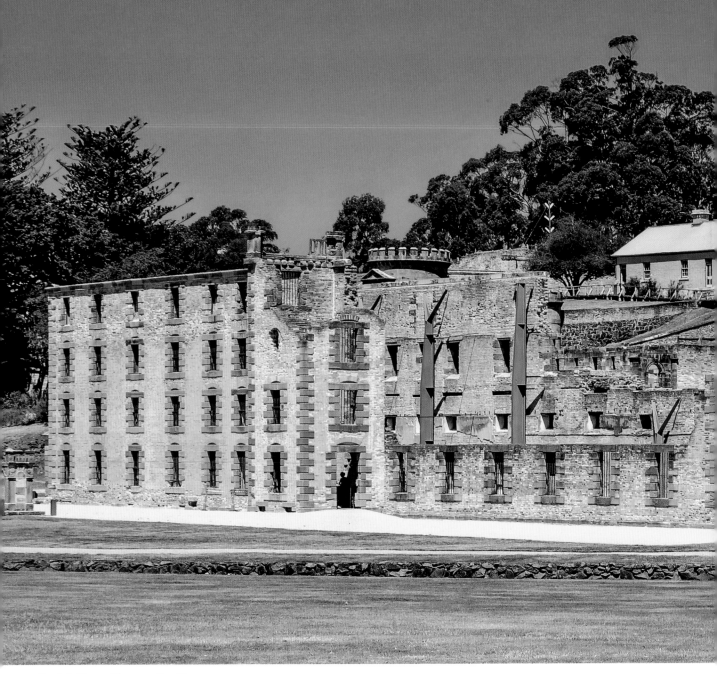

Port Arthur › The penitentiary

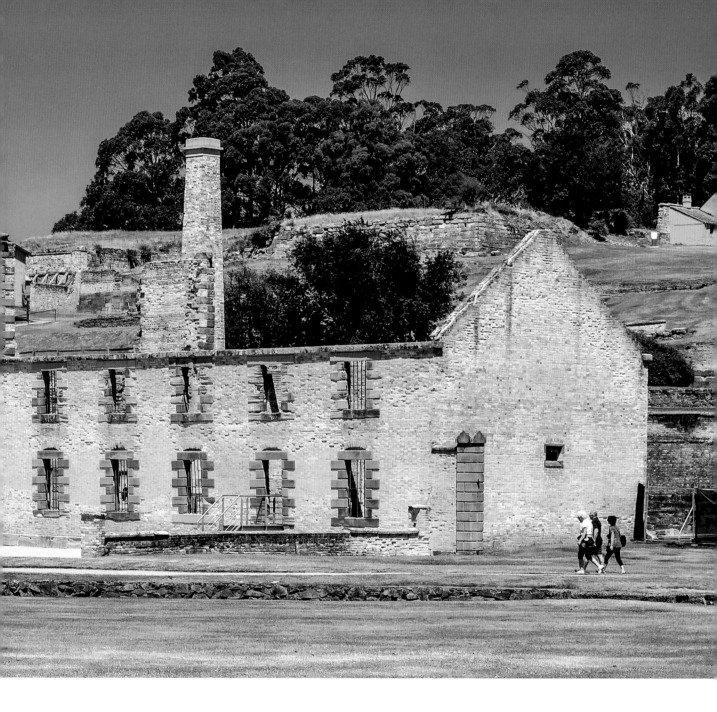

Tasmania

Huon Valley › The Apple Isle

Tasmania

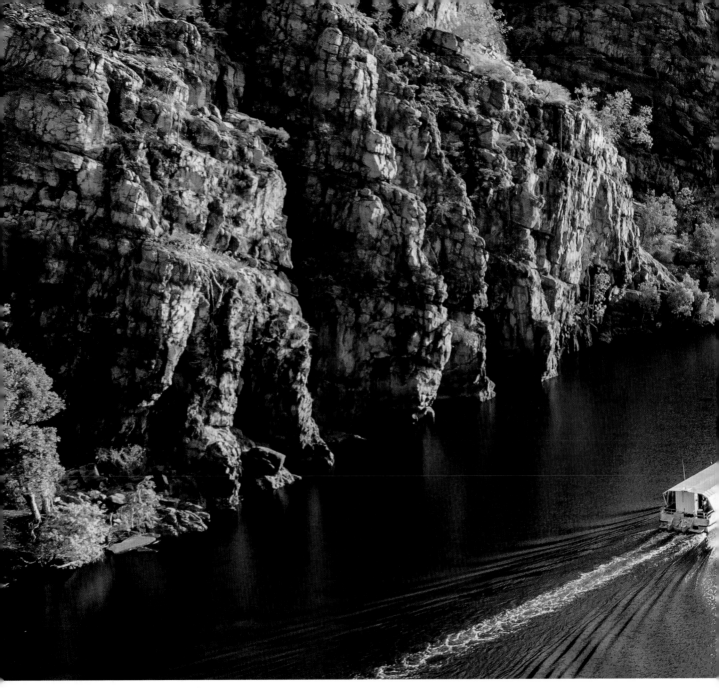

Nitmiluk National Park › Katherine Gorge

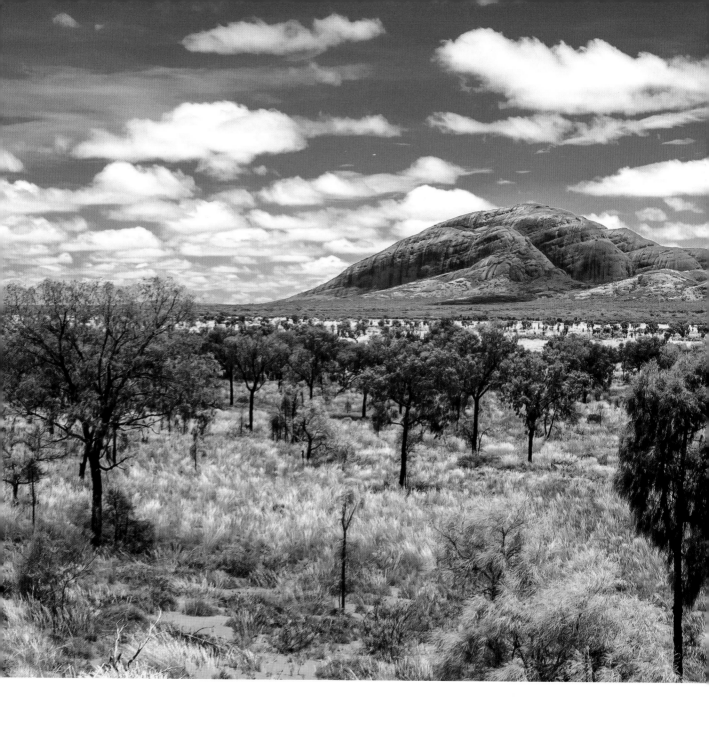

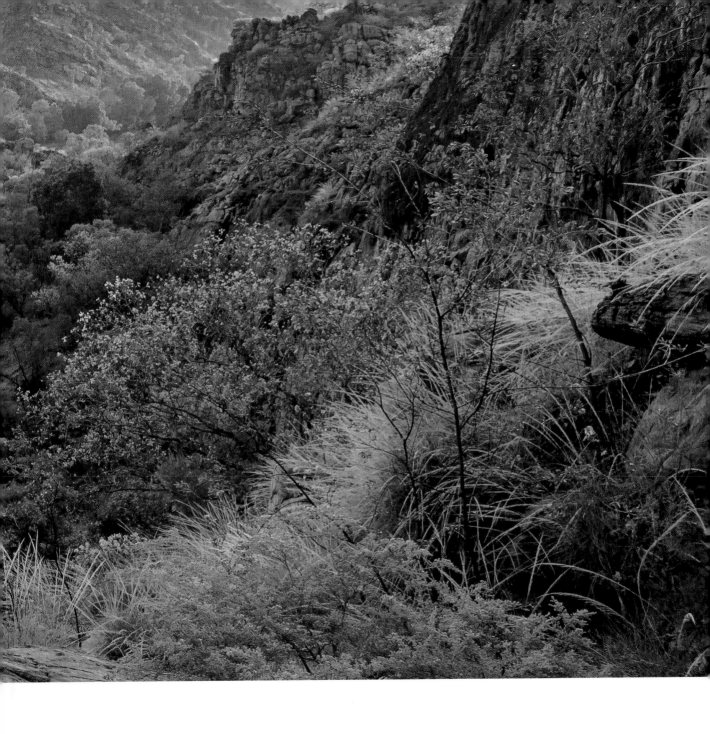

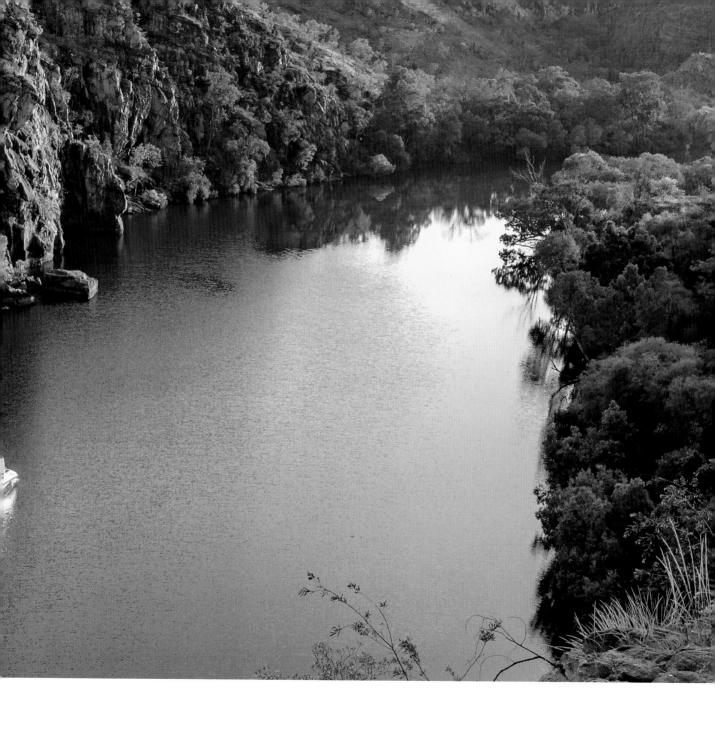

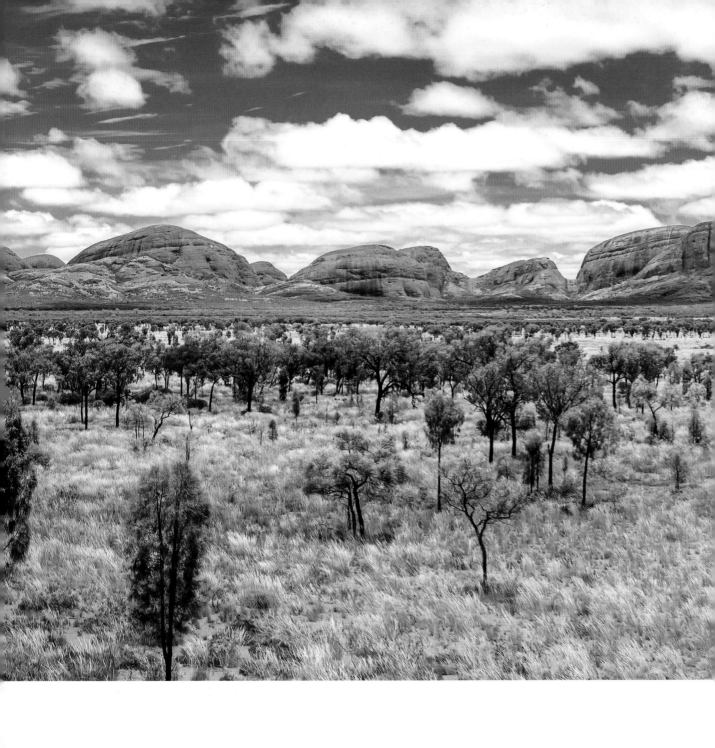

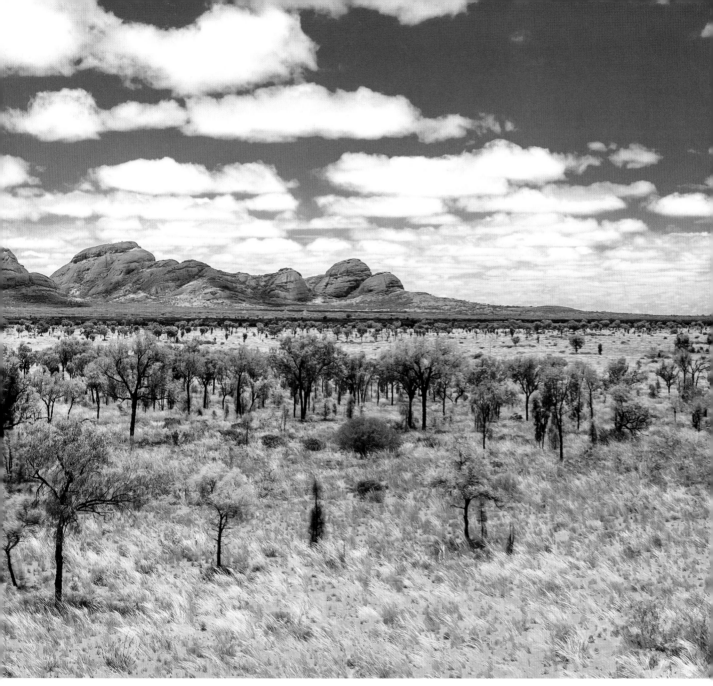

Uluru-Kata Tjuta National Park › Kata Tjuta

Northern Territory

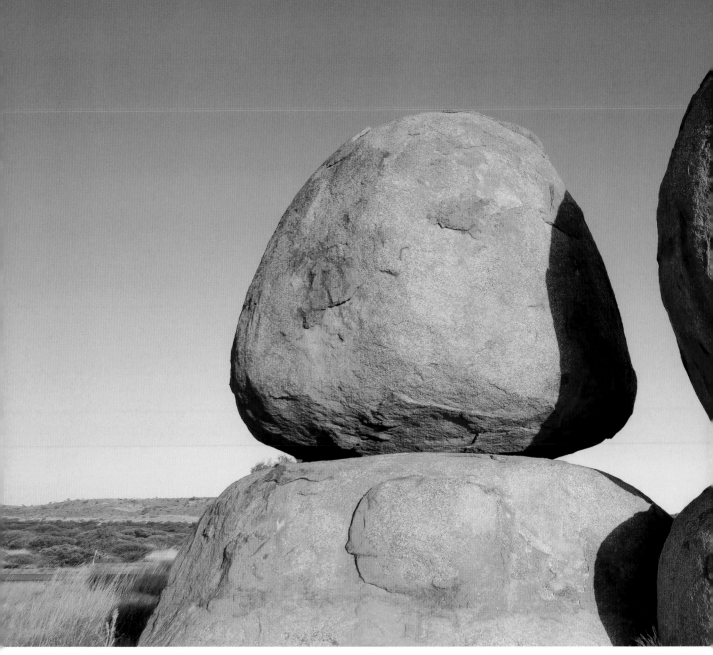

Devil's Marbles › Roadside rockery

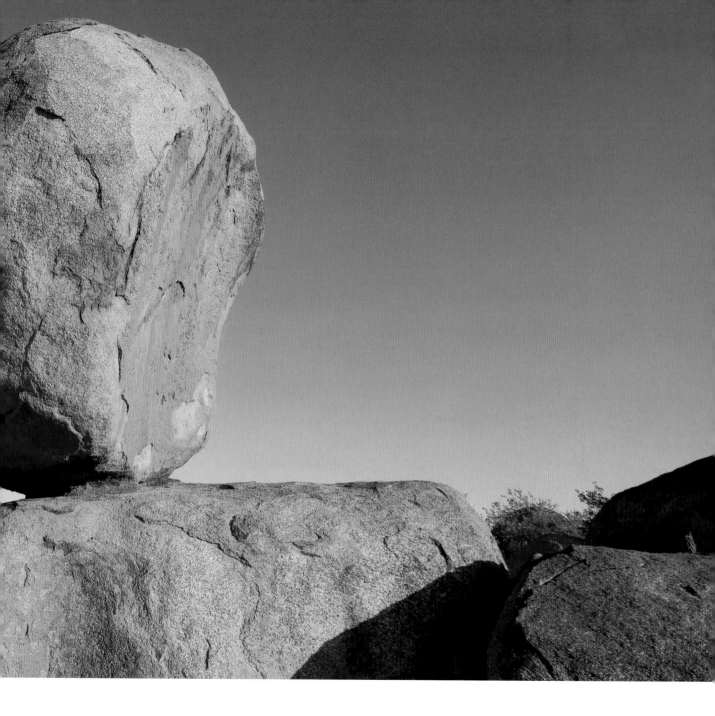

Northern Territory

Alice Springs › Indigenous culture

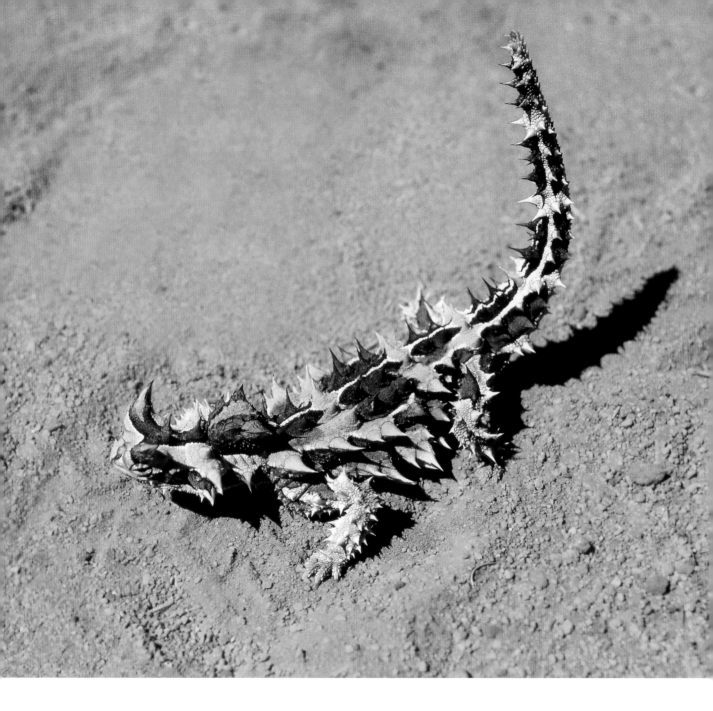

Northern Territory

MacDonnell Ranges › The Red Centre of the Northern Territory

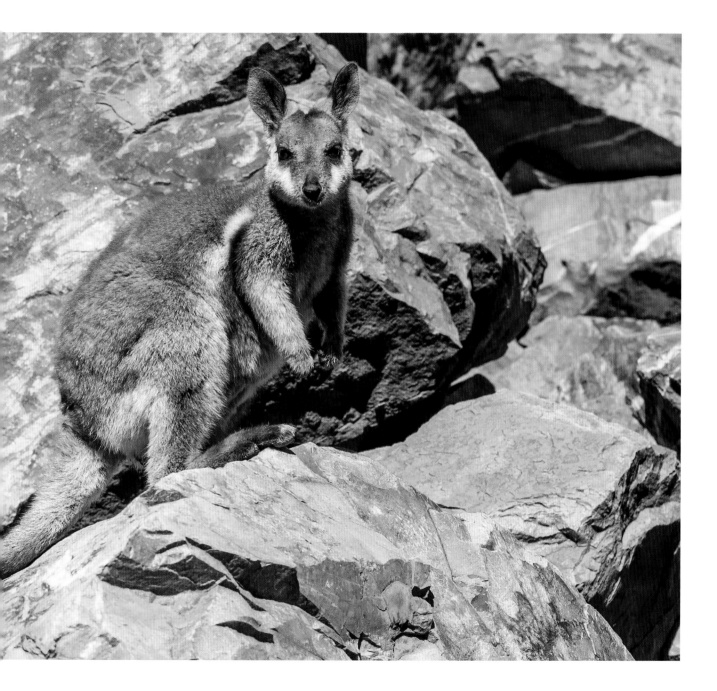

Northern Territory

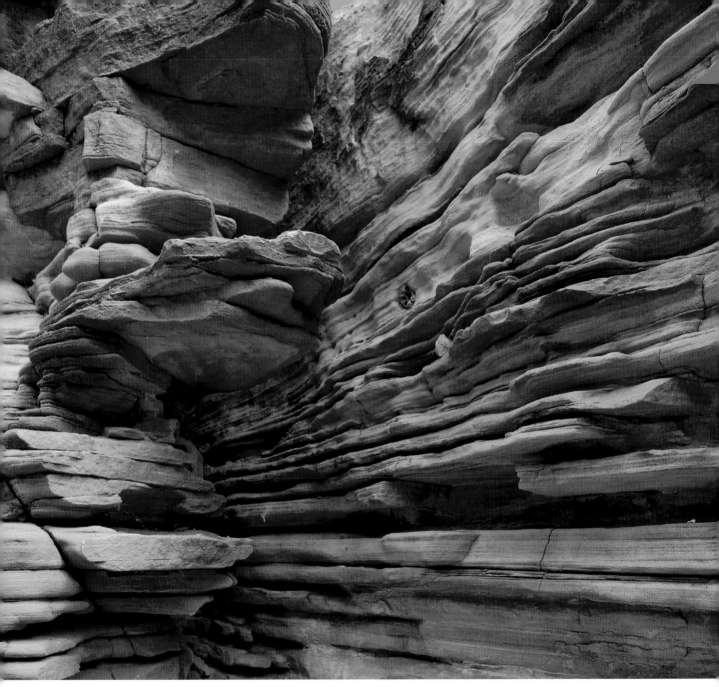

Watarrka National Park › Kings Canyon

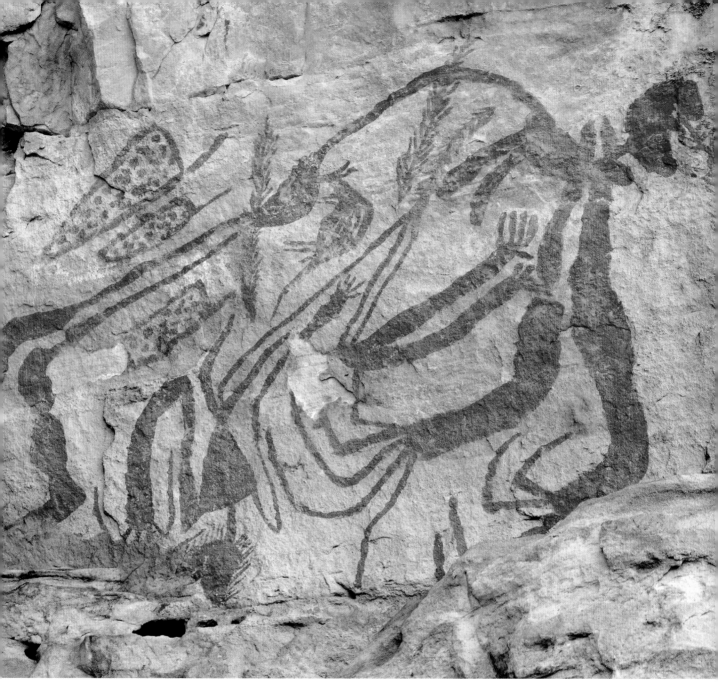

Kakadu National Park › Ubirr Aboriginal art gallery

Northern Territory

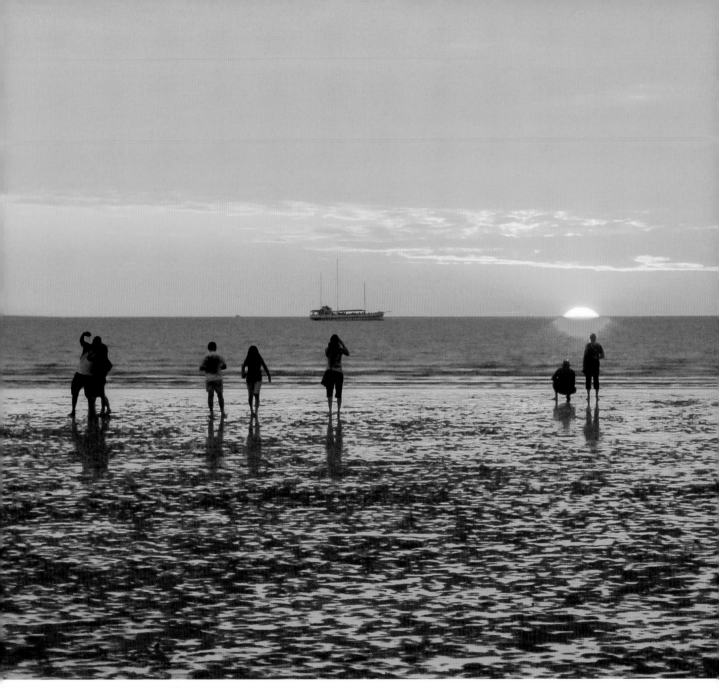

Darwin › Sunset at Mindil Beach

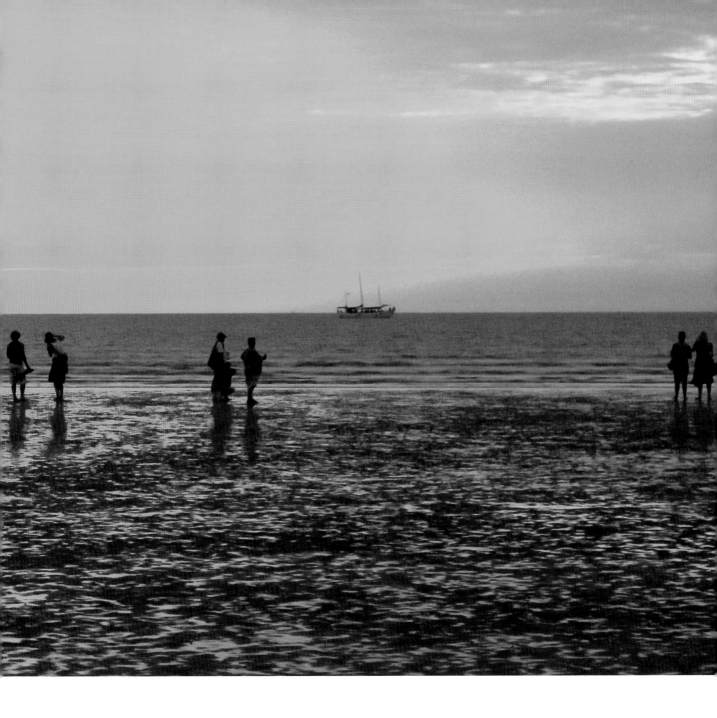

Northern Territory

Nitmiluk (Katherine Gorge) National Park › Bush tucker on the Jatbula Trail

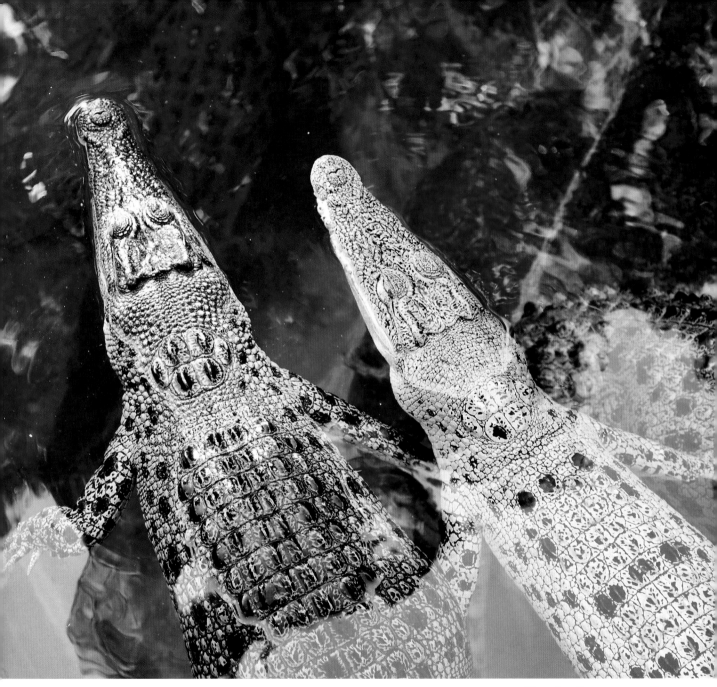

Darwin › Crocosaurus Cove

Northern Territory

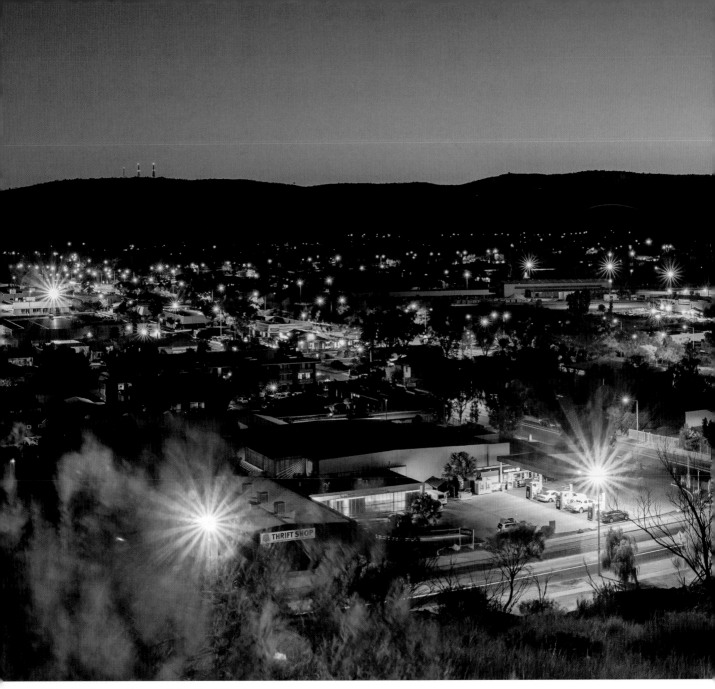

Alice Springs › Heart of the Red Centre

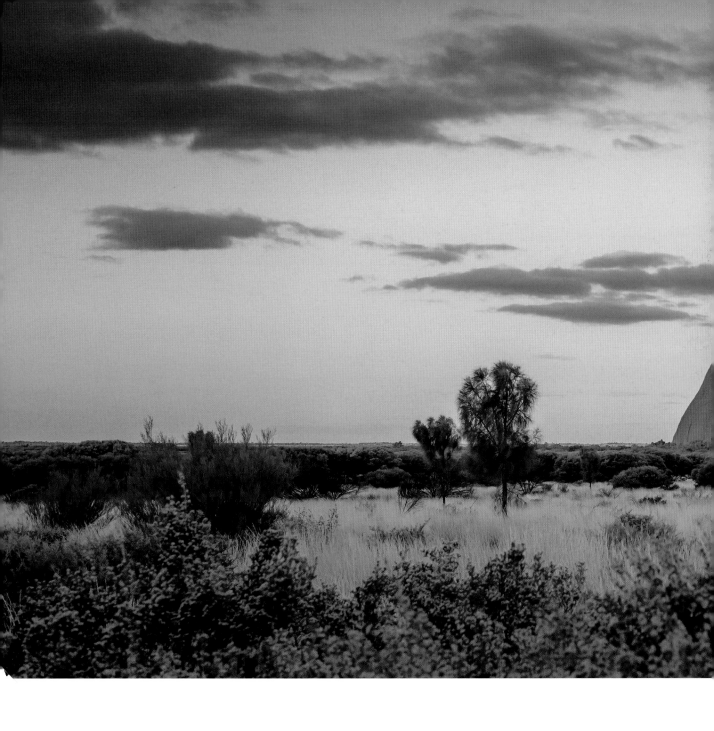

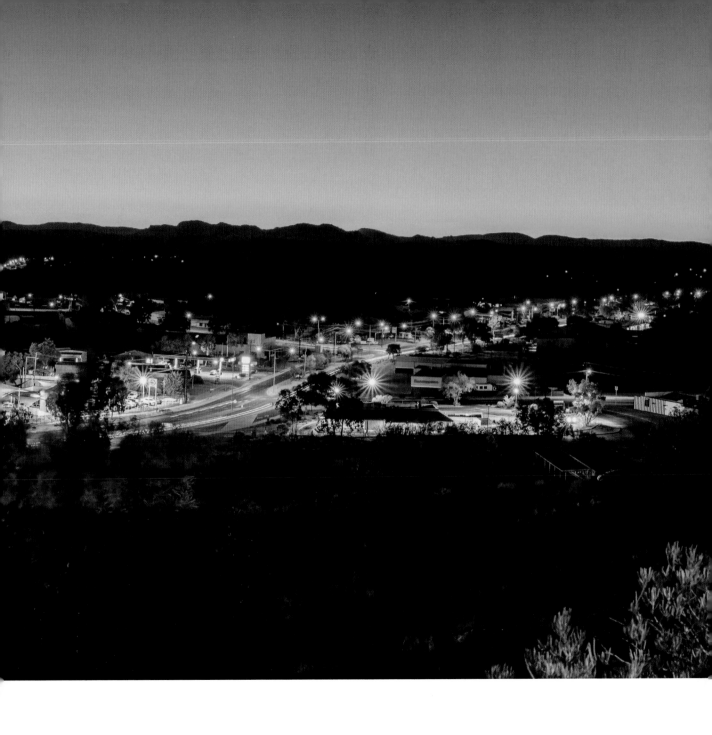

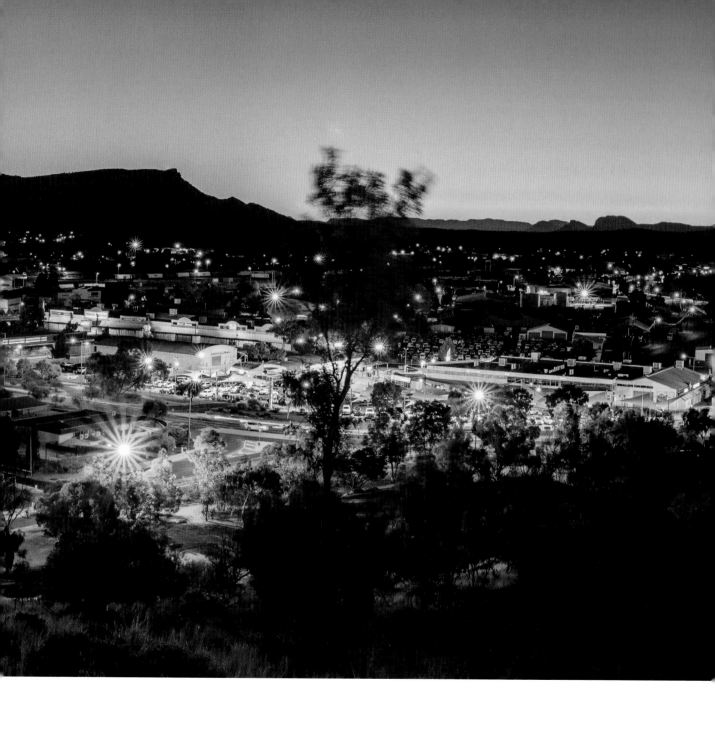

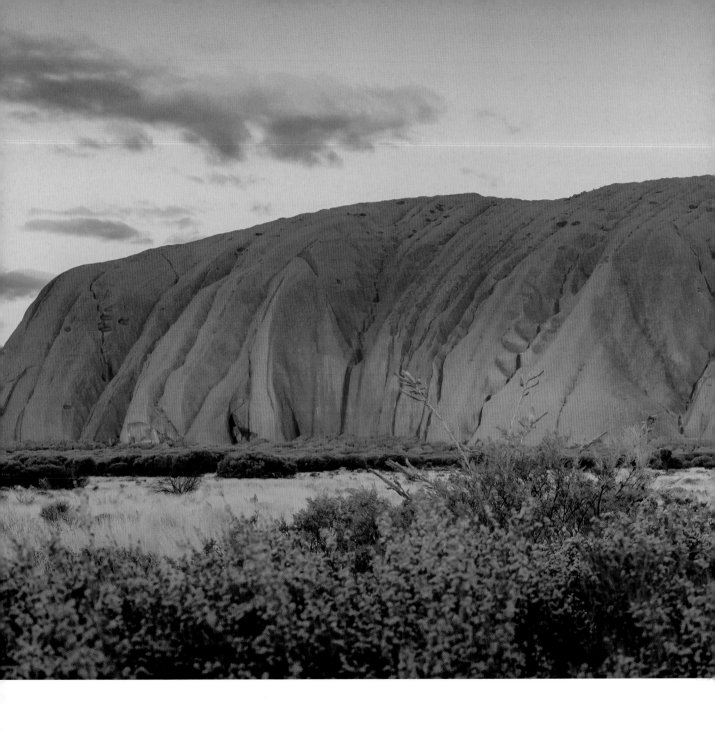

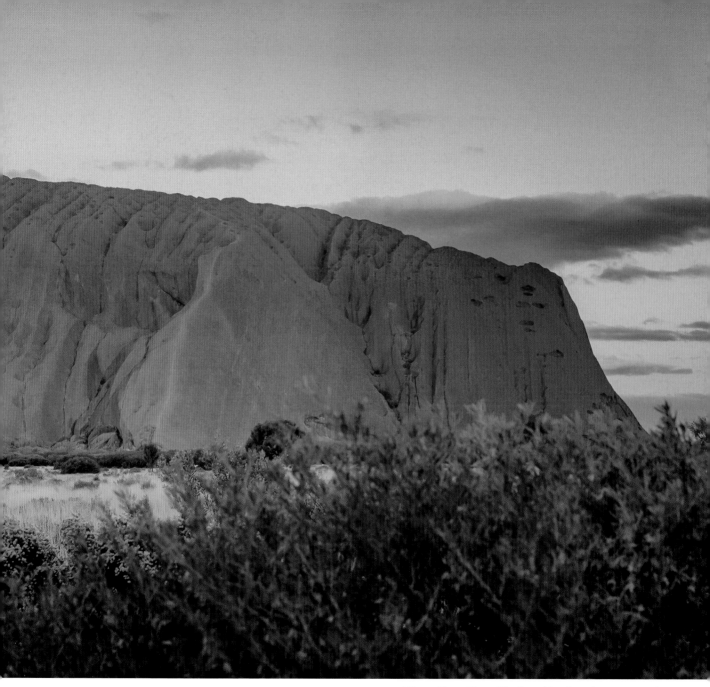

Uluru-Kata Tjuta National Park › Uluru at sunrise

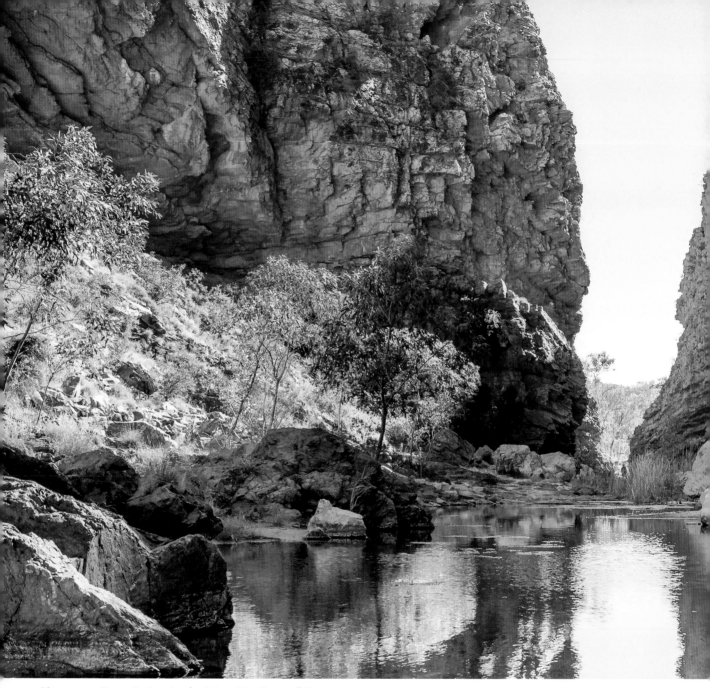

Simpsons Gap › A river in the West MacDonnell Ranges

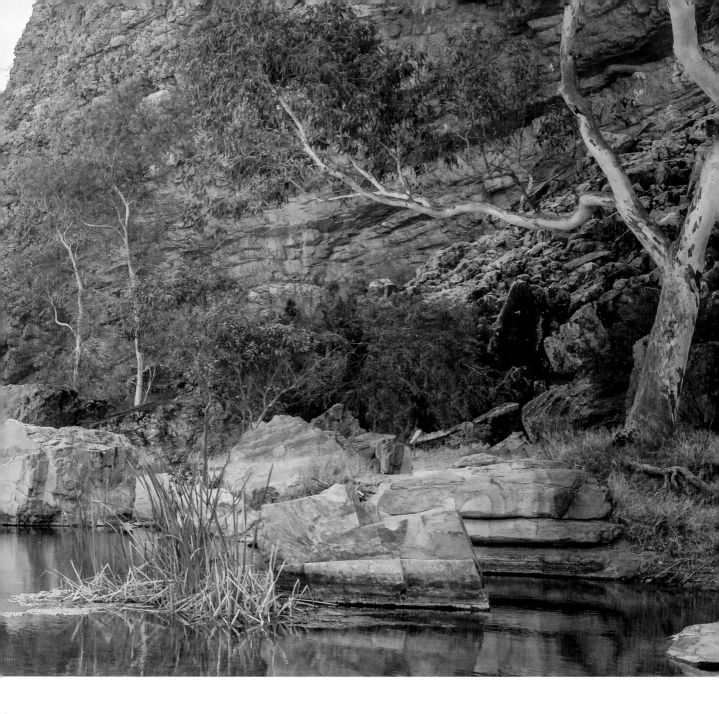

Northern Territory

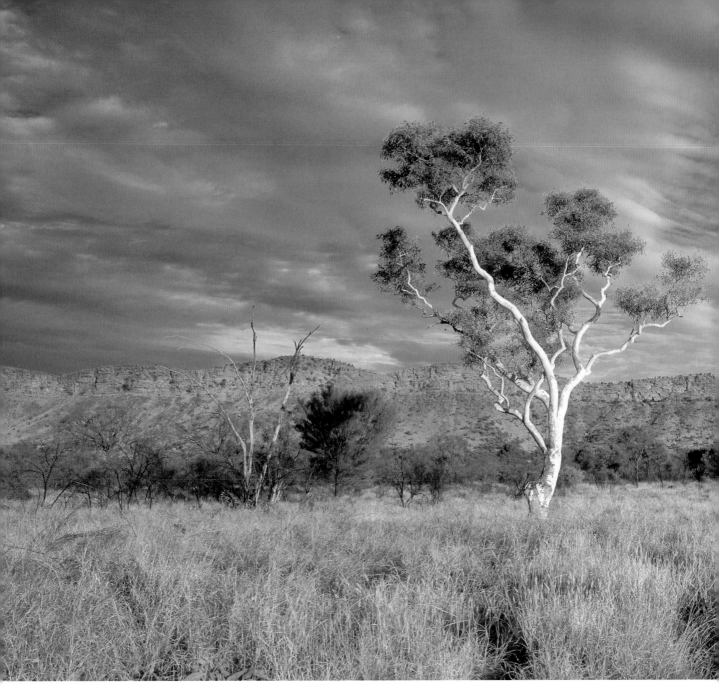

West MacDonnell Ranges › Gorges and ridges west of Alice Springs

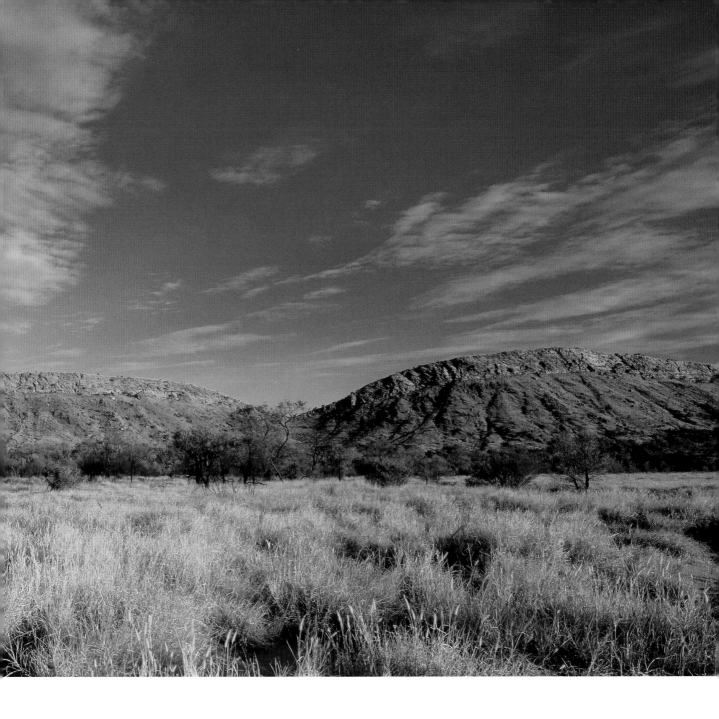

Northern Territory

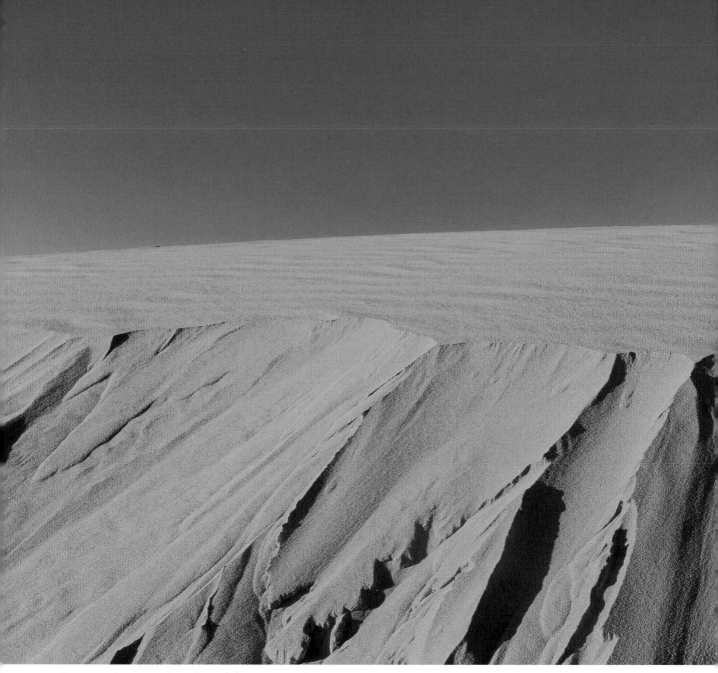

Northern Territory › Rich red sand dunes near Alice Springs

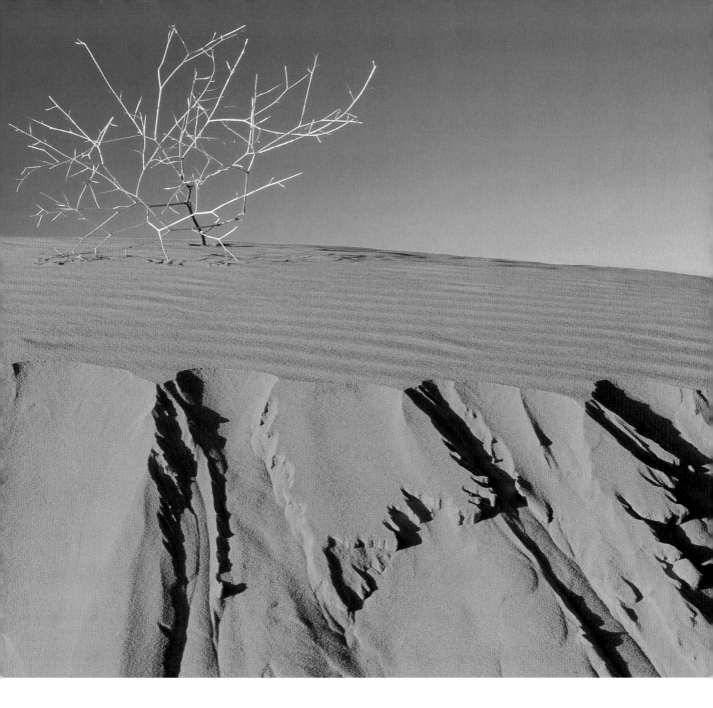

Northern Territory

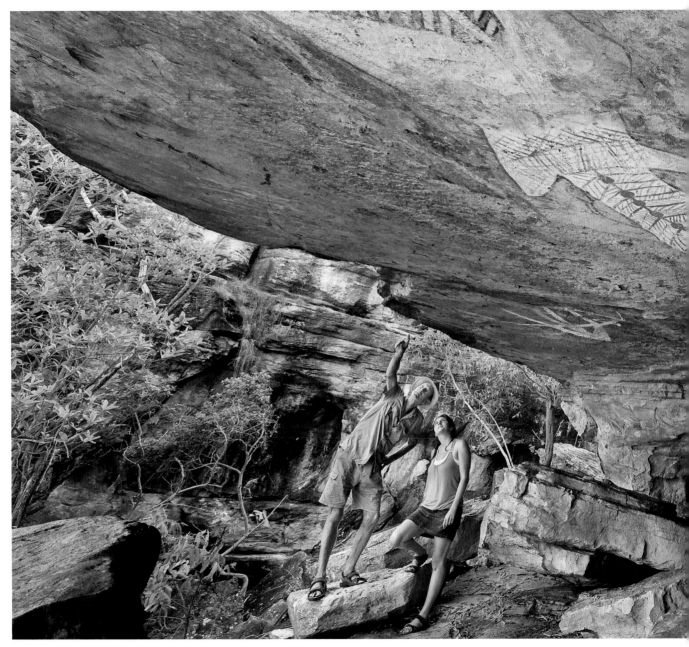

Arnhem Land › Ancient Aboriginal art at Mt Borradaile

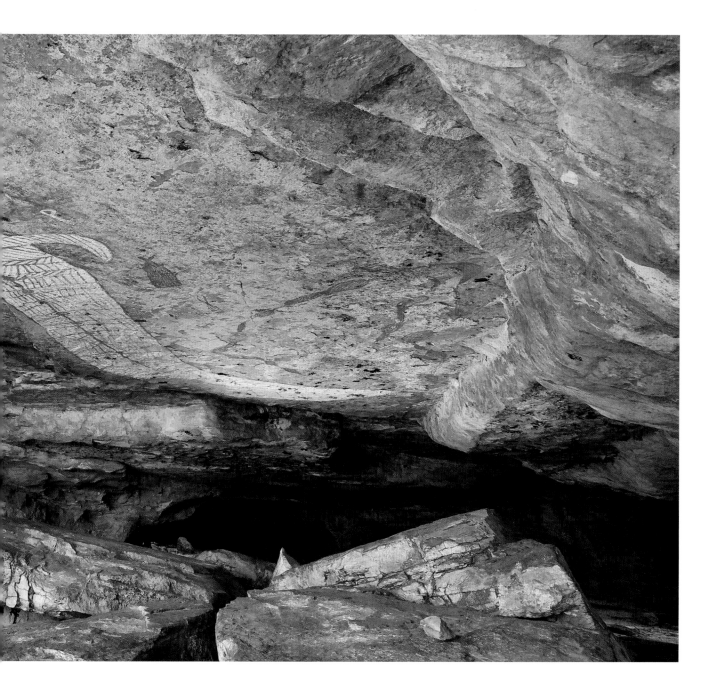

Northern Territory

Arnhem Land › The Gove Peninsula's coast

Northern Territory

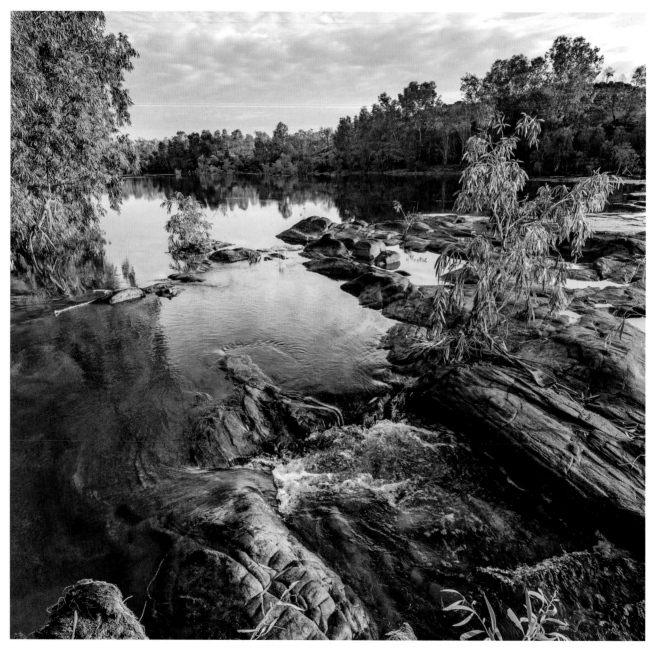

Kakadu National Park › Rivers and waterfalls in the wet season

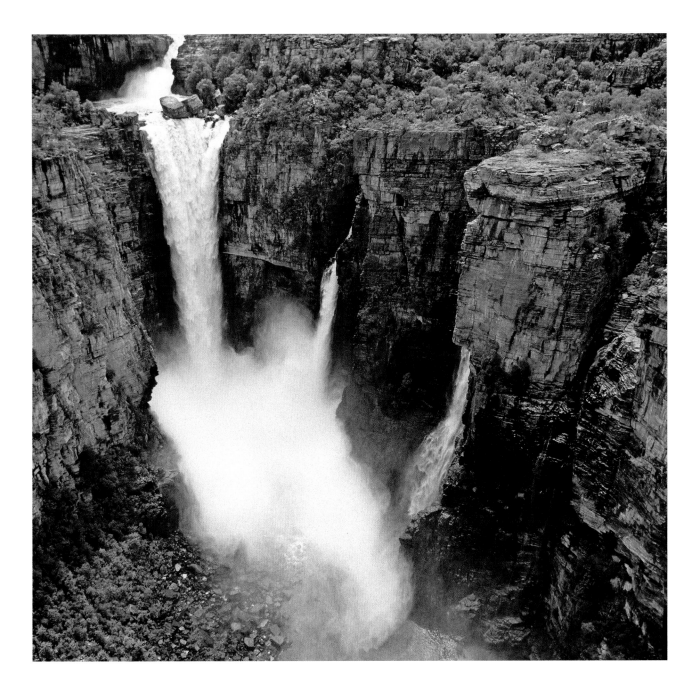

Northern Territory

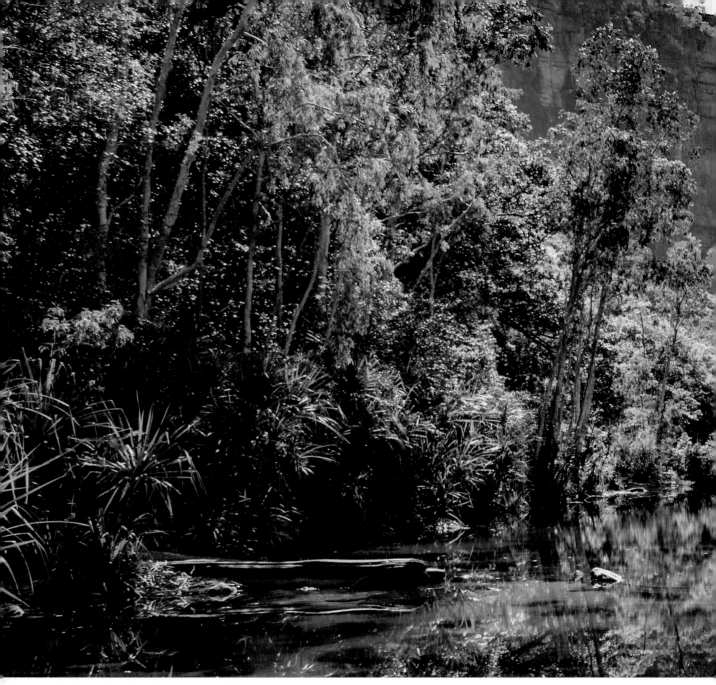

Kakadu National Park › Jim Jim Falls

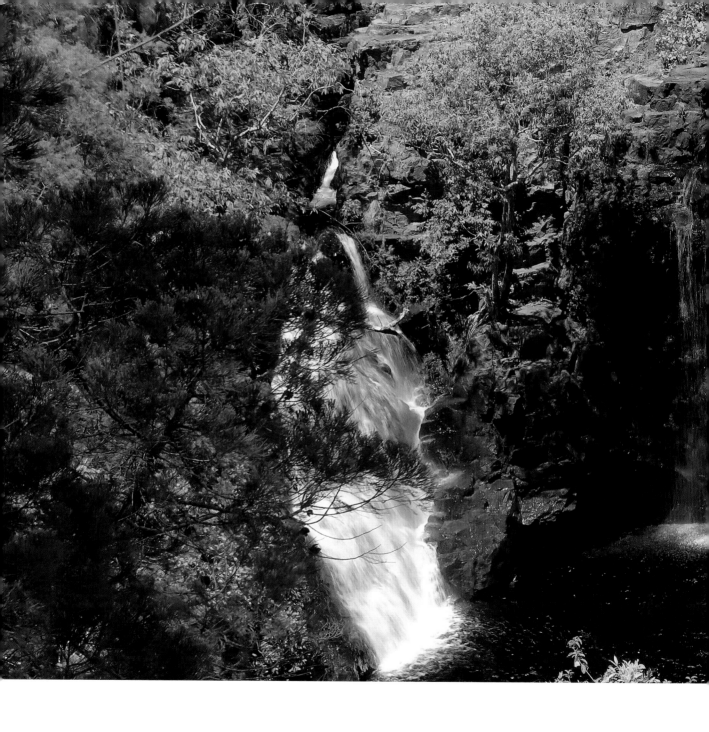

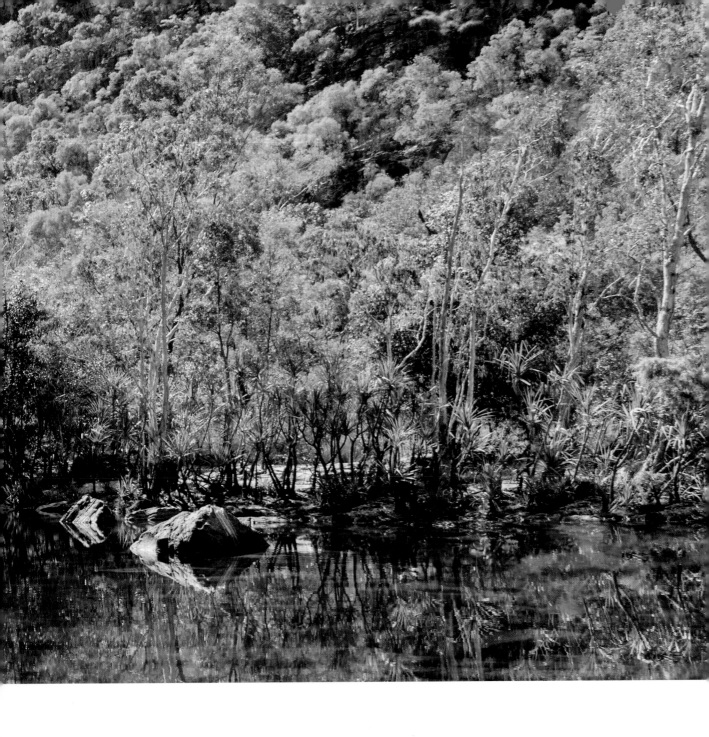

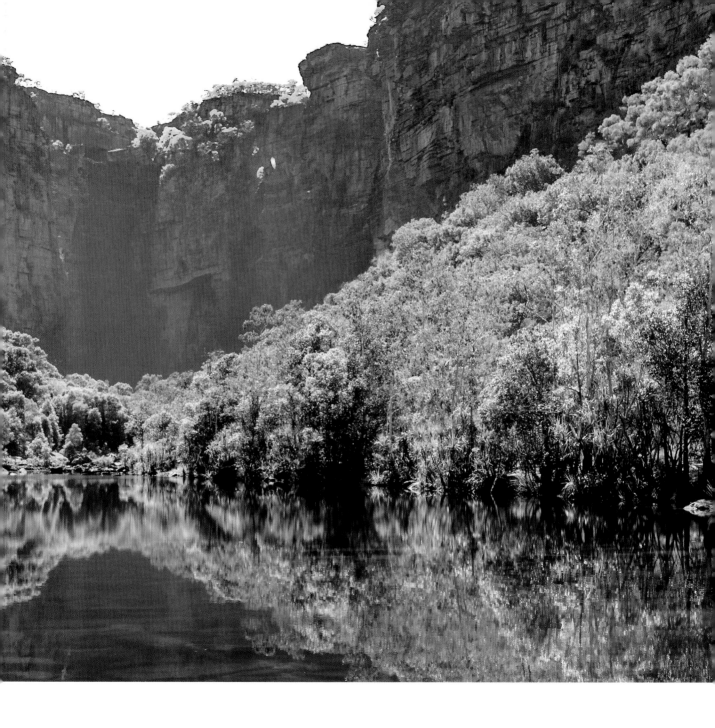

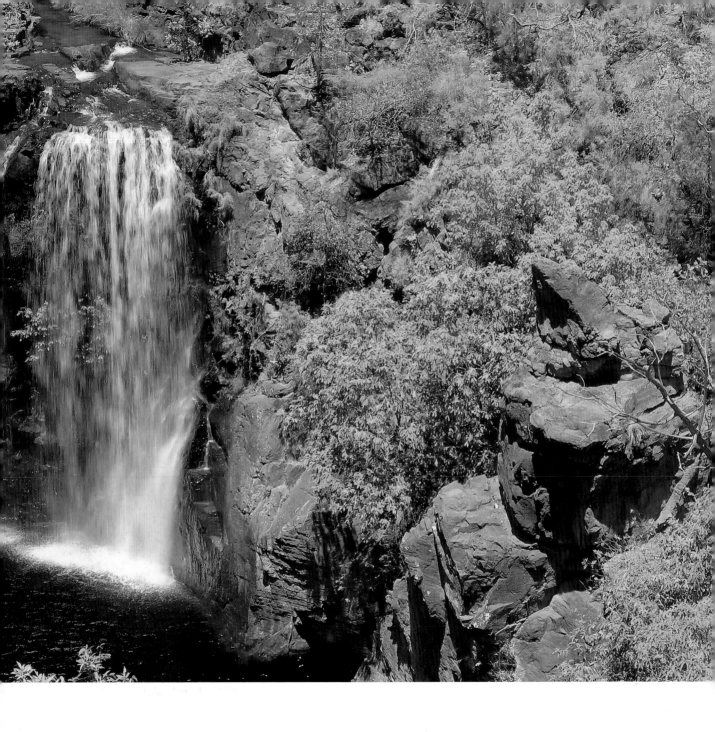

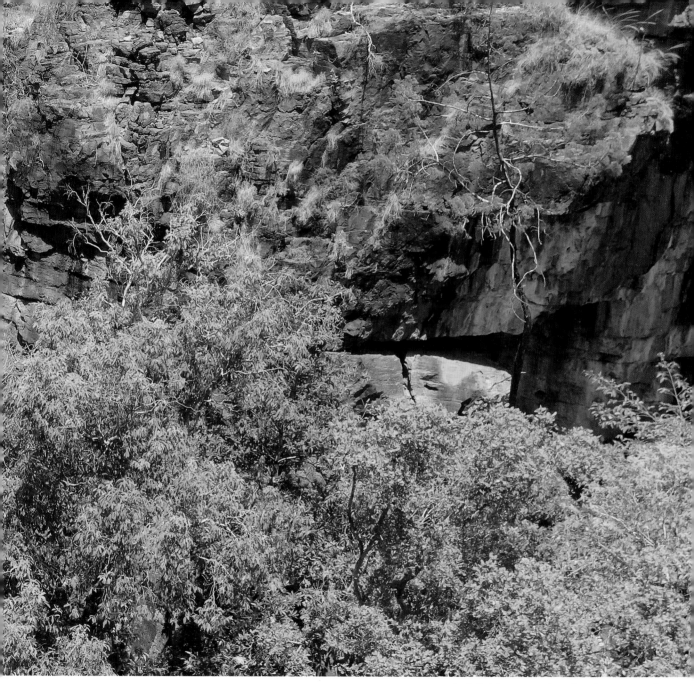

Litchfield National Park › Florence Falls

Northern Territory

Photo
Captions

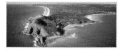

Byron Bay › Northern New South Wales is a region of pristine national parks, natural rugged beauty, epic beaches and delightful coastal towns. Bohemian Byron Bay is the standout and attracts everyone from surfers, hippies and yogis to models, musicians and backpackers.

6-7
Turnervisual | Getty Images ©

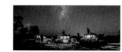

Bourke › Far beyond the city lights of Sydney lies outback New South Wales, where long empty stretches of road lead to middle-of-nowhere towns such as Bourke and Broken Hill. Clear night skies put on a dazzling Milky Way show out this way.

8-9
David Trood | Getty Images ©

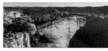

Blue Mountains National Park › The World Heritage Blue Mountains region delivers natural scenery of epic proportions. The sandstone plateau features gullies, waterfalls and lookouts. The name comes from the eucalyptus oil of the trees that cloaks the mountains in a blue-purple haze.

10-11
Craig Holloway | 500px ©

Byron Bay › The Cape Byron Walking Track winds its way around the Byron Bay headland along to the Cape Byron lighthouse (1901). Showboating dolphins can often be seen year-round in the waters below.

12-13
RugliG | Shutterstock ©

Byron Bay › Byron Bay is a surfer's paradise with a number of great beaches from which to pick. The Pass at Clarkes Beach is the most popular break, while the Wreck is a powerful right-hand break at Belongil Beach.

14-15
Andrey Bayda | Shutterstock ©

Hunter Valley › The verdant Hunter Valley is a popular weekender trip for Sydneysiders out to sample the region's excellent food and wine. The scenic countryside is home to a number of animal species and it's not uncommon to see roos hopping about.

16-17
Andrey Bayda | Shutterstock ©

Bondi Beach › World-famous Bondi Beach is a broad sweep of golden sand backed by rough-and-tumble surf. The average water temperature is a pleasant 21°C and sandbar breaks at either end of the beach churn out decent waves for surfing.

18
Jonathon Stokes | Lonely Planet ©

Jervis Bay › The south coast of New South Wales is a string of scenic national parks, idyllic beaches, fishing towns and turquoise bays. While the competition is fierce, Hyams Beach on Jervis Bay may be the most blissful beach – reputedly with the whitest sand in the world.

19
Kevin Mirc | EyeEm | Getty Images ©

Kosciuszko National Park › Snow gums glow in the sun at Kosciuszko National Park in the Snowy Mountains. Home to Australia's highest peak, Mt Kosciuszko, the mountains are a significant ceremonial spot for Aboriginal people.

20-21
Paul Wallace | 500px ©

Snowy Mountains › Australia's true alpine region, the Snowy Mountains form part of the Great Dividing Range, which straddles the New South Wales–Victoria border. This region is synonymous with horse riding thanks to Banjo Paterson's famous poem, 'The Man from Snowy River'.

22-23
Faraz Mirzaagha | 500px ©

Canberra, Australian Capital Territory › Canberra, the nation's capital and political centre, has been overlooked in the past but this is a city that's really coming into its own. Visitors are now flocking to sample its cosmopolitan dining, stroll its broad boulevards and see its cultural attractions.

24-25
Martin Ollman | 500px ©

Canberra, Australian Capital Territory › Canberra's Parliament House was opened in 1988. It's a striking piece of architecture complete with turf roof and a towering 81m-high flagpole. Visitors can watch parliamentary proceedings and join free guided tours.

26
Australian Scenics | Getty Images ©

Canberra, Australian Capital Territory › In a city filled with architectural marvels, the art deco Australian War Memorial manages to stand out. Built in 1941, its commemorative courtyard features an eternal flame and cloister walls engraved with the names of Australia's war dead.

27
Ingo Oeland | Alamy Stock Photo ©

New South Wales › The beautiful bush flower the waratah is native to Australia and serves as the emblem of New South Wales. This vibrant crimson flower can be found on the state's south coast and in mountain ranges near the state capital, Sydney.

28
Anna Calvert | 500px ©

South Coast New South Wales › Spectacular views are to be had from the Illawarra Fly Treetop Walk, 28km west of Kiama on the New South Wales south coast. Visitors can wander amid the rainforest canopy on a 1.5km return walk taking in the scenery.

29
Jonathon Stokes | Lonely Planet ©

South Coast New South Wales
› One of Australia's best driving routes, the Grand Pacific Drive takes in the southern coastal highlights of New South Wales. Starting near Sydney's Royal National Park, the drive passes through rainforest and the stunning coastal regions of Wollongong, Kiama and Jervis Bay.

30-31
zetter | Getty Images ©

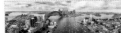

Sydney › With its glorious harbour, knockout beaches and iconic landmarks, Sydney certainly has the wow factor. This is a city that seamlessly combines stunning natural beauty with in-your-face sass and style.

32-33
Taras Vyshnya | Shutterstock ©

Sydney › Built in 1932, the Sydney Harbour Bridge ('the giant coathanger') is one of Sydney's most recognisable and loved landmarks. As you make your way around the city, it has a knack of sneaking into your line of sight when you least expect it.

34
Alberto Mazza | 500px ©

Sydney › Australia's most famous landmark is undoubtedly the eye-catching Sydney Opera House. This World Heritage–listed building was designed by Danish artchitect Jørn Utzon to resemble the sails of a yacht, and hosts everything from opera and theatre to concerts and dance performances.

35
Catherine Sutherland | Lonely Planet ©

Sydney › At the southern end of Bondi Beach is the incredibly photogenic historical landmark, the Bondi Icebergs Pool. Swimmers power through laps in the saltwater pool as breakers from the ocean douse them along the way.

36-37
©superjoseph | Shutterstock ©

Sydney › You don't need to venture far in Sydney to find the city's 'cool'. It's crammed with boutique hotels, the hottest bars and hipster hang-outs, whether you're wandering the central business district or hanging out in its hip inner-city neighbourhoods.

38 & 39
Matt Munro; Catherine Sutherland | Lonely Planet ©

Silverton › The old mining town of Silverton has been the setting for a number of Aussie films, such as *Mad Max 2*. The heart of the town is the Silverton Hotel, with walls covered in Australian larrikin and film memorabilia.

40
David Trood | Getty Images ©

Kentucky › A shearer shaves a sheep in the rural town of Kentucky in the New England region of New South Wales. Sheep shearing has been an iconic symbol of rural Australia since the start of the wool industry in the early 19th century.

41
Michael Hall | Getty Images ©

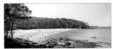

Jervis Bay › Jervis Bay is a large sheltered bay on the south coast of New South Wales, known for its national parks, blinding white-sand beaches, great camping areas and Indigenous heritage. No surprise it's a popular holiday spot for Sydneysiders.

42-43
Jonathon Stokes | Lonely Planet ©

Yarra Ranges National Park › The 30km Black Spur road between Healesville and Narbethong follows a twisting route past giant ferns and mountain ash trees. It is rated as one of the world's best drives. Don't rush it – though the motorbikers appreciate being allowed past.

44 & 45
THPStock | Getty Images ©

Bright › Founded in the 1860s, Bright has seen gold come and go over the decades but is now thriving as the recreational hub of the Victorian Alps, offering access to Mt Feathertop, Mt Bogong, Mt Buffalo and Mt Hotham. After a day of play, Bright's brewery beside the Ovens River beckons.

46-47
FiledIMAGE | Shutterstock ©

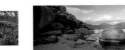

Wilsons Promontory National Park › It's still possible to find solitude in Victoria's ever-popular Wilsons Prom National Park, the most southerly part of mainland Australia. Hikes – for a day or overnight – radiate from the Tidal River hub, but even better to have a boat to reach such beautiful beaches as Refuge Cove.

48-49
Norman Allchin | Shutterstock ©

Wilsons Promontory National Park › Ancient rocks, highlighted in orange lichen, litter the bays and inlets of Tidal River on the west side of Wilsons Promontory National Park. Squeaky Beach is a popular one-hour hike from Tidal River. Or pack a tent to reach Refuge Cove or Sealers Cove for the night.

50-51
Pete Seaward | Lonely Planet ©

Great Ocean Road › Hugging the south coast west of Melbourne for 243km, from Torquay to Allansford, the Great Ocean Road is a classic road trip. What lies just off the road makes it special: waterfalls and giant trees in the Otways National Park, local communities, wildlife and foodie experiences.

52
Judah Grubb | Shutterstock ©

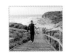

Bells Beach › At the start of the Great Ocean Road, near the town of Torquay, is one of the most famous beaches in surfing: Bells. The surf break came to prominence in the 1960s (the beach appeared in the movie *The Endless Summer*). But the final scene of *Point Break* wasn't actually filmed there.

53
maydays | Getty Images ©

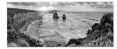

Port Campbell National Park › The Twelve Apostles are a series of sandstone sea stacks off Victoria's south coast. They're a popular stop along the Great Ocean Road and although only seven are visible from the viewing platform, it's an exhilarating experience to face the force of the Southern Ocean with them.

54-55

Taras Vyshnya | 500px ©

The Otways › The Great Otway National Park sprawls along the Great Ocean Road in southwest Victoria. Although not inside the park, Otway Fly Treetop Adventures offers a bird's-eye view of this rich ecosystem from the lofty rainforest canopy.

56-57

jefferyhamstock | Shutterstock ©

Alpine National Park › Across Victoria's High Country, huts were built by 19th-century cattlemen for shelter while they tended to livestock on the remote and mountainous land. Some, such as Wallaces Hut on the Bogong High Plains, still stand, maintained by the Victorian High Country Huts Association,

58

photosbyash | Getty Images ©

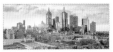

Mt Buffalo National Park › Near the town of Bright, Mt Buffalo National Park is a year-round adventure playground. The ski chalet at the top, built by the state government in 1910, was Australia's first ski resort. There are 90km of hiking trails across its rocky outcrops plus climbing and hang-gliding.

59

Ain Raadik | 500px ©

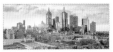

Melbourne › Downtown Melbourne is a mix of modern and historic. On the left is the iconic yellow facade of Flinders Street railway station (1909), and its neighbour, the Gothic Revival cathedral of St Paul's (1891). On the right of the photograph is the angular arts and social hub of Federation Square (2002).

60-61

f11photo | Getty Images ©

East Gippsland › Fertile Gippsland extends east to Croajingolong National Park and the holiday town of Mallacoota. Surrounded by water, Mallacoota is much loved by fishers and boaters while landlubbers are happy soaking in the tranquillity and exploring the park's 100km of wilderness coast.

62-63

Greg Brave | Shutterstock ©

Alpine National Park › Winter brings snow to Victoria's Alps. Ski, snowboard or toboggan at resorts such as Falls Creek, Mt Hotham, Dinner Plain and Mt Buffalo. An ice axe and crampons are often needed to cross Razorback Ridge, linking Mt Hotham and Mt Feathertop.

64-65

Neal Pritchard Photography | Getty Images ©

Hosier Lane › Victoria's capital has a famously tolerant attitude to street art. Giant murals brighten many buildings around the city but Hosier Lane, close to Federation Square, has a more graffiti-focused vibe. It's a popular location for photoshoots and even wedding photography.

66

patjo | Shutterstock ©

Pellegrini's › Melbourne has the largest Italian community in Australia (its sister city is Milan, after all). Italians arrived during Victoria's gold rush, after the 20th century's world wars and more recently. They opened businesses such as Pellegrini's, an iconic espresso bar on Bourke St in Melbourne's CBD.

67

Nils Versemann | Shutterstock ©

Phillip Island › Australia's only native penguin has several colonies around the coasts but their most famous breeding location is Phillip Island off mainland Victoria, where they can be viewed during the Penguin Parade at sunset. At about 30cm in height, they're the world's smallest penguin.

68

4FR | Getty Images ©

Phillip Island › In winter, roughly from May to October, humpback whales (and occasionally orca and southern right whales) migrate along the Victorian coast. They travel from feeding grounds in the Antarctic to breed in Australian waters. Phillip Island is a good location for whale-watching.

69

Nico Faramaz | Shutterstock ©

Croajingolong National Park › This giant wilderness occupies 875 sq km of eastern Victoria's coastline, offering remote, empty beaches and nature-filled hikes to explore. Aboriginal people are said to have lived in this area for 40,000 years, sustained by its abundant fish, birds and plants.

70-71

Greg Brave | Shutterstock ©

Grampians National Park › Rising from Victoria's western plains, the Grampians is a series of 400-million-year-old sandstone peaks, marking the tail of the Great Dividing Range, which runs all the way to Far North Queensland. It's a popular destination for climbers, wildlife-watchers and bushwalkers.

72-73

Peter Nguyen | 500px ©

Beechworth › Beechworth's beautifully preserved architecture dates from its Gold Rush heyday, when the town was a thriving regional hub. A courthouse, jail and telegraph station form the Historic Cultural Precinct. The Country Fire Authority building plus several pubs are also splendid.

74

Pawel Toczynski | Getty Images ©

Daylesford › The mineral springs of Daylesford have spawned lots of deluxe spas in this central Victorian town. Sybarites also come to explore the restaurants and wineries of the surrounding Macedon Ranges, and then to stroll the 3km around Lake Daylesford.

75

Jochen Schlenker | Getty Images ©

Noosa › The sophisticated resort town of Noosa on Queensland's Sunshine Coast is located within the Unesco-recognised Noosa Biosphere Reserve. With its crystal-clear waters, rainforest and happening main strip, it's the perfect mix of beach, bush and boutiques.

76 & 77
Darren Tierney | Shutterstock ©;
Matt Munro | Lonely Planet ©

Cape Tribulation › Following the winding road leading from the Daintree Rainforest brings you to the sensational beaches of Cape Tribulation, surrounded by lush rainforest in Queensland's far north. Watch out for crocs on your evening sunset beach strolls!

78-79
Ewen Bell | Lonely Planet ©

Great Barrier Reef › Stretching across more than 2000km of Queensland's coastline is the remarkable World Heritage-listed Great Barrier Reef. It's the world's largest coral reef system and attracts millions of visitors each year to dive and snorkel in its rich ecosystem.

80-81
superjoseph | Shutterstock ©

Great Barrier Reef › The Great Barrier Reef is made up of over 900 coral-fringed islands. This complex ecosystem is home to a number of plant and animal species, including sea turtles, 1500 species of tropical fish, manta rays, reef sharks and incredible coral.

82 & 83
Matt Munro | Lonely Planet ©;
Philippe Bourseiller | Getty Images ©

Queensland › Sugar-cane fields dominate the landscape on the drive along the Whitsunday Coast, with the town of Mackay known as the Sugar Capital of Australia. Sugar cane was first brought to Australia in 1788 on the First Fleet ships from South Africa.

84-85
blickwinkel | Alamy Stock ©

Great Sandy National Park, Fraser Island › The largest sand island in the world, incredible Fraser Island is the only known place where rainforest grows from the sand. Most of it is protected as part of the Great Sandy National Park and is home to the famous dingo.

86 & 87
Matt Munro | Lonely Planet ©

Surfers Paradise › High-rise hotels, nightclubs, bars and shopping malls: Surfers Paradise on the Gold Coast is party central and attracts plenty of young people looking for fun. And it does have an incredible beach to boot.

88-89
Airphoto Australia | Getty Images ©

Queensland › With so much coastline, it's little wonder surfing is high on the list of popular Australian activities. Queensland is home to countless great surf beaches including the crown jewel the Superbank, a 2km-long sandbar on the Gold Coast.

90
Darren Tierney | Shutterstock ©

North Queensland › *Jaws* isn't the only thing to look out for in Australian waters. Saltwater crocodiles, the largest of all living crocodiles, can be found in the waterways of tropical north Queensland.

91
Natalie Maro | Shutterstock ©

Wooroonooran National Park › Located in the Wooroonooran National Park in the hinterland of Far North Queensland, the Josephine Falls and the pools at its base, are the perfect spot to cool off on a hot summer's day.

92-93
Photography by Mangiwau | Getty Images ©

Whitsunday Islands › Australia is known for having some of the world's best beaches and many can be found on the Whitsunday Coast. Whitehaven Beach is the star of them all. It's a 7km-long stretch of blinding white sand and azure waters.

94-95
Bipphy Kath | 500px ©

Mount Mulligan › Situated 160km northwest of Cairns, Mount Mulligan is a rugged scenic mountain range and former mining town that was the site of Queensland's worst mining disaster in 1921. The 18km-long sandstone ridge is 10 times larger than iconic Uluru.

96-97
Matt Munro | Lonely Planet ©

Mount Mulligan › The stockman wearing an Akubra hat is an iconic Australian figure. They have been celebrated in ballads, poems and films over the years, the most famous being Banjo Paterson's poem *The Man from Snowy River*.

98-99
Matt Munro | Lonely Planet ©

Brisbane › Country fairs, held at showgrounds such as Brisbane's, are part of farming's social life. Queensland's state capital retains an agricultural flavour.

100-101
Janelle Lugge | Shutterstock ©

Girringun National Park › At 305m-high, the majestic Wallaman Falls is Australia's longest single-drop waterfall. It's located in the Girringun National Park, 51km west of the town of Ingham, and there's a steep trail leading to the base of the falls.

102
Zac Robinson | 500px ©

Daintree National Park › The flightless prehistoric cassowary can be found in the wild in parts of Queensland, including here in the World Heritage Daintree National Park. They can grow as tall as a person, with razor-sharp claws and a fierce kick.

103
Markus Bierschenk | Shutterstock ©

Rossville › Legendary pub the Lions Den Hotel has been keeping travellers through the Cape York Peninsula cool with ice-cold frothy beer since 1875. The walls are covered in Australian memorabilia and there's on-site camping for those who've had a few too many.

104 & 105
Ewen Bell | Lonely Planet ©

Mt Warning › The Mt Warning Rainforest Park sits between the Gold Coast in Queensland and Byron Bay in NSW, with Mt Warning itself located on the NSW side. The surrounding hinterland is made up of subtropical rainforest and cosy mountain villages.

106-107
THPStock | Shutterstock ©

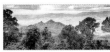

Mossman Gorge › Part of the traditional lands of the Kuku-Yalanji people, magical Mossman Gorge can be found in the southeast corner of the Daintree National Park. Water gushes over ancient rocks and there is a swimming hole for cooling off.

108 & 109
Matt Munro | Lonely Planet ©

Cooya Beach › A short drive from Port Douglas is pristine Cooya Beach and the traditional fishing grounds of the Kuku-Yalanji people. Guides take visitors out to learn about mud-crabbing and spear fishing.

110-111
Ewen Bell | Lonely Planet ©

Purnululu National Park › This geological marvel has mesmerised visitors since the park was founded in 1987 – but these beehivelike rock formations, aged around 350 million years, have been a part of Aboriginal folklore for 40,000 years. The orange bands are silica and the darker bands are lichen.

112-113
David Wall / Alamy ©

Tunnel Creek National Park › This is one of several national parks in the Kimberley, lying east of Windjana Gorge National Park. Tunnel Creek's claim to fame is subterranean: squeeze past boulders to enter a vast 750m tunnel that goes under the Napier Range. Bring a torch and expect bats.

114-115
Catherine Sutherland | Lonely Planet

Windjana Gorge National Park › Windjana Gorge is one of the Kimberley's most beautiful, with 100m-tall walls that glow in the sunlight. It was created by the Lennard River flowing through the Napier Range – the river is also a habitat for (usually harmless) freshwater crocodiles.

116-117
Catherine Sutherland | Lonely Planet ©

Montebello Islands Marine Park › This archipelago of 265 coral-fringed islands, located 130km off the Pilbara coast of northwest Australia, is a 580 sq km marine park. Visitors can camp on six islands; other islands in the group are turtle hatcheries or were used by the British for atomic weapon tests in the 1950s.

118-119
Salty Wings | 500px ©

Ningaloo Marine Park › From March to July, whale sharks congregate along northwest Australia's Ningaloo reef (accessed via Exmouth) to feed on plankton. The world's largest fish – up to 13m in length – swim slowly through the clear water, mouths agape. Each shark's mottled skin is uniquely patterned.

120-121
Rich Carey | Shutterstock ©

Cocos (Keeling) Islands › Beneath the surface of the tropical Indian Ocean surrounding the Cocos (Keeling) Islands, lying 2750km northwest of Western Australia's capital Perth, maxima clams filter food from the warm water. Their colours range from vibrant blue to purple and green.

122-123
Chris de Blank | Shutterstock ©

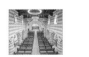

Geraldton › The exterior of St Francis Xavier cathedral in this city 425km north of Perth is as distinctive as its interior. Architect Monsignor Hawes eschewed ornamentation but the twin towers and a large dome add impact. Inside, the striped stonework recalls Italian churches and the Great Mosque of Cordoba, Spain.

124
Alberto Mazza | 500px ©

Nambung National Park › These limestone pinnacles were formed when the wind scoured sand from the land 30,000 years ago. Thousands punctuate the desert 200km north of Perth. Visits timed for the wildflower bloom from August to October will witness new life rising from the sand.

125
Simon Bradfield | Getty Images ©

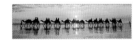

Cable Beach › White sand? Check. Blue skies? Check. Red rock cliffs? Check. A sunset that sears into your memory? Definitely. Cable Beach, close to Broome, the hub of the state's northwest, is a 22km beach with space for everyone, including the regular camel safaris.

126-127
paulmichaelNZ | Shutterstock ©

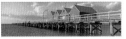

Busselton › There's more to Busselton's timber-piled jetty than its impressive length. At the end of the 1.8km jetty, a spiral staircase descends 8m to an underwater observatory on the Indian Ocean floor that allows visitors to view 300 species of sea creatures, including corals, sponges and fish, that live beneath the jetty.

128-129
Theo Allofs | Getty Images ©

Cape Naturaliste › Sugarloaf Rock provides the photo opportunities along this part of the Margaret River coast, unless you're quick enough to snap bottlenose dolphins playing in the surf. Surfing is a favourite pursuit of local dolphins, with up to 100 catching a wave at a time.

130
ianwiese | Shutterstock ©

Rottnest Island › The cute quokka is the only native mammal on Rottnest Island, just off the coast of Perth, where up to 20,000 of them live. The marsupials are part of the macropod family (of kangaroos and wallabies) but its larger relatives aren't as meme-friendly.

131
Catherine Sutherland | Lonely Planet ©

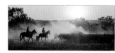

The Kimberley › The cattle muster in the Kimberley takes place after the wet season in April or May with thousands of fattened cattle rounded up on the region's vast stations so that they can be checked, branded and some exported. Several stations offer visitors the chance to ride with the stockmen and women.

132-133
Janelle Lugge | Shutterstock ©

Monkey Mia › The west coast of Monkey Mia is pounded by the ocean, but the other side of the peninsula offers a more sheltered habitat for dolphins, dugong, turtles and the eponymous finned predators of the Shark Bay World Heritage Area.

134-135
Andrea Izzotti | Shutterstock ©

The Kimberley › The baobab trees of the Kimberley are very well adapted to the extreme climate of the region. In the wet season they take in as much water as their trunks can store. In the dry season they shed their leaves to reduce transpiration.

136-137
bmphotographer | Shutterstock ©

Margaret River › Voyager Estate winery, founded in 1978, is a Margaret River original. Its understated Cape Dutch architecture and walled gardens may be elegant, but in the winery the spirit of adventure lives on with some bold experimental wines.

138
Travelscape Images | Alamy Stock Photo ©

Margaret River › World champion surfer Carissa Moore demonstrates flawless poise on the consistently firing Main Break wave at Surfers Point, Margaret River. You can watch the action on the left-hander reef break from the shore.

139
Kelly Cestari | WSL | Shutterstock ©

Esperance › Lucky Bay was named by Captain Matthew Flinders, who led the first circumnavigation of Australia. During a storm he sought shelter in the bay while exploring Australia's southwest coast in 1802. It remains a secluded spot today, with kangaroos hopping along the beach.

140
Jan Abadschieff | 500px ©

Esperance › Lake Hillier, near Esperance, popped up on many people's travel goals for an obvious reason. Scientists have explained the lake's distinctive hue as being due to the beta-carotene pigment found in some species of algae that flourish in highly salty water.

141
melnais | Stockimo | Alamy Stock Photo ©

Perth › Western Australia's capital is closer to the Indonesian capital of Jakarta than it is to Sydney. But in some ways it is more closely connected to the rest of the world, with nonstop flights between Perth and London now possible.

142-143
Ashagi Harahap | 500px ©

The Kimberley › King George Falls, at the very top of the North Kimberley Marine Park, are difficult to reach but the rewards are unforgettable: the river splits in two and plunges over ancient sandstone cliffs into tidal waters. The only way of seeing the spectacle is by boat or plane.

144-145
Janelle Lugge | Shutterstock ©

King Leopold Ranges › Mt Hart Homestead, once a cattle station, now a wilderness lodge, makes a great base for discovering the pockets of rainforest, creeks, gorges and epic sunsets of the King Leopold Ranges Conservation Park. It's reached via the Gibb River Rd.

146-147
Catherine Sutherland | Lonely Planet ©

Leeuwin-Naturaliste National Park › To cycle or hike through Boranup Karri Forest in southwest Australia's Leeuwin-Naturaliste National Park is to be dwarfed by these tall, pale, straight eucalyptuses. With the canopy being so far above, it can feel like being in a natural cathedral.

148-149
Philip Schubert | Shutterstock ©

South Australia › South Australia is known for its excellent wines and there is no shortage of cellar doors scattered around. From the world-famous shiraz of the Barossa Valley to the Adelaide Hills' cool-climate drops, there's a vineyard to suit everyone's taste.

150-151
kwest | Shutterstock ©

Barossa Valley › The compact Barossa Valley is one of the most historic wine regions in the country, with a collection of old growth vines dating back to the 1840s. The region is best known for its shiraz along with riesling.

152
Paul Kingsley | Alamy Stock ©

Clare Valley › Two hours north of Adelaide, Clare Valley's gorgeous countryside is rich with vineyards producing excellent rieslings and mineral-rich reds. Leave the car at home and cycle the Riesling Trail between cellar doors.

153
travellinglight | Getty Images ©

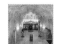

Coober Pedy › Summer temperatures skyrocket in Coober Pedy, a desolate opal-mining town in outback South Australia, so locals prefer to seek underground shelter. The town's most impressive church is the subterranean Serbian Orthodox Church, with intricate rock carvings.

154
Mike Greenslade | VWPics | Alamy Stock Photo ©

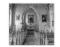

Clare Valley › An incredible example of Gothic Revival architecture, the St Aloysius Church was completed in 1875 and sits within the vines of the Sevenhill Cellars winery. Established by Jesuits in 1851, this is the oldest winery in the Clare Valley.

155
Fotoaray | Shutterstock ©

South Australian Limestone Coast › Recognised as a wetland of international importance, the Piccaninnie Ponds Conservation Park is a diver's paradise on the Limestone Coast. Pressure forcing freshwater to the surface has created an underwater cave made up of sculpted limestone walls.

156-157
kaohanui | Shutterstock ©

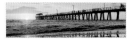

Adelaide › Adelaide scorches in the summer so locals hit the inner-city beaches to cool off. Glenelg is the most popular but Henley Beach, with its old wooden jetty, offers fewer crowds and a bounty of nearby bars and restaurants.

158-159
amophoto_au | Shutterstock ©

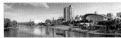

Adelaide › A little slice of Venice, sort of, on Adelaide's River Torrens. Gondola rides take passengers on a scenic journey down the river, otherwise you can chug along on a boat cruise or get the legs working on an old-school pedal boat.

160-161
Robert Lang Photography | Getty Images ©

Eyre Peninsula › The triangular Eyre Peninsula stretches all the way from the Western Australia border to Port Lincoln in South Australia. This is Australia's big-sky country; the pollution-free dark skies are perfect for stargazing.

162-163
John White Photos | Getty Images ©

Flinders Chase National Park › Off the mainland of South Australia lies the underdeveloped and laid-back Kangaroo Island. The Flinders Chase National Park occupies the western end of the island where Admirals Arch can be found – a huge archway eroded by crashing seas.

164-165
Pisit Kitireungsang | Shutterstock ©

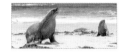

Kangaroo Island › Kangaroo Island is home to an abundance of native wildlife. At Seal Bay Conservation Park, guided tours take visitors along the beach to observe a colony of snorting Australian fur seals.

166-167
Rodrigo Lourezini | Shutterstock ©

Flinders Chase National Park › The signature landmark in Flinders Chase National Park on Kangaroo Island is the aptly named Remarkable Rocks. Located at Kirkpatrick Point, this cluster of granite boulders teeters atop a rocky dome 75m above the sea.

168-169
Bildagentur Zoonar GmbH | Shutterstock ©

Flinders Ranges › Dusty red roads, towering cliffs and jagged peaks make up the Flinders Ranges, one of South Australia's most iconic landscapes. Known for its remarkable colours, this ancient mountain range shifts from mauve at dawn to burning red sunsets.

170-171
Cultura RM Exclusive | Philip Lee Harvey | Getty Images ©

Flinders Ranges › Located in the Flinders Ranges National Park is the awe-inspiring Ikara (Wilpena Pound) – an 80-sq-km natural sunken basin encircled by jagged and gnarled ridges. Scenic flights over the park take in the amazing aerial views.

172-173
Southern Lightscapes-Australia | Getty Images ©

Adelaide Hills › South Australia serves up a slideshow of iconic Australian landscape in its many national parks and conservation areas. An emblem of Australia is the gum tree, with its bluish green leaves emitting the heady scent of eucalyptus.

174-175
mastersky | Shutterstock ©

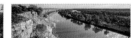

Murray River › The mighty Murray River is Australia's longest river at 2508km. It marks the New South Wales–Victoria border before slowly flowing 650kms through South Australia, where it's tamed by weirs and locks.

176-177
kwest | Shutterstock ©

Coober Pedy › To travel in outback South Australia is to head into the red heart of the country. Empty dusty-red roads stretch out in front for hundreds of kilometres, and the only company you may have is the native wildlife hopping by.

178
John White Photos | Getty Images ©

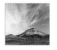

Coober Pedy › Thirty-three kilometres north of the opal mining town of Coober Pedy in outback South Australia is the Breakaways Reserve – a desolate, stark landscape of arid hills and scarp.

179
Tim De Boeck | Shutterstock ©

Kingston SE › One of Australia's iconic and much-loved 'big things', the giant red lobster stands proud here in the town of Kingston SE. These kitschy oversize outdoor sculptures can be found dotted around the country and are an essential photo pit stop on road trips.

180-181
Photodigitaal.nl | Shutterstock ©

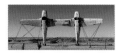

Oodnadatta Track › Mechanic-turned-artist Robin Cooke has created a number of giant sculptures, such as Planehenge, at Alberrie Creek on the dusty Oodnadatta Track (with thanks to the Arrabunna People, the traditional custodians of the land).

182-183
Darryl Leach | Shutterstock ©

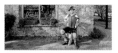

Hahndorf, Adelaide › Australia's oldest surviving German settlement, Adelaide's Hahndorf colonial enclave was founded in 1839 by 50 Lutheran families fleeing religious persecution in Prussia. It's a judiciously well preserved town, with just a hint of kitsch.

184-185
mophoto_au | Shutterstock ©

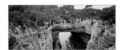

Tasman National Park › The Southern Ocean has forced its way beneath the spectacular sea cliffs of Tasmania's southeast coast, creating such features as arches and blowholes. Sightseers can drive all the way up to Tasman Arch, one of the largest.

186-187
Ingo Oeland / Alamy Stock Photo ©

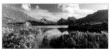

Cradle Mountain–Lake St Clair National Park › Dove Lake is a beautiful memento of the glaciers that carved the landscape of Tasmania's Central Highlands 10,000 years ago. The plant and animal species here go back even further, with roots in the ancient Gondwana landmass.

188-189
Catherine Sutherland | Lonely Planet ©

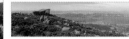

Mt Wellington › The climb up to Mt Wellington's summit, whether you're cycling or driving, begins just past the Cascade Brewery in South Hobart. Despite its proximity to the Tasmanian capital, the windswept peak is still a wild place, often snow-covered in winter.

190-191
boripan chatree | Shutterstock ©

Museum of Old and New Art › As David Walsh – founder of this remarkable collection – admits, his Museum of Old and New Art was constructed in thrall to Sidney Nolan's *Snake*, the Australian artist's masterpiece made between 1970 and 1972 and influenced by Aboriginal Australia and New Guinea's snake dances.

192-193
Joyce Mar | Shutterstock ©

Hobart › In the depths of winter at the southern tip of Australia, the Dark MOFO festival takes place over two weeks in June, with events manifesting at the Museum of Old and New Art and across Hobart city. Expect incredible installations, music and the traditional nude solstice swim.

194-195
Michael R Evans | Shutterstock ©

The Tarkine › The heart of the Tarkine, an as-yet-unprotected but extraordinarily precious wilderness in northwest Tasmania, is inaccessible except by boat or 4WD, allowing creatures such as the giant freshwater lobster to survive in its pristine rivers.

196-197
Kazuki Yamakawa | Shutterstock ©

Tasmanian echidna › This Australian native is unusual if not uncommon – it's an egg-laying mammal, a monotreme like the platypus. In Tasmania, the local echidnas tend to be larger than those on the mainland, with a thicker fur coat. Look for them in open country along the east coast.

198
Taylor Wilson Smith | Shutterstock ©

The Tarkine › The Pieman River is one of several wild rivers that flow through the Tarkine rainforest in northwest Tasmania. Kayaking these silent, tannin-stained waters is a great way to appreciate the tranquillity of the wilderness, floating past misty old-growth forest.

199
Peter Walton Photography | Getty Images ©

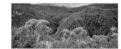

Franklin-Gordon Wild Rivers National Park › Set within the Tasmanian Wilderness World Heritage Area, this national park is to the west of Tasmania. It's named after its key rivers: the Franklin can kayaked or rafted, which is a world-class trip best attempted between December and March.

200-201
ian woolcock | Shutterstock ©

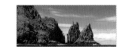

Tasman Island › Tasman Island, off the east coast's Tasman Peninsula, tumbles into the Southern Ocean in a stack of hexagonal dolerite columns rising up to 300m from the ocean. It is thought they were formed about 185 million years ago during a volcanic event.

202-203
Catherine Sutherland | Lonely Planet ©

Cape Huay › Scaling the Totem Pole, a sea stack on the Tasman Peninsula, is a popular challenge for rock climbers. At 65m high and with a diameter of 4m, the physical distance isn't huge but the mental leap, with waves crashing below, isn't to be underestimated.

204-205
Ulla Lohmann | Getty Images ©

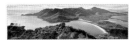

Freycinet National Park › For the best view of Wineglass Bay, it's necessary to make the 3-hour scramble up Mt Amos. From this peak in Freycinet National Park, the bay's curves are revealed, but its name comes from the 19th century, when the whaling industry would turn the waters red with the blood of cetaceans.

206-207

Visual Collective | Shutterstock ©

Hobart › Tasmania's state capital and the island's largest city is home to about 220,000 people, or 40% of Tasmania's population. It's surrounded by forest, mountain and water. With an enviable food, wine and art scene, it may be small but it's perfectly formed.

208-209

Yevgen Belich | Shutterstock ©

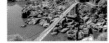

Cataract Gorge › The Alexandra Suspension Bridge crosses the South Esk River at the First Basin near Launceston. A path runs along the north side of the river, and to the south the deep basin, caused by the intersection of two fault lines, has a swimming pool, cafe and funicular railway.

210-211

Ikonya | Shutterstock ©

Tasmanian Devil Conservation Park › Take a right turn on the road to Port Arthur to find this sanctuary for the island's endangered devils. The terrier-sized marsupials are plagued by a mouth cancer spread by their fondness for sparring over food. Here, cancer-free populations are nurtured.

212

Rob D | Shutterstock ©

Stanley › Established in London in 1824, Van Diemen's Land Company's purpose was to tame Tasmania and make money from merino wool. The sheep farming didn't work out but the Highfield Estate, overlooking the Nut headland near Stanley, was the company's base until 1856.

213

Australian Scenics | Getty Images ©

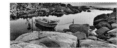

Bay of Fires Conservation Area › Beautiful Binalong Bay lies at the south end of the Bay of Fires and its weathered rocks, white sand and clear waters are ideal for exploration. The Bay of Fires refers to the Aboriginal fires seen by Captain Tobias Furneaux when he sailed by in 1773.

214-215

Taras Vyshnya | 500px ©

Launceston › The suburb of Launceston known as Trevallyn extends to the bank of the tranquil Tamar River. As the river flows north to its mouth it becomes the focus of one of Tasmania's and Australia's finest wine regions, the Tamar Valley, famed for pinot noir and idyllic river views.

216-217

David Lade | Shutterstock ©

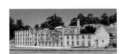

Port Arthur Penitentiary › Port Arthur was Tasmania's most notorious prison colony. In this heavenly setting on a remote forested shore was a deliberate form of hell. Some prisoners were kept in darkness and silence indefinitely. This ruined penitentiary is the largest building in the World Heritage–listed site.

218-219

jejim | Shutterstock ©

Huon Valley › Tasmania, aka the Apple Isle, was one of the world's largest exporters of apples. The first trees were planted in 1788 by none other than Captain William Bligh of the *Bounty*. Today it remains a $35m industry, concentrated in the Huon Valley and the central north of the island.

220-221

Janelle Lugge | Shutterstock ©

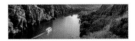

Nitmiluk National Park › The majestic Katherine Gorge is a series of sandstone gorges created by the Katherine River in the Nitmiluk (Katherine Gorge) National Park. During the wet season, the river gushes through the gorge creating an awesome sight.

222-223

Posnov | Getty Images ©

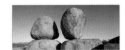

Uluru-Kata Tjuta National Park › Uluru may be Australia's most iconic sight but just as mesmerising and of cultural significance is Kata Tjuta (meaning 'many heads' aka the Olgas). Thirty-six boulders huddle together across the Uluru-Kata Tjuta National Park, the tallest standing 200m higher than Uluru.

224-225

Marvin Minder | Shutterstock ©

Devil's Marbles › Devil's Marbles is a sacred site consisting of massive granite boulders resting in piles on the side of the Stuart Highway. The traditional owners believe the boulders are the eggs of the Rainbow Serpent.

226-227

Janelle Lugge | Shutterstock ©

Alice Springs › Alice Springs is a hotbed of Indigenous culture, with local communities demonstrating art and dances, often inspired by the distinctive desert wildlife, such as this thorny devil lizard.

228 & 229

Grant Faint | Getty Images ©; Steve Lovegrove | Shutterstock ©

MacDonnell Ranges › In the Red Centre of the Northern Territory, the incredibly scenic MacDonnell Ranges stretches 400km across the desert. The ranges are home to an abundance of native plant and animal life, including the black-footed rock wallaby.

230-231

Whitworth Images | Getty Images ©

Watarrka National Park › One of the most impressive sights in central Australia, Kings Canyons sheer rust-coloured cliffs are located in the Watarrka National Park. Native wildlife roams the canyon, from dingoes and kangaroos to feral camels.

232

Paul Souders | Getty Images ©

Kakadu National Park › Kakadu's majestic natural beauty and remarkable human history can be experienced at Ubirr, 40km north of the Arnhem Highway. Rock paintings create a natural art gallery of native wildlife images and yam-head figures, some dating back around 15,000 years.

233
EcoPrint | Shutterstock ©

Darwin › Mindil Beach, in the cosmopolitan state capital of Darwin, is a popular spot to see burning sunsets, particularly on market days. The Mindil Beach Sunset Market features an international mix of food stalls, along with arts and crafts.

234-235
Fon Hodes | Shutterstock ©

Nitmiluk National Park › The Jatbula Trail in the Nitmiluk National Park gets you up close to the best of the Aussie outback bush. Learn about bush tucker, native flora and fauna, and Aboriginal culture on this five-day intensive bushwalk.

236
Janelle Lugge | Shutterstock ©

Darwin › The safest way to see a croc in the Northern Territory is with a visit to Darwin's Crocosaurus Cove. For brave visitors there is the not-very-reassuringly-named Cage of Death, where a transparent cage is lowered into the crocs' pool.

237
CAPE COCONUT | Shutterstock ©

Alice Springs › The heart of the Red Centre has a big personality. Its original owners are the Arrernte people. The town is famed for its Aboriginal culture and quirky traditions, and for being the hub for adventures in the surrounding desert.

238-239
Jess Yu / coloursinmylife / 500px ©

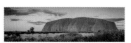

Uluru-Kata Tjuta National Park › The sheer immensity (867m above sea level) and natural beauty of Uluru is something that needs to be seen to be believed. This icon of Australia is a magical place of deep cultural significance to the Pitjantjatjara and Yankuntjatjara Aboriginal peoples.

240-241
Hervé DUCHENNE / 500px ©

Simpsons Gap › In a stunning corner of the West MacDonnell Ranges is Simpsons Gap, with its red-rock cliffs hulking over a gum-tree strewn riverbed. This is a great spot for wildlife-watching, particularly well-known for spotting black-footed rock wallabies.

242-243
Maurizio De Mattei | Shutterstock ©

West MacDonnell Ranges › Incredible gorges, an abundance of native wildlife and enriching bushwalks define the West MacDonnell Ranges in the Northern Territory's Red Centre. Sweeping views across the desert can be seen from the Mt Sonder lookout – especially beautiful at sunrise and sunset.

244-245
Janelle Lugge | Shutterstock ©

Northern Territory › The Northern Territory dishes up plenty of quintessential Australian landscapes, from the imposing rock formations of Uluru and Kata Tjuta to burning-red sand dunes against a vivid blue sky in the outback desert.

246-247
Australian Scenic | Getty Images ©

Arnhem Land › Evidence suggests that rock art was being produced by Aboriginal people in Arnhem Land as far back as 60,000 years ago. Some of the best rock art in the area is located at Mt Borradaile, including an enormous Rainbow Serpent.

248-249
Marc Dozier | Getty Images ©

Gove Peninsula › The Gove Peninsula, one of Australia's most unspoiled paradises, is in the northeastern corner of Arnhem Land. The region is home to incredibly beautiful coastline, and is known for producing some of the most respected Indigenous art.

250 & 251
Craig Ramsay | 500px ©

Kakadu National Park › There are countless ways to experience the truly unforgettable Kakadu National Park. Cruises take visitors along rivers spotting wildlife while scenic flights show off the sheer scale of the park, taking in the view over Jim Jim Falls in the wet season.

252 & 253
Posnov; Auscape/UIG | Getty Images ©

Kakadu National Park Kakadu National Park's rich and diverse ecosystem sprawls across 20,000 sq km. Billabongs burst with wildlife, rock art shows the important history of the region and waterfalls tumble down gorges into swimming holes below.

254-255
Michele Boldo | 500px ©

Litchfield National Park › Smaller but by no means less impressive than Kakadu, the 1500-sq-km Litchfield National Park is easily accessed from Darwin. Waterfalls cascade off a wide sandstone plateau into pools below, making this one of the best spots for swimming – no crocs!

256-257
Paul Hollins / 500px ©

Index

Beautiful World Australia
May 2019
Published by Lonely Planet Global Limited
CRN 554153
www.lonelyplanet.com
10 9 8 7 6 5 4 3 2 1

Printed in China
ISBN 978 17886 8298 5
© Lonely Planet 2019
© photographers as indicated 2019

Managing Director, Publishing Piers Pickard
Associate Publisher & Commissioning Editor Robin Barton
Art Director Daniel Di Paolo, **Designer** Lauren Egan
Image re-touching Ryan Evans, **Writer** Kate Morgan
Editor Nick Mee

Cover and endpaper image: © Matt Munro / Lonely Planet

Lonely Planet Offices

Australia
The Malt Store, Level 3,
551 Swanston St, Carlton, Victoria 3053
T: 03 8379 8000

USA
124 Linden St, Oakland,
CA 94607
T: 510 250 6400

Ireland
Digital Depot, Roe Lane (off Thomas St),
Digital Hub, Dublin 8,
D08 TCV4

Europe
240 Blackfriars Rd,
London SE1 8NW
T: 020 3771 5100

STAY IN TOUCH lonelyplanet.com/contact

MIX
Paper from
responsible sources
FSC™ C021741

Paper in this book is certified against the
Forest Stewardship Council™ standards.
FSC™ promotes environmentally responsible,
socially beneficial and economically viable
management of the world's forests.